A Practical Guide to
LANDSCAPE
PAINTING
by Colin Hayes

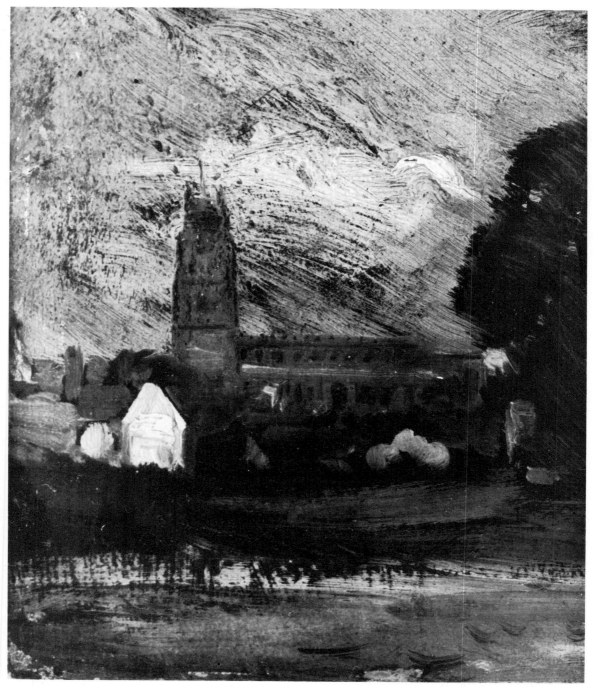

JOHN CONSTABLE 1776–1837
Stoke by Nayland
18 cm × 26 cm (7¼ in. × 10⅜ in.)
Tate Gallery, London
This study shows how strongly contrasted textures of
paint can enhance the special character of each
element. Constable kept such use of texture under
masterly control. Without control, and unguided by
structural demands, wilful texture-making is
more likely to imprison the subject than reveal it

A Practical Guide to LANDSCAPE PAINTING

by Colin Hayes

Watson-Guptill Publications/New York
B. T. Batsford Limited/London

Copyright © 1981 by B. T. Batsford Ltd.
Published 1981 in New York by Watson-Guptill Publications, Inc.

First published 1981 in the United States and Canada by
Watson-Guptill Publications, a division of Billboard Publications,
Inc., 1515 Broadway, New York, N.Y. 10036.

Library of Congress Cataloging in Publication Data
Hayes, Colin.
 A practical guide to landscape painting.
 Bibliography: p.
 Includes index.
 1. Landscape painting. I. Title.
ND1340.H38 751.45′436 80–19861
ISBN 0–8230–0322–1

Manufactured in Great Britain

First Printing, 1981

Contents

Acknowledgment

The author and publishers thank individuals and galleries for
their permission to include the following illustrations in this
book:

ADAGP for page 89
Birmingham Museums and Art Gallery for page 48
Boymans Museum, Rotterdam for pages 34 and 88
Bury Art Gallery for page 31
Courtauld Institute, London for page 61
The Fine Art Society for page 94
Indianapolis Museum of Art for the colour plate facing page 73
Ipswich Borough Council for page 31
The Louvre, Paris for pages 24 and 72
Manchester City Art Gallery for page 49
Musée Marmottan, Paris for page 60
Musée de Rouen for page 32
The National Gallery, London for pages 10, 19, 84, 86
The National Galleries of Scotland for page 96 and the facing
colour plate
The National Museum of Wales for page 26
Rochdale Art Gallery for page 100
Royal Academy of Arts, London for page 36
Royal Albert Memorial Museum, Exeter for page 62
SPADEM for pages 98 and 99
The Tate Gallery, London, for frontispiece and pages 44, 46, 50,
52, 89, 98
Victoria and Albert Museum, London for pages 68 and 70

Introduction

This book is predominantly about the kinds of landscape which derive from observation. It is concerned to be of help to painters who attempt to express something of what they see before them in a particular place at a particular time.

The difference between the 'observed' and the 'imaginary' is not clear cut, but it may be remembered that what is called 'imaginary' landscape can sometimes be a generalized amalgam of scenic memories couched in the visions and experiences of other painters. Such amalgams are likely to be compounds of what the artist already knows or has culled from the knowledge of others: they are preconceptions.

The landscape of direct visual experience has the particular quality of bringing the painter face to face with the unexpected. However well-known its countryside, however familiar its *genius loci*, an actual subject will contain shapes the artist has not seen before, relationships which cannot quite have been anticipated, qualities which are beyond preconception.

Since we are to occupy ourselves principally with observed landscape it is worth recalling its antecedents. For landscape painting has not always been concerned with this expression of specific natural appearances.

References to landscape in medieval art were largely symbolic in purpose. Even from the Renaissance until the late eighteenth century, most painters who used landscape themes did so from an obsession with classical ideal or romantic drama. Certainly they often used observation as a working basis for their inventions and fantasies; the drawings of Titian, Claude, Rubens and Rembrandt are examples of acute study. Even in paintings reference can be found to actual places. But the idea of capturing in paint the special quality of open-air light, of 'out-of-doors', seems missing, or is very rare. Some of the Dutch seventeenth-

century painters, Ruisdael among them, came near to this, but their rendering of space and light still depended extensively on Baroque studio devices.

Among those who led the way out of the studio door, English artists have a fair claim to be in the vanguard. Watercolourists such as J R Cozens and the short-lived Thomas Girtin were among the first to make observed landscape a central preoccupation of their art. Turner and Constable following them, were perhaps the first to take the expressive capacities of oil paint truly into the open air. Constable in particular did more than any other painter to cultivate our open-air vision, and the immense popularity of his reproductions shows how even now his vision of landscape is widely accepted as a kind of norm. Turner's daring in rendering light almost to the apparent exclusion of form released our eyes from the bonds of picturesque and 'acceptable' subject matter.

Of course the Impressionists, Post-Impressionists, Fauves, and many others have supplemented and enriched our vision since the days of Constable and Turner; so much that it might easily be felt that all has been said about landscape, and that the time has come to turn our backs on that which can be observed. Certainly critical attention is hardly focussed on landscape, and we may be absorbed by valid artistic expression which has nothing to do with observation. Nevertheless, once our powers of looking have been opened up by masters, they are not easily closed again by a critical climate.

Perhaps it is a special property of the landscape masters to have said so much about the subject without closing the door on it. The material is inexhaustible, and we need not pessimistically assume that there is less vision in the world than there was.

Painters can still look, if they wish, and find something of their own to contribute to what they see. Landscape painting has no need to be apologetic about its existence, and this book has assumed its validity.

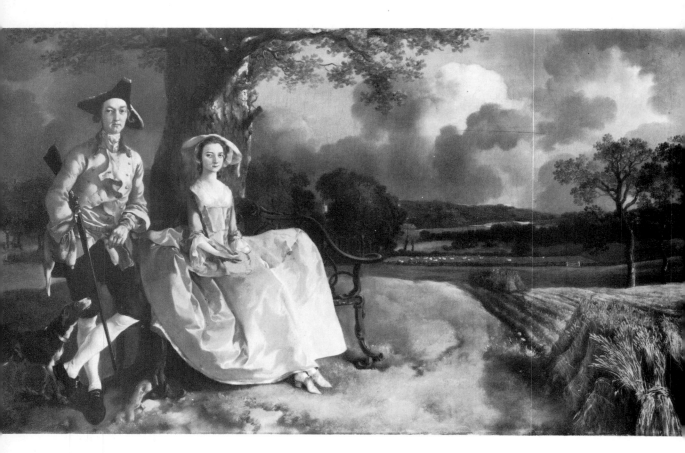

THOMAS GAINSBOROUGH 1727–88
Mr and Mrs Andrews c.1748
Oil on Canvas 70 cm × 119 cm (27½ × in. × 47 in.)
National Gallery, London
This early painting by Gainsborough is of course
essentially a double portrait of a newly married
couple, but it shows how well also the arts of
portraiture and landscape can be married. It is a
difficult undertaking, and we can see so many
examples of the genre in which studio and out-door
tonality remain unhappily at odds.

The Structure of Landscape

The structure of a room, or of a still life on a table is not too difficult to understand. To draw and paint these things is a demanding problem but to know their dimensions need not be. Things that we draw and paint indoors are usually within a few paces of our touch, and we can see, if we cannot so easily render graphically, the distance of one thing from another. Normally-sighted people possess binocular vision which enables them to assess, by the reflex stereoscopic working of the eyes, the third dimension to the limits of distance of most indoor subject matter. If all else fails we can even take a tape measure to things.

We cannot take a tape measure to a landscape. A topographical surveyor might; though possessing more subtle skills and instruments, he does so no more than he must. The landscape painter, without benefit of trigonometry and theodolite, cannot directly measure his subject even to the extent that he could roughly estimate the spatial dimensions of a still life or an interior. Even the natural benefits of stereoscopic vision operate only within a limited distance of foreground.

Direct linear measurement of depth in a scientific sense is something for which the landscape painter seems unequipped: much of the lie of the land before him may in any case be hidden from view, and it might seem that except by reference to a large scale contour map of the neighbourhood, he can give nothing except a surface rendering of the outlines and colour values visible to him.

Nevertheless, it is possible for a painter to sense and express the structure of landscape in his own ways. Sheer familiarity with a district is one way of 'reading' a landscape, and can be more valuable than a map. The two most firmly structural masters of observed landscape, Constable and Cézanne, had each trodden the ground of his favourite subject-matter since childhood.

Even without this special familiarity, a painter may find explanations in the resources of scale, atmospheric recession, topographical character and simply common sense.

Linear factors

To start with, let us leave for future consideration questions of colour, light, tone and atmosphere. Are there any guidelines which will help us towards a linear sense of landscape structure? Linear factors are those consisting of edges, intervals, points and proportions.

What can we infer from such factors about the lie of the land without being geologists? Common sense tells us some things. However deceptive appearances may be, we can remind ourselves that water does not flow uphill, and that a descending river bed which disappears behind a foreground obstruction cannot be ascending when it reappears on the other side. Still water lies in a horizontal plane; the far shore of a lake or a pond lies at the same level as the near one. Suppose that we are in a valley and that the top of a foreground tree occupies a higher place in the skyline than the peak of a distant mountain. Common sense tells us that the peak is in fact at a higher altitude. It does not take much practice to estimate a point in the distance at one's own eye level; the horizon runs through this point, and again common sense will then tell us that what lies above or below the horizon also lies above or below ourselves. (We must remember, of course, that the 'horizon' does not mean the visible skyline.) Such things are obvious enough; others less obvious.

Let us notice a few points about linear scale, for while this is usually one of the principal factors by which we sense distance, scale can be deceptive.

Linear scale

We all know that when objects of like size process into the distance they appear to get smaller. Let us look in a very simple diagrammatic way at how this apparent reduction relates to distance. We need not worry ourselves about theories of arithmetical and geometrical progression: all we need is a ruler, paper and pencil.

Take first the case of vertical scale, that is, of the vertical heights of objects. These objects may be of any kind, trees, houses, hills, poles: but let us take the simplest case of a series of objects all of the same height.

(i)

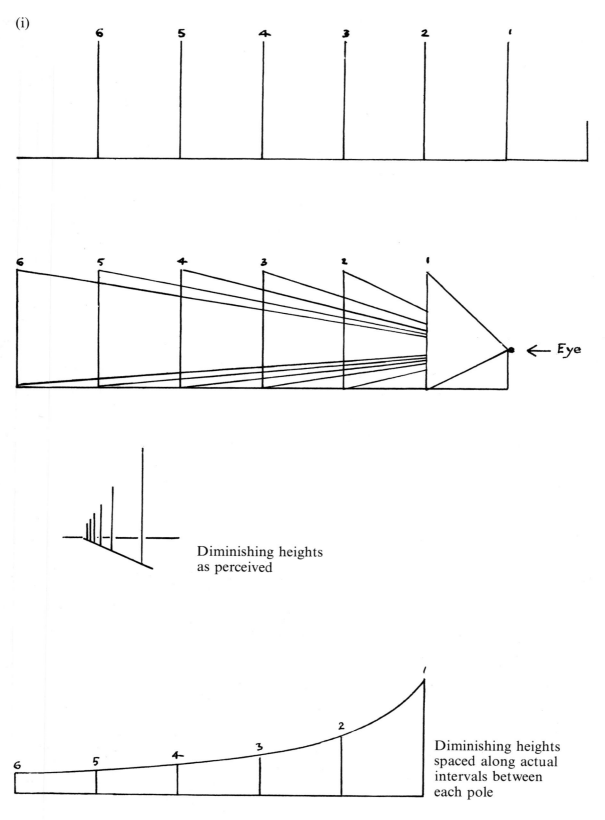

Diminishing heights
as perceived

Diminishing heights
spaced along actual
intervals between
each pole

Draw a horizontal line and mark it out at, say, six equal intervals. Leave one end, and raise verticals of equal height from the other intervals, as in diagram (i). The horizontal line represents a stretch of flat straight road, the vertical lines are telegraph poles. Now raise a shorter vertical at the end you have left: the top of this line is your eye. Draw lines from the eye point to the top and bottom of the first pole. This is your view of this first pole. Now do the same thing for the next pole. This second pair of viewing lines will cut the first pole so the second pole appears about half as high; reasonably, since it is at twice the distance. But do the same thing for the third pole and it will seem nearly two thirds as high as the second pole. Again, the fourth pole will seem more than two thirds the height of the third pole. And so on.

In other words, scale does not diminish equally with distance. The more that like objects retreat at equal intervals from your eye, the less is the apparent difference in their scales.

(ii)

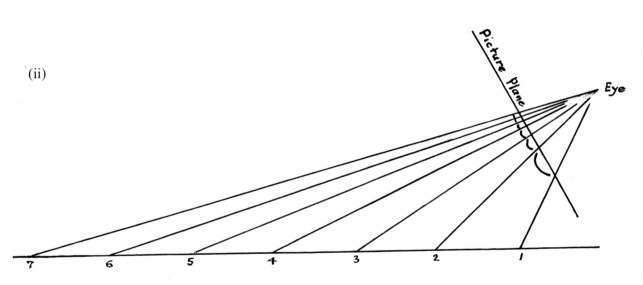

This is also true of receding horizontal intervals, as diagram (ii) will show. In this diagram I have introduced a tilted line in front of the eye to represent the actual picture surface, which we might think of as a sheet of glass on which we are tracing. (You can add this in diagram (i) if you like.)

Draw lines from the eye to points 1, 2, 3, 4, 5, 6, etc, placed at equal receding intervals. We see that these intervals projected onto the picture surface (sheet of glass), start by appearing to diminish rapidly: but the diminutions become progressively less contrasted as the points depart from the eye.

These diagrams may seem a ponderous way of pointing out what seems clear enough once you have drawn them: but as with all things in drawing, it is better to prove a given rule to yourself by experiment, rather than take it on trust. The experiments are worth while because the truths* of these geometrical diagrams may be extended as a general application to other phenomena arising from only approximately comparable dimensions and intervals.

For instance, a sloping wood in the foreground will reveal a scene of sharply diminishing tree scales: a similar wood on a distant similar slope will appear to be bunched up, its furthest trees hardly smaller in appearance than its nearest. Thus we can be deceived into supposing a distant facing slope to be much steeper than it actually is and if we do not understand the relation between scale and distance we may have difficulty in understanding how this slope can relate to the surrounding landscape structure.

Another instance is that of the mountain village which appears from a distance to be almost plastered against a cliff face: only as we enter it do we discover it to be built on a negotiable incline. Of course we must not let rules and guides to observation make us sceptical towards the exceptional or blind us to the unexpected; some mountain villages really are almost plastered to cliff faces.

However, all the above means that, in general, departing intervals in a linear sense become progressively less revealing and informative about real comparisons of depth as they recede into the distance.

Such considerations are so far purely linear, and it will be necessary at a later stage to relate what I have said about scale and interval to the matter of linear perspective. But perspective systems are not in themselves structure, only methods of expressing structure. For the moment let us remain with more basic linear considerations of the structure of landscape.

* Not quite so true as they have been made to look here, since the projection of the way we see onto a flat surface involves some distortion of natural vision; but more of this in the section on Perspective. These distortions do not invalidate the point now made.

Foundations

We have seen that some things are a matter of common sense, that apparent scale in interval proceeds according to visual rules which can both inform and deceive. Are landscapes subject to any other rules of a linear nature?

One factor may be taken as a useful structural assumption rather than a rule, and it involves our asking a question which is often overlooked. We assume that trees grow out of the ground, and that houses are built on land; this is visibly evident. 'Roots', 'foundations', 'ground level', are expressions of everyday use. A structural drawing of a house might naturally be expected to make some reference to the ground on which it is built and might even imply the existence of foundations. But what is landscape built on? What are its foundations and from what does it grow? It could be said that it simply stands on more of itself, down to the centre of the earth, but this is not very helpful to the landscape painter. It may be said that all but the surface weathering and accretions of landscape is ordered by its geological structure; this is certainly true, but it implies a degree of specialist knowledge.

In the meantime we may make an assumption about the foundations of landscape which, although artificial, can be of use in many circumstances.

And here we may remember the map-maker, who since he must refer all the heights he has measured in the field to some governing datum point, refers them to 'sea level'. Now a landscape painter need not do this (unless the sea features in his subject), but he may find it very useful to invent his own 'plane of reference'. He may, that is, liken his landscape to a vast still-life, where all the disparate objects in their complex relationships are ultimately supported on the surface of a table.

A landscape may be thought of as supported, as a house is supported, on a flat surface under its own lowest level. This level will not necessarily be the lowest visible level, but rather the lowest which the painter must sense 'supports' his entire subject. This surface then becomes an invisible plane to which all the visible masses and surfaces can be related.

This feeling for horizontal foundation is of more use to some than others. An evocation of atmospheric fragility may wish to avoid the very sense of weight and firm relationship which foundations give. But where weight and structure are sought, where an artist feels it necessary that a landscape might seem able to support the buildings which lie on it, then the idea of growth from even an assumed base may help towards an expression of this needed strength. A model of this assumed base is the table upon

which a sand-table landscape is made.

A painting which needs this feeling of underlying solidity and support, but which lacks it, can only too easily make a landscape look like the flabby surface of an almost collapsed balloon.

Surface forms: natural and man-made
What is true of the land itself (that weight and mass require foundations) is equally true of the things on it, natural or man-made. Trees and houses which grow or are built out of the ground are structural extensions of that ground. They must not be made to look as though they have merely been placed on a landscape like models on a sand-table. When the form of a hill must be described by the trees covering it, then a sense of the underlying contours which support them must be grasped.

An individual tree has roots which must be felt under the surface. There must be a sense that a house has foundations or it may seem to have merely dimension and no weight. All forms built on or growing from the ground have visible or implied verticals and the points where these verticals meet the ground must be discovered: indeed they not only meet but enter the ground. In the work of great landscape painters, especially in their drawings, it is often possible to see where the verticals of structures have been emphasised and such horizontals as might cut the structures off at ground level have been minimized.

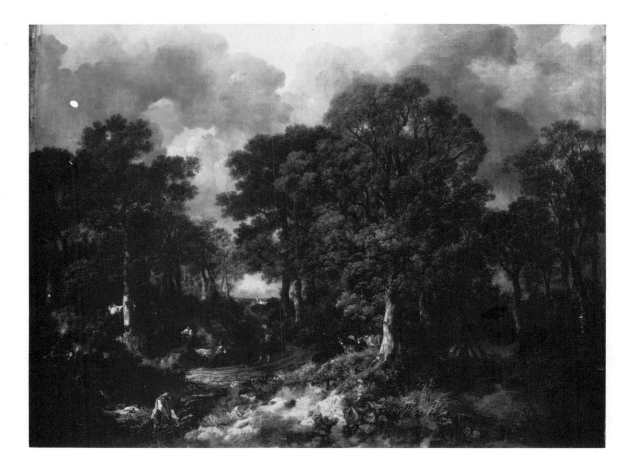

THOMAS GAINSBOROUGH 1727–88
Cornard Wood, 1748
Oil on Canvas 122 cm × 155 cm (48 in. × 61 in.)
National Gallery, London
Most of Gainsborough's landscapes, apart from his
fine direct drawings, are an amalgam of the invented
and the observed. In the conventions of his forms, in
his placing of accents and in the compositional
ordering of his masses he adapted tradition. But as
Cornard Wood shows, he had a sense of place and a
feeling for the tonal unity of nature, which lift his
landscapes far above convention. He commanded the
admiration (not lightly given) of Constable, who
recalled of a favourite Gainsborough landscape, 'I
cannot think of it even now without tears in my eyes'

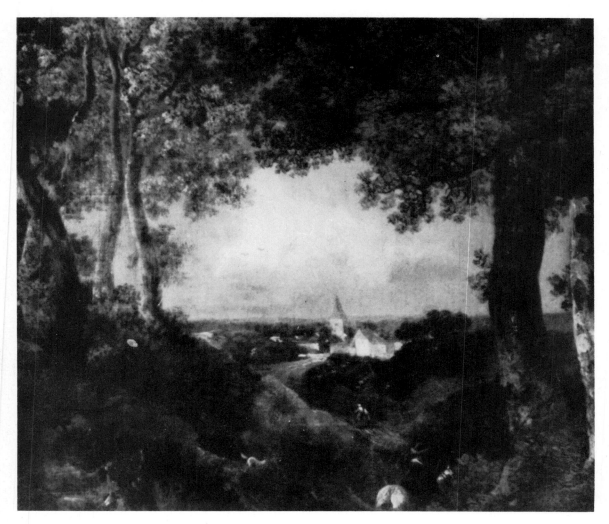

Cornard Wood, details

CAMILLE COROT 1796–1875
Fontainebleau, Les chênes du Mont Ussy, 1873
Oil on Canvas 49 cm × 59 cm (19½ in. × 23½ in.)
Later Corot landscapes tend to suffer critical
comparison with his own earlier and more classically
severe works. He came to adopt, as here a 'feathering'
shorthand for finely placed intervals and a sense of
contrasting forms. The French painters of this Realist
period knew well that landscape paintings would not
make themselves mindlessly: nevertheless they stood
against studio contrivance and the grandness of
design summoned by Corot derives less from wilful
rearrangement than from a thoroughly pictorial
choice of motif.

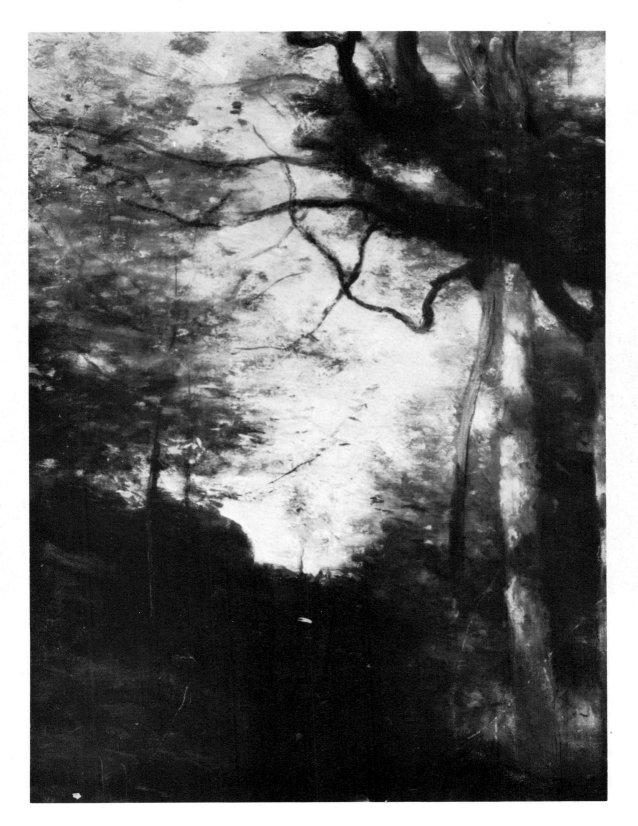

PAUL CÉZANNE 1839–1906

Pont de Maincy 1882
Oil on Canvas 59 cm × 70 cm (23¼ in. × 28¼ in.)
Louvre, Paris

Any landscape painter who has not seen this work, and who finds himself in Paris, would do well to head for it. It is a masterpiece of the language of painting; there are no 'literal' marks, but all that is necessary to the idea is described. For the landscape painter in particular it is an object lesson in the discovery of a subject. There is nothing particularly picturesque or dramatic here in its elements (no *Mont de Ste Victoire*), yet the result is pictorial drama of the first order

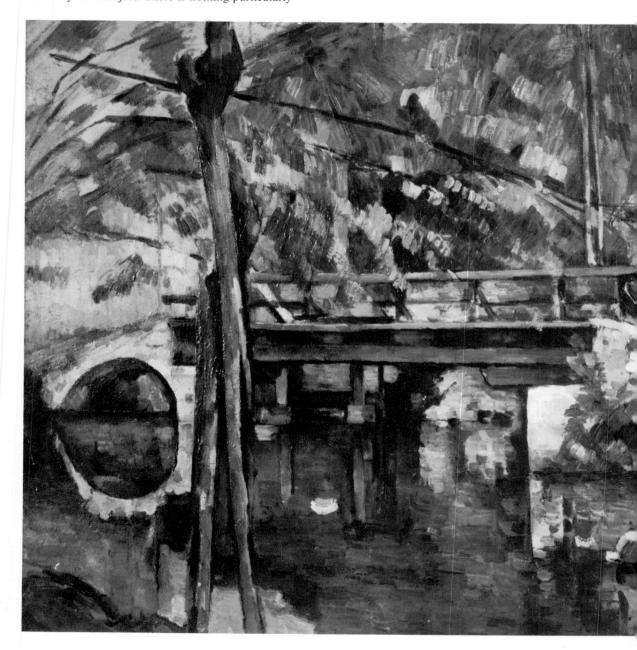

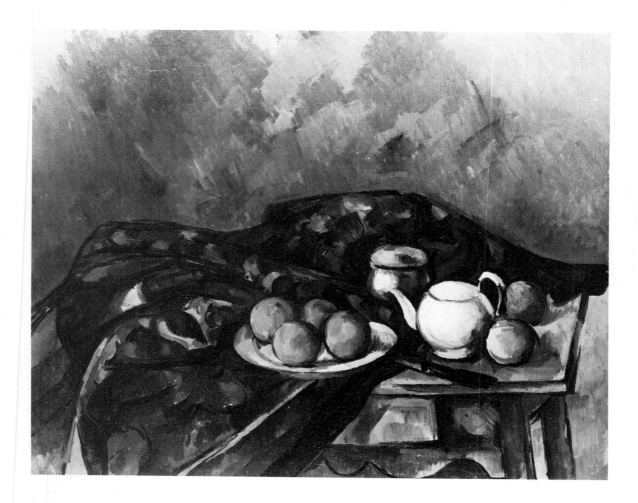

CÉZANNE
Still Life with a Teapot
Oil on Canvas 58 cm × 72 cm (23 in. × 28½ in.)
National Museum of Wales, Cardiff
The inclusion of a Still Life in a book on landscape
may seem puzzling but I bring this painting to the
reader's attention to show how close in some ways
may be the affinity between the two subject matters.
Cézanne in particular often demonstrates how a still
life can within its small physical limits present some
of the formal problems which face the landscape
painter. There is a spatial analogy between
background and sky, between draping and hill forms,
between fruit and jugs, and trees and buildings. The
support of the still life objects by an underlying
surface is much more readily grasped than that of
landscape features and the possibilities of design
inherent in the subject often show themselves more
immediately. A landscape painter may profitably turn
aside sometimes to still life to clarify persistent
problems of structure

26

Subject Matter

In a sense, it is presumptious to write about landscape subject matter, except to say that it should be anything the individual painter decides. This is true, and there might seem nothing more to say on the matter. But inexperienced painters, nevertheless, can fall into traps in selecting their subjects. First of these, perhaps, is the common tendency of the beginner not to distinguish his own subject matter from that of others. To be influenced by the masters of landscape is inevitable and even necessary; to hunt about for a scene which looks as nearly as possible like one of their paintings is not inevitable and not probably even beneficial.

The masters drew and painted things which arrested their attention and sometimes, as with Monet and Cézanne, subjects which continued to absorb them over long periods. It is not usually enough that your subject matter should have arrested and absorbed someone else, however eminent; it should arrest and absorb *you*. It is for the same reason that motifs which look, in a more general way, 'picturesque' should be regarded with some caution. The picturesque landscape is that which one fashion or another considers to be a suitable subject for landscape painting, and you may well be noticing such subjects through the eyes of fashion rather than through your own. Classical ruins (often a conventional exaggeration of the real thing) were a prime picturesque motif of the eighteenth century. The rustic scene with its cottages and village churches which followed, in turn gave way to Impressionist suburbia. Industrial social realism with its pit heads, steel plants and cooling towers may today be the nearest thing to an acceptable picturesque. To an extent, one generation's revolt against the picturesque becomes in itself the picturesque of the next. There is no reason why we should not paint cottages or cooling towers if we feel deeply that we have something of our own to say about them: but we will be heading for

the banal if we use such subjects only because we sense that they will meet with approval.

More contentious a subject matter is that which, whether acceptably picturesque or not, is in itself already a work of art. Fine architecture and great statues are inviting things, but how much can we say about them that has not already been said by the architect or the sculptor?

It need not be a bad thing for the novice (or the old hand) to attempt these subjects. In former times it was the standard art school practice that a student would lead up to life drawing with the study of classical casts: the theory was that the clarifying of forms by the sculptor would help the student to recognize their more elusive presence in the human figure. It may be that some study of 'ready-made' design in the open-air can in a similar way help the student towards identifying the design that lies behind the often highly elusive forms of natural landscape. But such subjects are usually at their most valuable as matters of study, not as substitutes for the development of our personal responses.

To be excited by a subject for our own reasons is the only positive precept which should govern our choice. Some painters, such as Canaletto, made subjects out of densely packed incident and detail: others, such as Turner, Seurat and Monet could find equally arresting motifs out of an almost complete absence of 'things' – from empty stretches of sky, sea and field.

But all the great landscape artists have been able to identify some essentially pictorial element in their subjects, however apparently empty. If any precept can be said to apply to subject matter, it lies in this quality of the pictorial, for this is what makes the difference between a subject and a mere view. The subjects of all good landscape paintings have about them a unity the seeds of which existed in nature.

Nature may offer us unity in its clear potentiality for geometrical design, or more elusively in colour or atmosphere, but it does not make these offers altogether invariable: sometimes it will present us with very attractive views whose elements are so scattered, or so equal in emphasis that they almost defy organisation within the limits of a rectangular format. Turner, Seurat and Monet may have painted landscapes with a notable absence of incidentals, but they avoided those in which no element of broad design could be found.

Then there are subjects with pictorial possibilities, but which may bristle with unnoticed difficulties – unnoticed, that is, until the painter is well embarked on his canvas.

It is not that a painter should be advised to avoid

difficulties, but he should be careful to identify them so that he can realise how far he is about to stretch his abilities. An exciting middle distance seen through a gap in a foreground of tangled undergrowth may offer splendid opportunities: but in your excitement with that middle distance, do not fail to notice that perhaps half your painting will have to deal with the undergrowth. Try to see a way forward to resolving this part of the problem, realise how very difficult it may be to make something of, and beware of proceeding with all the easier bits only to discover that you are faced with large passages intractably beyond your powers. We all come up against problems of this sort; if we are determined to solve them, then it is worth taking time to make many careful studies and drawings of undergrowth or whatever, until we discover the underlying structures and can begin to make order out of chaos.

Because nobody should tell a landscape painter what to paint, it is easier to be cautionary than positive about subject matter. Perhaps the only positive advice I would give is that when you look for a subject, in however apparently familiar a countryside, you should find it because in one way or another it takes you by surprise.

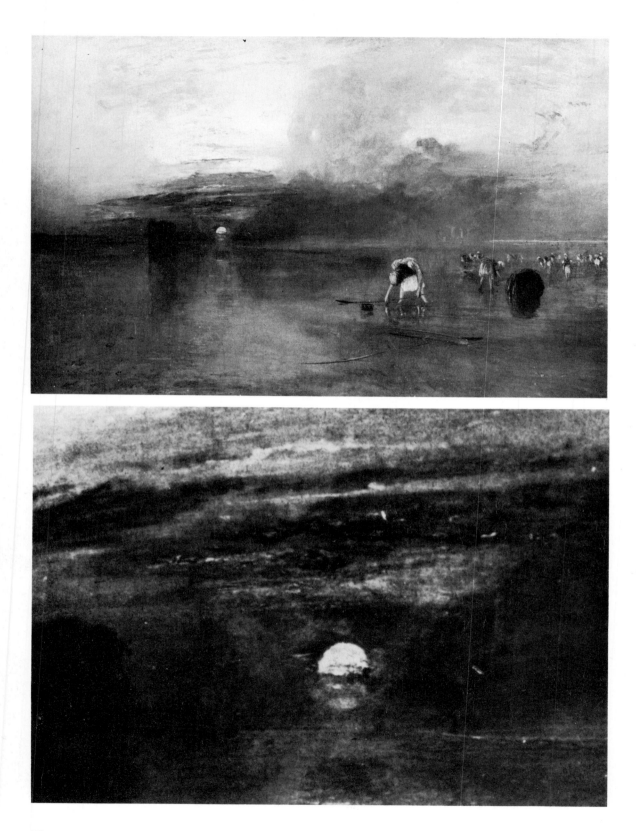

J M W TURNER 1775–1851
Calais Sands, Low Water. Poissards collecting bait
1830
Oil on Canvas 72 cm × 106 cm (28½ in. × 42 in.)
Bury Art Gallery
This famous painting is an example of a design
created from passages of atmospheric tone, generated
by the setting sun. The horizon line is hinted, and
really discovered in terms of the balance between sky
and reflections. The accents of the figures and the
harbour arm punctuate the space and are set well off
centre, not to detract from the essential theme of
light

JOHN CONSTABLE 1776–1837
Golding Constable's Flower Garden c.1815.
33 cm × 50 cm (13 in. × 20 in.)
Ipswich Borough Council (Museums)
By comparison with his mature work this scene by
the youthful Constable of his home as an innocent
charm. All the elements are stated with an equally
assiduous intensity: but it was from such close study
in youth that he learnt to select. Already there is a
powerful confidence of design

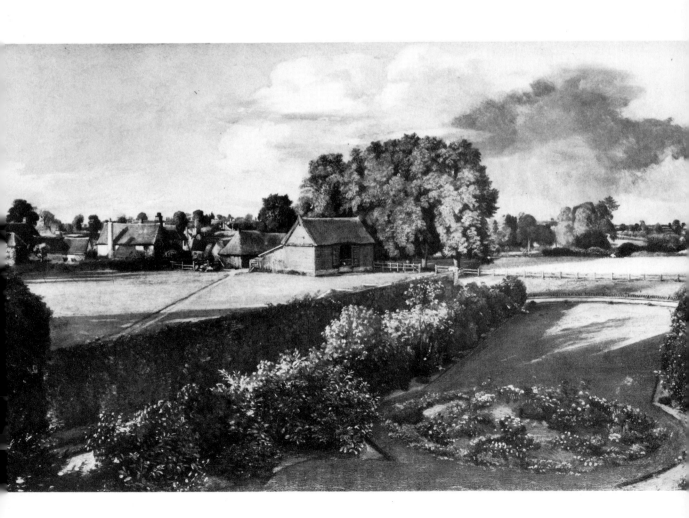

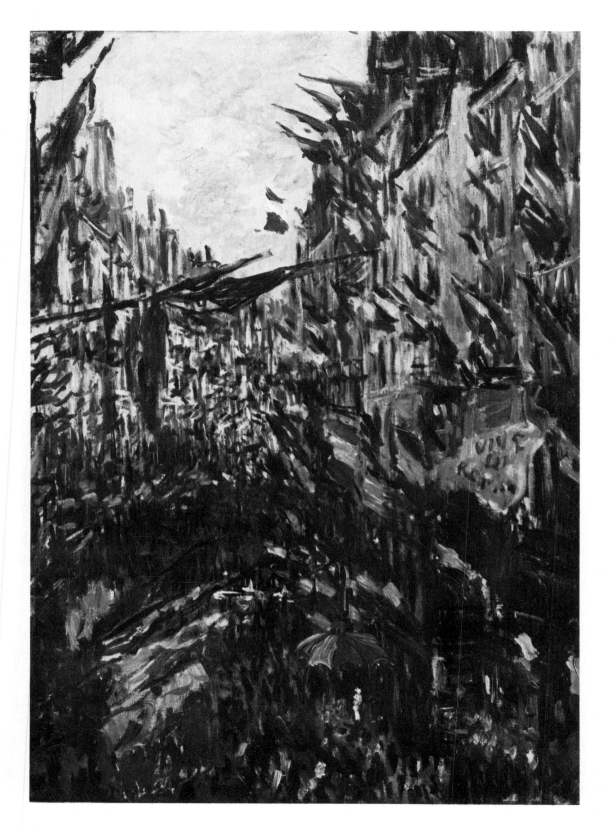

CLAUDE MONET 1840–1926
The Rue Montorguerl decked with flags 1878
Oil on Canvas 61 cm × 33 cm (24¼ in. × 13 in.)
Musée de Rouen
This work shows well how Impressionism was able to
express not only atmosphere but local colour.
Sharply stated contrasts of light and shade tend
towards the exclusion of saturated local colours, and
the expression of these had often been inhibited in
earlier Realists with their inheritance of chiaroscuro.
The Impressionist substitution of colour for darkness
in the depiction of shadow was in this sense a
release. The flags in this painting seem to present
Monet with none of the awkward local colour
problems he had sometimes experienced in his earlier
work; he is able to make them the central theme

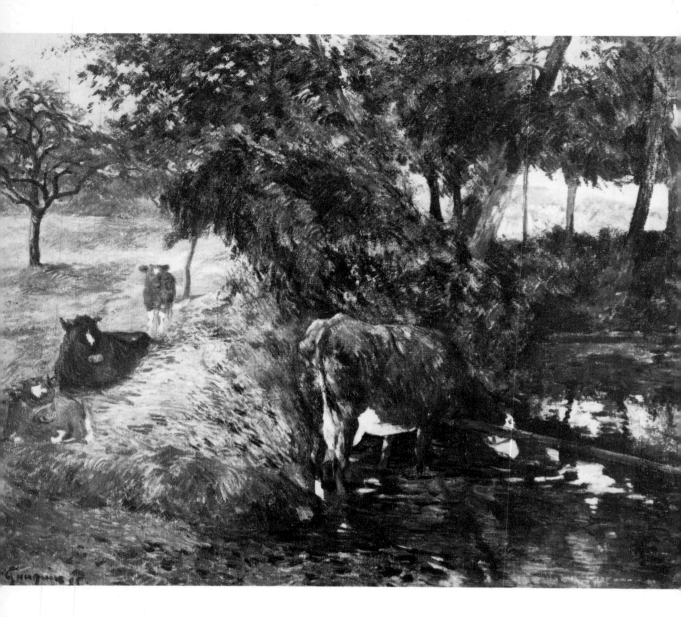

PAUL GAUGUIN 1848–1903
Landscape with cows in an orchard 1885
Oil on Canvas 64 cm × 85 cm (25½ in. × 33½ in.)
Boymans Museum, Rotterdam
Of all the Impressionists, Gauguin was to react most
strongly against the movement. This painting,
however, was made soon after he had been working
with the older Pissarro and reflects his influence. This
landscape might have comprised two separate and
equal views on either side of the central mass of
foliage but they are beautifully linked into a unit by
the movement of the cows, which loops round
bringing the eye to rest in the right foreground.

ROBERT BUHLER 1916–
Olive Trees, Algarve 1976
Royal Academy of Arts, London
71 cm × 91 cm (28 in. × 36 in.)
Nature does not always obey the text book. In this
painting the subject has given the artist the
opportunity to gather his darkest and lightest tones
together not in the foreground but in the distance.
 The screen of foreground trees is held together
with closely related half-tones, none of which
compete with the distant strip: the spatial sense is
fully given by the finely stated contrast of intervals
and scale. It may be noted that, in this frontal view
of the scene, only a few hints of diagonal perspective
are needed to support the recession and more would
obtrude on the pictorial conception.

Drawing
and Design

It is possible to draw a landscape in a way that amounts to a linear record of topographical detail, assembled perhaps in a way that recognizes the feel of the landscape as a whole, but which is unconcerned with recording any sense of illumination.

But when we come to consider the painting of landscape, we will probably recognize that light is an essential part of our response to what we see. It is light in its many moods that plays a large part in unifying foreground and distance, generalities and details, in all their complexity.

This is why (although there can be no simple or single definition of 'drawing') it is wise to approach any preliminary drawing of landscape with a feeling for its ultimate expression of light, whatever form that expression may take.

Some painters, for instance, may start by sweeping in large masses of tone and broad colour suggestions, setting up a soft evocation of mass and light which seems to have little relation to linear drawing. But the matter of decisive placing of masses, then of selection of detail, will raise its head. Then what we may call 'drawing' of the sort relevant to this kind of conception becomes a matter of placing. Detail may be limited or absent; intervals and directions must still be decided upon. It is only too easy for these elements of drawing, if they have not been thought of from the start, to become a succession of imposed disappointments upon a promising luminous beginning.

If a painter chooses to start by a careful rendering of linear detail, with the idea that any further considerations may follow in due course, he will fall equally into the opposite trap. When he comes to the stage of recognizing the existence of light, he may find it impossible to fit this into the rigid linear framework he has already created.

Whatever kind of drawing is initiated, it is likely to lead the painter into rapid difficulties unless from the start it takes into account this basic luminosity, and considers the painting from the point of view of what it is eventually to become.

Of course it is all very well to preach in such general terms, but how can we set about the business of preliminary drawing?

Remember that your painting will be a design, strong or weak, which stems from the interest in the scene which engaged you in the first place. It is a good idea to make a number of quick thumb-nail drawings which will help to clarify in your own mind what this interest really is. These need be for nobody's eyes but your own and need therefore not be made to 'look well', but one of them will strike you as the key to what you want to express. This preliminary drawing is valuable in two ways. It will be something to which you can refer back while you work to remind yourself of your initial enthusiasm. But it will also at the start give you a clue about the approach you will have to make to space and recession and to the sort of drawing which will best help your painting to take off. You will have discovered whether you are most interested in the recessive depth or the landscape with a special focus at some stage in the distance; or on the other hand in the flat pattern which the elements make, with the sense of focus more dispersed. These two kinds of interest are not mutually exclusive, and in fact most good landscape paintings will combine them both. But since they will also usually emphasize one or the other bias, it will be convenient to consider them for a little as extreme points of view.

Intrests

When the motif of a landscape lies in strong linear perspective recessions such as of roads or rivers, the eye is usually being led to some focal incident. When this is so, then the careful placing of such a focus as a first stage of drawing is all-important, far more than that of detail. There may, of course, be more than one focus, but the placing of the dominant one will determine the disposition of the large masses, (very likely to be recessive triangles converging on the focus). Inexperienced painters will often start drawing the attractive focal subject, church spire or whatever, in what seems an 'important' place on the canvas with little regard to the placing it will enforce on everything else in the painting. But, except by luck, this will be to everything's disadvantage, since the focal points and the receding planes depend upon each other for their combined power of expression.

Take trouble, and make enough preliminary drawings, to

discover where the centre of interest will be best placed so
that the large planes of the painting will be best disposed
round it. It may be far from the centre of the canvas. The
important thing is that the eye be led to the right place in
the most expressive way that the surroundings can
contribute.

If your motif suggests a more flat overall pattern, and this
is what has arrested your attention, then the placing of a
particular detail, though important, may play a more
subordinate role.

At any rate the demands of linear perspective recession
must not initially be allowed to take over. It is the frontal
surfaces of the subjects which will be the first consideration.
The drawing process should start by enquiry into the way in
which the subject suggests a flat geometry of colour values
across the canvas. Detail will be 'focussed' in a more
subordinate way, but will find its place in punctuating the
geometry. It would be absurd to lay down rigid laws about
how the drawing marks of landscape should be made. But it
may be well to resist the early demands of detail; rather start
looking for placings, intervals and large directions. These
directions are the lines which link incidents of detail across
the canvas so that together they link to form coherent
masses. It is very necessary to discover how the large tonal
and colour masses make up such directions, for it is such
masses that will form the design of the completed work.
The kind of drawing which best discovers them, controls
them, and thereby initiates a sense of unity to the work
cannot be injected as an afterthought.

Remember that in the perception of landscape, the quality
of the third dimension is interpreted 'stereoscopically' by
binocular vision only in the foreground. The recessions of
middle distance to distance are understood by the way our
visual senses perceive tone, colour and reductions of scale.
Our understanding of a landscape's form may therefore be
in a sense more 'intellectual' or more analytical than the
understanding of a model of that landscape seen from the
same viewpoint. Or at least our optical mechanism has to
operate on a more elusive set of clues.

As I have indicated, there can be no prescription for
drawing a landscape, especially for that drawing which is to
lead into a painting. Nevertheless, a theoretical procedure
considered as a kind of mental reference which may help to
sort out our thoughts can do no positive harm.

I have suggested that the masses and rhythms of a
landscape can be seen as creating a potential geometry of
shapes and directions. Within this geometrical framework
or the natural abstract design lies a series of silhouettes

40

denoting facts. They may be solids – woods, groups of buildings or clouds – or tonal phenomena, cast shadows or areas of light. Most likely they will be a mixture of the two. If we think of silhouettes as being made from the edges of the various shapes we can distinguish, then we can begin to sort them out in terms of distances. I do not suggest this as any kind of a rule, but as an aid to clarifying recessions. If we think (at least temporarily) of all that we see as imposed variously on a series of receding transparent backdrops, then we can begin to sort out silhouettes (simply 'shapes', if you prefer) in receding families. Certain sets of shapes will be felt to be on, or near, one particular backdrop. If we were very elementary we would allow ourselves only three such backdrops, foreground, middle distance and distance. But we can be more sophisticated and allow ourselves, say, nine backdrops or twelve backdrops. We could postulate a hundred and twelve of them, but this would clearly be confusing to the point of absurdity.

A little practice will enable us to judge how many backdrops, or stages of distance, we really need in our minds to simplify and yet do justice to what is before us. With the idea that all shapes will collect together on our canvas in a limited number of recessive sets we can begin to find these sets of shapes within the more abstract geometry we have already demarcated or at least felt on the canvas. Facts can begin to be realised in their most expressive places with a sense of comparative distances. Perhaps it does not matter too much which fact comes first. If there is a particular centre of interest, some single element of this might be stated, and everything that can be felt to be on the same 'backdrop' or plane of distance be also indicated. The objects on a substantially nearer or further plane can then be 'silhouetted'. As the surface builds up (I am thinking of this as a linear procedure) with lines round shapes, there will be a good deal of overlapping. If we leave slight gaps between successively receding silhouettes, we shall soon find that we have created a coherent and simplified suggestion of depth from foreground to distance. Of course all this is too theoretical to be a rigid procedure, but let us proceed with the theory for a little.

Between our sets of separate vertical planes (the backdrops) we shall see phenomena which link them to each other in places. Receding roads, wall edges, branches and surface markings will wind their way (also guided by a preliminary abstract framework) from front to rear in 'perspective' giving spatial continuity to what we have already done.

So far we have been thinking in a linear way. Suppose we now consider the tonal masses which have been in suspense since we conceived the first framework. We shall find that

multiple backdrops

overlapping backdrops

spatial continuity

41

the tones, broadly suggested, will also weave across the linear silhouettes, sharply differentiating them in some passages, merging from front to rear in others. In this way we can begin to link, in counterpoint as it were, a coherent set of tones to a coherent set of shapes, combining to develop a coherent sense of distance.

Now all this is by way of being more theoretical than practical, a way of helping us think. In practice, I must repeat that it is not, for me at any rate, a good idea to let too much line build up on a canvas without the introduction of some statement of tone and colour value. Once lines build up too far, it is possible to find that one is faced with what has become a linear conception; it remains only to convert it not so much into a painting as a coloured drawing. The procedure of sorting distance out into sets of vertical planes is therefore something probably better experimented with on paper as a part of one's preliminary notes. The important thing is that the 'drawing' stage of painting tackles the problem of resolving the mass of visual events into manageable quantities.

It is a feature of oil paint that lines can be wiped out very easily where they are superfluous, and advantage should be taken of this. If your motif is leading you to make a direct rendering of strong light and shade, beware of leaving sharp dark lines of drawing passing through potential areas of deep shadow; it is the nature of deep shadow to reduce sharp accents, and such lines will only impede you when you come to paint these passages. Again, as I have mentioned, some tone values in nature will merge though the forms creating them may be widely separated in distance. A sharp line dividing such similarities of tone will tend to impede and even destroy the sense of openness and separation. Of course on a very flatly conceived painting you may want to do just this, but you should know what you are doing.

Because lines must almost inevitably play some role in the search for design, placing, and realization of shape, but yet can interfere with the development of the painting, it is usually well to draw in a tone which is itself quite light. Some painters like the freedom and flow of charcoal to start a canvas; it is a broad and uninhibiting medium and has the advantage of discouraging a finicky preoccupation with detail at an early stage. But nothing can more quickly impose a network of lines. I find it best to flick off all superfluous charcoal with a cloth until the marks I need are just showing, and then to go over them with a light thin colour such as terre vert reduced in turpentine.

Usually I prefer to dispense with charcoal and start drawing lightly with a brush, since it allows not only line

but some indication of tone to be rubbed in at the earliest stages when necessary. With a brush and pale paint (easily rubbed out) those lines which are to remain lines as part of the substance of the painting can be imposed more emphatically, and in a colour which will incorporate itself in the colour scheme of the painting.

Of course it is possible to start a landscape without any lines: a painter of sufficiently decisive eye for design may place on the canvas directly in terms of tonal and even colour masses. (It is only necessary to look at late Turners to see such linear accents as are needed being discovered during the course of the painting.) Then edges between values take the place of lines: but the same principles hold good – the multiplicity of nature must be sorted out into manageable quantities. Tonal design established by the building up of large masses is drawing in a linear sense at one remove, but it is drawing nevertheless.

If a painting is started in this way, it is best to start thinly (for technical reasons, too), almost like a watercolour, so that areas which turn out to be unhappily placed can be wiped out with as much readiness as they have been put in. There is no reason why shapes conceived in colour values should not be realised as well by 'pushing out' from their centres with tones as by bounding them with lines, so long as we remember that the process does not absolve us from discovering shapes.

Experiment with these different approaches to drawings, and others; no two motifs will demand quite the same kind of beginning. Each approach will have its advantages and its dangers. If you carry drawing to a highly developed stage of linear structure before you start to express values of colour, you may have difficulty in recalling and injecting the broad colour design that you originally intended. But if you can succeed, then each stage of colour development should progressively add to the unity of the painting. If on the other hand you start at the opposite pole with a broad simplified tonal design washed and rubbed in across the canvas then the sense of unity will be there from the start. The attendant danger is that as you progress to more and more particularised statements, this initial unity may become fragmented.

There is no better lesson than to study landscapes by masters and compare them with the kinds of drawings they made for them. There are many such lessons to be found from Rubens, Claude and Poussin to Constable, Turner, Cézanne and Bonnard. They are examples of the way in which drawing may be conceived appropriately in terms of the completed painting.

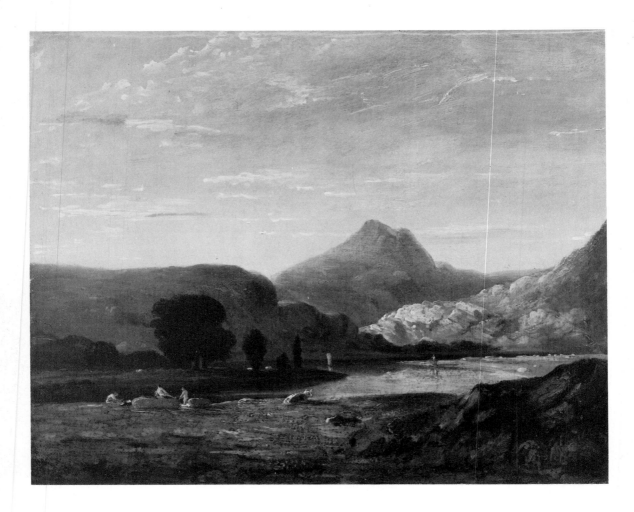

RICHARD WILSON 1713–82
On The Wye
Oil on Canvas 25 cm × 31 cm (10 in. × 12¼ in.)
Tate Gallery, London
Wilson, the first great English landscape painter,
shows the influence of his Italian study more in his
grand sense of placing and design than in the
classical figures which are gathered into its own tonal
mass. In the Claudian way, opposition of light and
dark intervals push the landscape into the distance.
Wilson was perhaps one of the last who would do
full honour to this device; by Constable's day it had
becoming time-worn, and it was he who found an
escape from it.

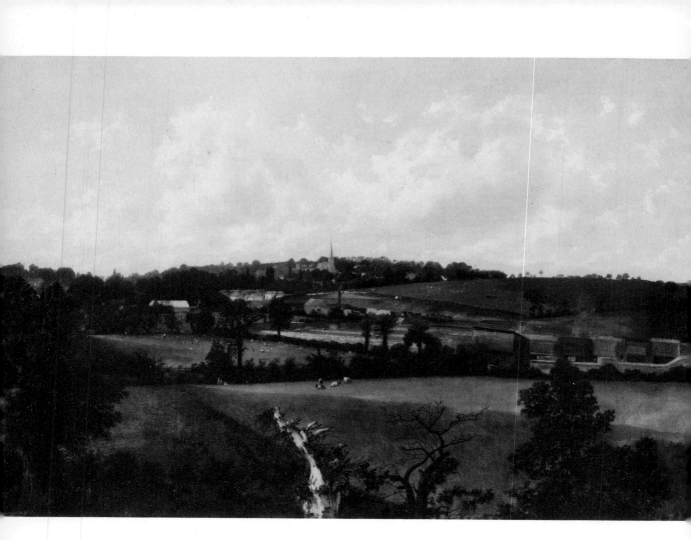

ALFRED CLINT 1807–1883
Hampstead from the Heath
61 cm × 91 cm (24 in. × 36 in.)
Tate Gallery, London
A landscape carried out with unrelenting detail from
foreground into distance can have a kind of intensity
peculiar to the genre. But only if, as here, it is no less
unrelentingly organized. Formal arrangement may
have its traces cunningly hidden, but without it such
a mass of highly wrought detail is likely to fall into
confusion.

46

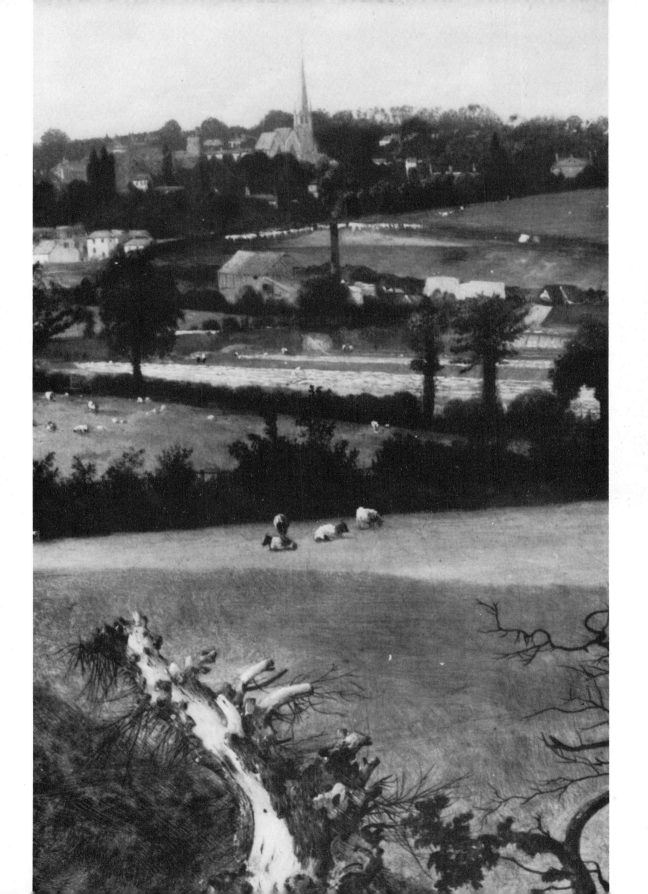

FORD MADOX BROWN 1821–93
Walton on the Naze, 1859–60
Oil on Canvas 31 cm × 42 cm (12¼ in. × 16¼ in.)
Birmingham Museums and Art Gallery
Ford Madox Brown, like the Pre-Raphaelites who
looked to his example, indulged in a 'truth' to
natural detail not always to more recent taste. The
work may be of much artifice; nevertheless the
sustaining of detail through such a range of depth
depends on a remarkable opposition of scale and
sense of interval. It is a lesson to 'detail' painters not
to neglect the foreground, which is here resolved to
its limits

WALTER SICKERT 1860–1942
Statue of Duquesne Dieppe 1902
Oil on Canvas 131 cm × 101 cm (51½ in. × 39¾ in.)
Manchester City Art Gallery
Sickert had been the studio assistant of Whistler, and
enjoyed an artistic upbringing in the company of the
Impressionists. Among his illustrious peers it was
Degas whom he especially revered, and it was the
older master's capacity to paint from drawn studies
that Sickert absorbed. He drew, but seldom painted
on the spot. There could be few better examples to
justify the practice for a realist: Sickert could carry
the authentic sense of outdoor values and immediacy
into the studio with the aid of the copious colour
notes which cover many of his drawings. This
townscape shows how well he could then organise his
experience into a grand design without the pressures
which outdoor painting imposes. Such a method is
time-honoured, but for a realist needs the
development of a practised visual memory.

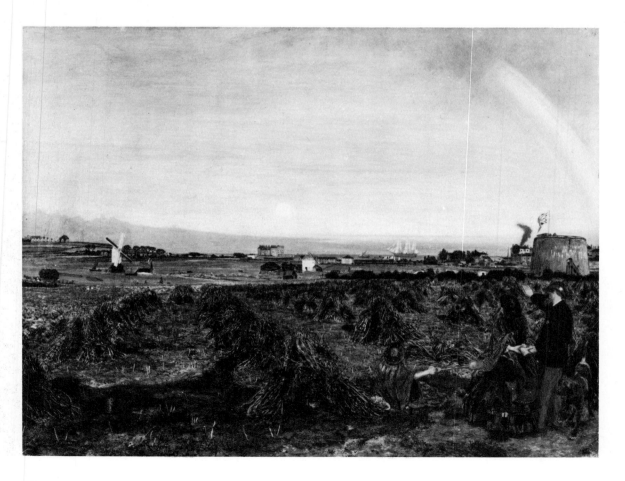

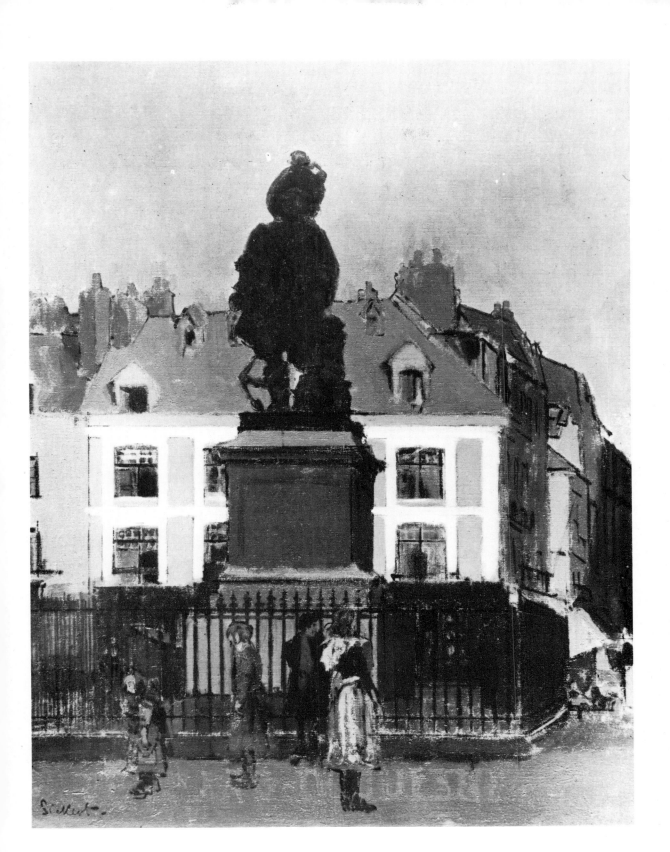

49

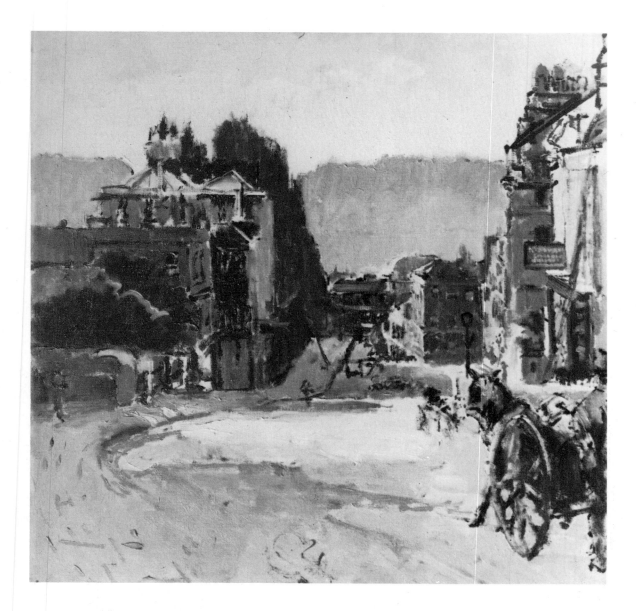

WALTER SICKERT
Belvedere, Bath 1917–18
Oil on Canvas 68 cm × 68 cm (26¾ in. × 27 in.)
Tate Gallery, London
This later painting follows the method of painting
from studies seen in his *Statue of Duquesne*. Sickert
exemplifies well the practice of building a picture
surface from lean to fat paint in an orderly
progression of layers, which he saw as the essence of
la bonne peinture. He likened such a surface to a
pack of cards thrown on a table, so that parts of
each layer may peep through the gaps in those
superimposed on it

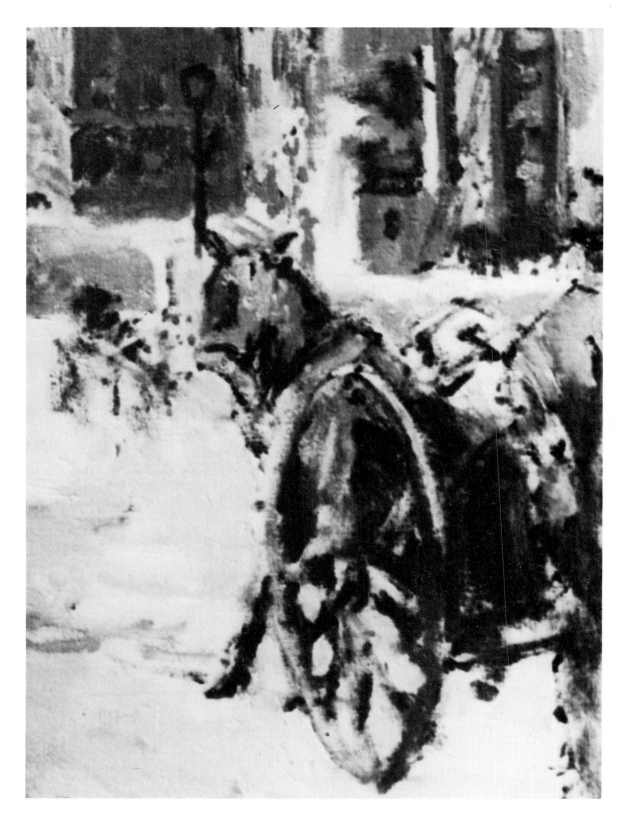

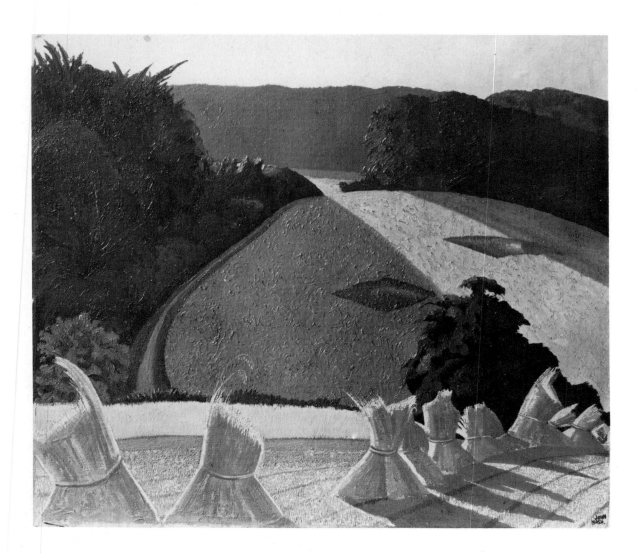

JOHN NASH 1893–1977
The Cornfield, 1918
Oil on Canvas 68 cm × 76 cm (27 in. × 30 in.)
Tate Gallery, London
There is the utmost contrast of characteristic
silhouettes in this deceptively simple rendering; each
element is almost symbolically defined, and the
nature of each part is strengthened by the textural
contrasts of surface. John Nash was a considerable
botanist and understood how a knowledge of
detailed plant forms helps to a resolving of the
general shapes, even though the details themselves
are largely eliminated

The Structure of Atmospheric Recession and Tone

The junctions and separations of forms and surfaces in nature which we are able to represent graphically as lines, are really edges, hard or blurred between differences of illumination and colour. For it is light, and the effect of light on the tones and colours of things, that enables us to see at all.

In landscape, the distances involved also place between the features and ourselves a body of air, humid and dust laden to varying degrees. Thus recession is perceived through successive veils of air to give us that sense of natural landscape distance which is 'atmospheric recession'.

The linear considerations of structure that we have so far looked at allow us to place the receding shapes and positions of landscape features more or less accurately. The result will be a rendering of structure which carries explanation a certain way. But, as we shall see, such a linear structure forms a framework across which light and colour play a deeper role: and it is a role played in counterpoint, for the shapes made by light and colour will pass across the shapes made by line, only sometimes coinciding. It may be pointed out that landscape drawings made purely with lines can convey a sense of light and air, and we have only to look at the drawings of Rembrandt, or among moderns, Bonnard, to see that this is so.

But such apparently linear drawings were made from a great understanding of light: the lines that comprise them are not only measurement marks, but shorthand notations, as it were, of illumination. We shall look at some ways in which line can be made to imply light, but this is part of method, the questions about which we have yet to face. Before we do this, we must see what tone, atmosphere, and colour can tell us about the structure of a landscape, and how they, like linear considerations, can be examined beyond mere surface appearance.

The phenomena of light and colour in a landscape combine to give a unity of visual effect, and we must think of the separate components with due caution; any single one is always modified by the others, and cold-blooded analysis is somewhat artificial. However, for the sake of simplifying complexity, let us take 'atmosphere' first.

The air is, as I have said, a particle laden body whose transparency depends on its condition and its depth. Clouds, for instance, are a specifically visible reversion of the air's transparency, capable of obscuring not only landscape but the sun itself. But even cloudless air always carries a degree of particle substance. The deeper the distance the more air we look through, and the more progressively opaque its substance. On a clear day the transparency through which we see distance is merely reduced: on a heavy day transparency may be reduced to nothing.

The first effect of this reduction is that differences of light and shade, of 'tone' become less and less contrasted through to the distance. A foreground structure of rock may be revealed in a strong contrast of light and shadow. A distant structure of the same sort in the same light will show only a very slight difference of tone between the lights and the darks. The lights may be slightly reduced in relation to the foreground lights, but it is the shadows which will have lost the major part of the contrasting strength: their tone will have moved towards that of the light. Compared to the foreground shadows, the whole tone of the distant rocks will appear light, including the shadows. The reason for this is that the intervening air particles are themselves illuminated and therefore light in tone: it is the shadows that suffer most loss from this veiling. The effect on lit surfaces is more variable. White-washed surfaces in sunlight will probably be lighter in the foreground than in the distance. But the illuminated surface of something very dark and non-reflective in 'local colour' in the foreground, will probably be darker than its distant equivalent. This is because we see a dark surface near to us with very little air in the way. In the distance most of what we see by way of tone is the belt of illuminated air itself.

This kind of atmospheric behaviour generally holds good, but it must not be given the title of a rule. It is possible for eccentric local conditions of atmosphere to confound it: a patch of foreground mist together with distant clear sunlight could reverse the norm.

A second effect of atmospheric depth is on colour. The atmosphere layer not only reduces tonal contrast but has the property of acting as a filter through which cool colours pass while warm colours are held. The blue and violet part

of the spectrum reaches us more readily than the red and yellow.

Because of this we experience the familiar sight of distant blue hills which we may know to be in fact as variegated in colour as the foreground if we get close to them. This cooling off of local colour values and shadow values varies of course with the atmospheric conditions. It is important to notice that this effect, which can be very obvious in the distance also occurs more subtly at intervening depths. Colours four hundred metres/yards away which look very warm seen in themselves, may, compared to the immediate foreground, look not quite so warm after all. This cooling effect, by shifting all values towards blue or cool grey and reducing red and yellow, has also the property of reducing all contrasts of colour.

Thus the very presence of air, by these reductions towards coolness and pale tone, tells us something about distances in landscape and contributes to our understanding of its structure.

Tonal recession: local colour and cloud shadows
Tonal recession in landscape is almost atmospheric recession under another name, but it is perhaps worth defining separately, since tones seem to group themselves together in landscape for other reasons than atmosphere and illumination only. Tones are the various gradations, thought of in the first instance monochromatically from the darkest dark to the lightest light that we can see.

Two things complicate tone. The first is that a surface has a degree of tone not just from the light, but from its own local colour. A black house looks darker than a grey house, if both are at the same distance. But as we have seen, a black house in the distance may seem no darker than a grey house in the foreground.

Thus the way in which we must judge recession by the tones we perceive is not quite so simple as 'atmospheric recession' might make it seem. What we shall have to notice is that though tones of different things at different distances may group together, we shall almost certainly find that there is a difference in their colour values.

A second complication, not always present, is the cast shadow of clouds. Indoors, a subject is normally lit by a restricted source of light which is interrupted only by parts of the subject itself as in a still life. An 'off-stage' obstruction may cast a shadow on the subject, but in a static way. Not always so in landscape.

The landscape painter's source of light is the sky, often the direct sun. The orderly tonal and atmospheric recession of

56

a sunny landscape may be interrupted by cool bands of darker value laid across it which are the cast shadows of clouds. If they are rare passing clouds on an otherwise clear day, they can be left to pass; but if they characteristically linger, use may be made of them. Alternate bands of illumination and of cloud shadow from foreground to distance can be used to enhance recession. It must be remembered that this was a formal and often artificial device used for this purpose by seventeenth- and eighteenth-century painters; it was generally avoided by the Impressionists. It should be used if it can be observed, not imposed as a trick, and it must be noticed that cast cloud shadows themselves follow the behaviour of atmospherically recessive tones.

J M W TURNER 1775–1851

Venice, The Piazzetta, with the ceremony of the Doge marrying the sea 1835–40

Oil on Canvas 91 cm × 121 cm (36 in. × 47¾ in.)

In many of Turner's Venetian paintings the detail is highly resolved. Here, although the design is laid out by the placing of figures, buildings and boats, detail is suppressed and all is held together by tonal masses playing across the substance

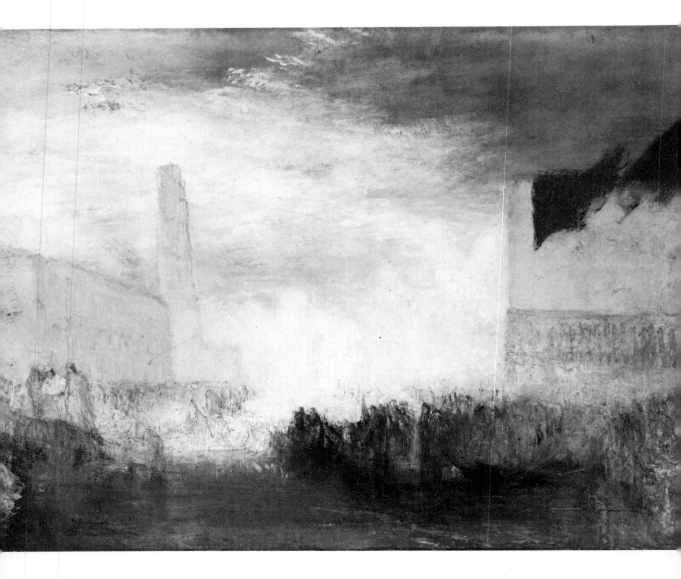

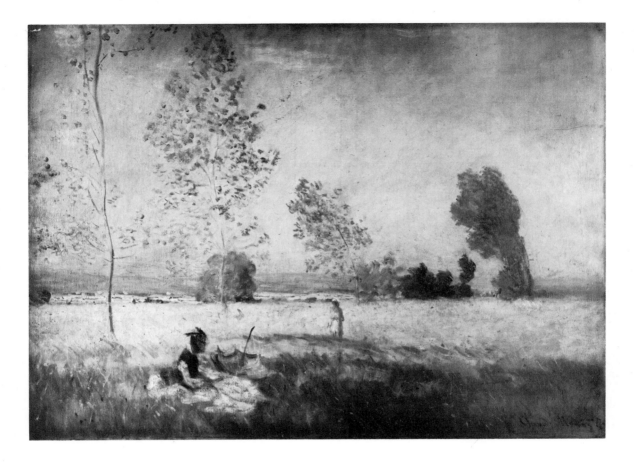

CLAUDE MONET 1840–1926
Les Champs 1874
Oil on Canvas 57 cm × 80 cm (22½ in. × 31½ in.)
Painted in the year of the first Impressionist
Exhibition in Paris, this canvas typifies the ethic of
the movement in its fairly brief period of total self-
confidence. All is submitted to the truth of luminous
atmosphere: from this subordination of form were to
spring the doubts in the minds of the movement's
own adherents. Even Monet, its high priest, was too
strong a draughtsman and designer to disregard
pictorial arrangement; as in this painting, his chosen
viewpoints always manage to produce a forceful
composition

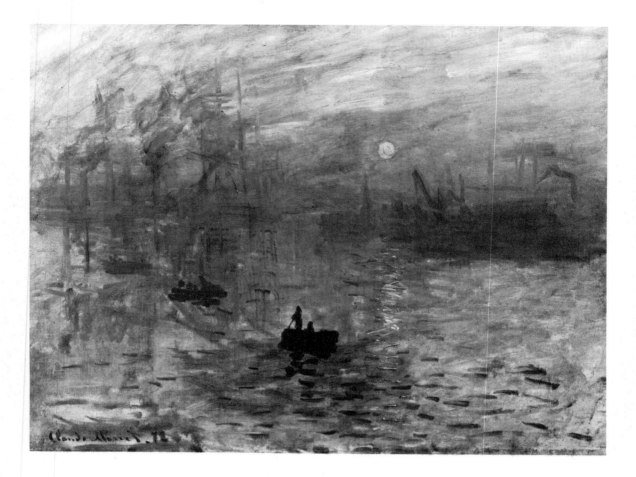

CLAUDE MONET 1840–1926
Impression, Sunrise 1872
Oil on Canvas 49 cm × 65 cm (19½ in. × 25½ in.)
Musée Marmottan, Paris
This is the painting whose title gave currency to the
initially derisive term 'Impressionism'. It has affinities
with Turner, whose work Monet had seen in
London. Indeed there is a small gouache by Turner,
painted over forty years earlier, which startlingly
anticipates this work both in subject and expression.

Yet Turner's brilliant observation was habitually
ordered by a grand, if eccentric pictorial conception:
Monet has in this canvas reached a point where
direct visual experience could take virtual control of
the surface

GEORGES SEURAT 1859–91
Courbevoie Bridge 1886–7
Oil on Canvas 45 cm × 54 cm (18 in. × 21½ in.)
Courtauld Institute, London
Camille Pissarro described Seurat's 'pointillism' as
scientific impression. The superiority of Seurat's
work over that of his followers suggests that his
achievement was as much the result of sensibility as
of his pretensions to have created a scientific system
of painting. The method, based on prevalent theories
of colour, did not entirely meet its claims, and
perhaps it succeeds most in its effect of irridescent
atmosphere. The quality of this canvas lies in
Seurat's power of containing his system within a
classic sense of interval and balance. Pointillism had
an attendant virtue. The painstaking method made
slick lines impossible: Seurat's landscapes are
characterized by the careful searching of forms and
edges

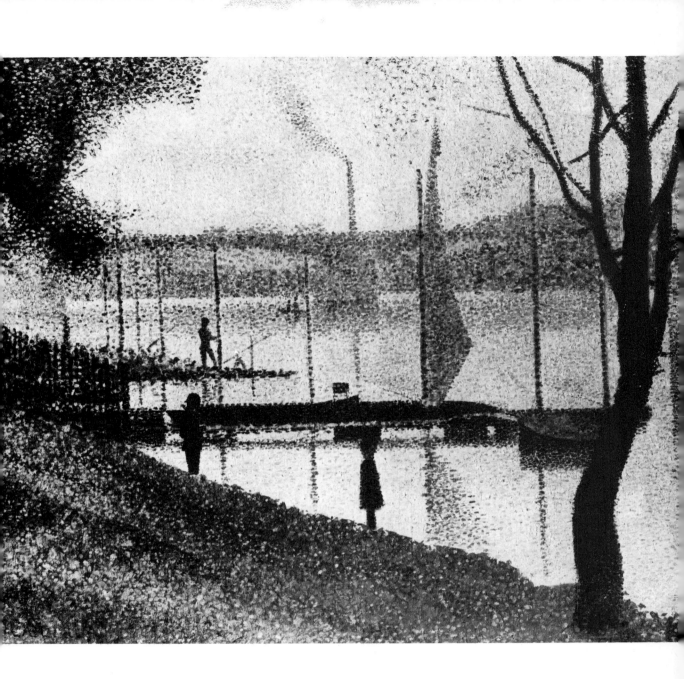

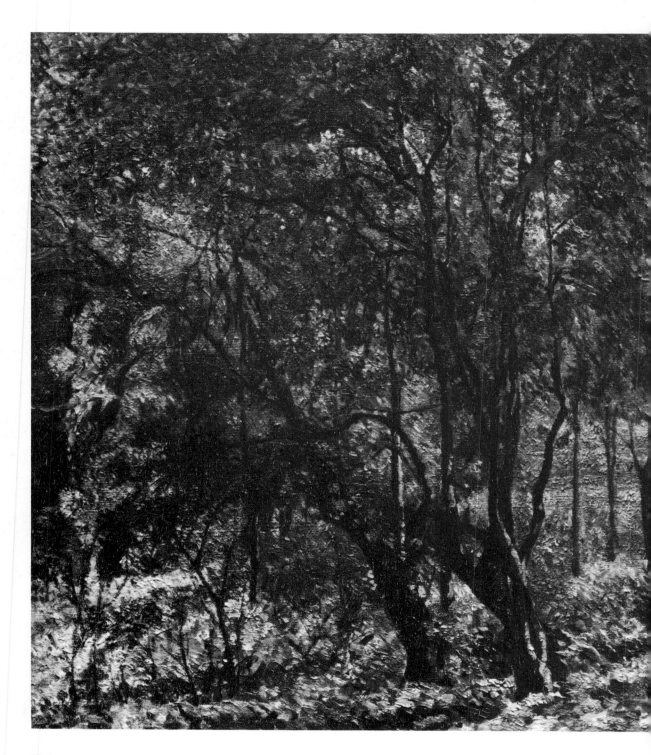

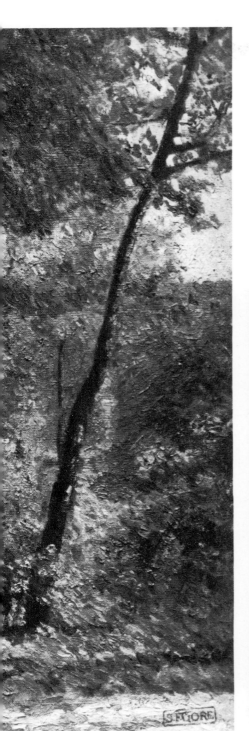

SPENCER GORE 1878–1914
*Panshanger Park c.*1909
Oil on Canvas 50 cm × 61 cm (20 in. × 24 in.)
Royal Albert Memorial Museum, Exeter
Gore, like his Camden Town associate Gilman, was in
a broad sense an English heir of 'Neo-Impressionism'.
As in a late Pissarro this painting uses a restrained
divisionism to control what could have been
confused. A *sous-bois* such as this, with its close up
views of trunks, branches and twigs, can easily turn
into a maze of aimlessly wandering lines which soon
convert the subject from the inviting to the
intractable. Gore avoids this pitfall with mastery. The
obvious linear elements, so dangerously easy to latch
on to, are all ordered by what lies between. It repays
study of this work to see how every branch combines
with another to enclose a coherent space. The tonal
masses are as much drawn and designed as the
branch forms and all is blended into a unity. The
painting is such a natural response to the subject that
it is worth looking at the plate upside down to
appreciate how broadly the artist has grasped
nature's design

Sky: Structure and Light

The sky presents a problem which, though not unique to landscape painting, is characteristic of it. In interior painting, windows and light sources sometimes present passages which are many times higher in tone than anything else, but it is a choice of the artist to face himself with such motifs. In landscape, the sky is frequently, perhaps usually, many times higher in tone than the landscape beneath it, but this will be a fact that the landscape painter cannot usually avoid facing. Of course it is not always so; in conditions of very brilliant sunlight, or of lowering clouds, landscape elements of light surface may be illuminated to a higher tone. Sometimes a view of the sky may be eliminated altogether.

But it will be a general and recurring problem of landscape that the tone of a sky compared to the tone of ground values will present a range far greater than can be matched with white and black paint on the palette. I have already discussed the problem of re-organising the tones of nature into what the palette can manage. It holds good of most indoor tonal subjects, but in landscape the range will characteristically be extreme.

So perhaps one of the first matters the landscape painter must consider is that he cannot be literal about the tone of a sky: he must reduce it because in most cases he has no alternative. This means inventing: a way must be found, through colour, of implying the sky's luminosity.

There is a factor common to the elements of sky in most landscape paintings which makes this not so impossible as it seems. The sky is the landscape's source of light. It is often erroneously assumed that therefore the part of a sky which appears on a canvas is the source of light. This is in fact very seldom so (there is an exception which I shall come to). The visible arc of the sky is anything up to 180°. That part of the sky which appears in a painting is unlikely

to be more than 20° to 30° of this arc from the skyline. Whether on a sunlit or on a cloudy day, by far the greatest part of the illumination will be coming from that part of the sky which is out of the painting. So the inevitable reduction of tone of a 'picture-sky' is not really so inconsistent with natural luminosity; it is a very minor source of light. On a sunny day, the sun itself is of course the main source, the rest of the sky supplying the half-tones to surfaces turned from the sun. Only when we are facing onto a low sun, painting *contre-jour*, does the picture-sky become a main light source. In these circumstances the painter is even further in his resources from the tonal range of nature. He must arrive at an equivalent to nature by responding to the way in which such brilliant light reduces nearly all the accents and contrasts on the ground in an aura of shadowy tone, from which the illuminated edges of forms will spring as exceptional tonal events. Indeed the main accents might be found in cloud-screens. This was a recurring motif of Turner.

But either in *contre-jour* subjects or in those where, as normally, the source of light is outside the canvas, it is of the greatest importance that the sky be felt as part of the design of the painting. This is true both in a linear sense and in colour, and is certainly one of the more difficult problems of landscape.

As to colour, it is only too easy (because in nature it often seems at first sight to be so) to make the colour of a painted sky divorced from the colour of everything else. A blue sky seems so very blue when everything else seems green and yellow and red. This is all the more reason for not treating the sky as a separate colour problem. The sky, after all, is visibly illuminated atmosphere, and this atmosphere is what we breathe. It does not end on the skyline. If we think of the sky as something which reaches to our toes as we paint, enveloping the whole landscape, then we can begin to feel towards a total relationship of colour.

A blue sky will give 'blueness' or coolness to some facets of the terrain, and it is not evenly blue all over. It will change its own colour character from the skyline upwards toward the zenith, perhaps from violet through ochre to green-blue to red-blue, or some equivalent change. Its juxtaposition to the varied colours of the skyline will impose apparent shifts to its own colour. 'Windows' of sky seen through gaps will vary considerably in colour.

From these shifts of value it will always be possible to find common qualities between sky and ground, and it is well to keep the developing colour of each working together. If you detect, say, a greenness in some part of a

sky, look to see what greens exist on the ground, and try introducing a paler version of some of this in touches in the sky area – so with reds, yellows, violets and other colours. You may be surprised to find just how far a convincing blue sky, which is not just an imitative coloured back-drop but is part of the picture, can be built out of the hints from the colours of the whole subject; a very little blue out of the tube may go a long way. Perhaps no painter built skies out of the total colour of his subject more convincingly than Cézanne.

In a concern with colour, it must not be forgotten that the sky, like the earth, has structure: sometimes it is elusive, sometimes clouds make it very apparent. I will not dwell on the meteorological nature of different cloud formations (Constable devoted much study to this), but a little observation of varied weather shows how often the sky will present its structure as a receding surface seen from underneath, with its own perspective. It is not too difficult to see, in certain conditions, how banks of cloud reduce in scale into the distance, with a successive overlapping, like an inverted landscape. But look hard and you will see how often these cloud formations, although constantly altering in size and position, will respond to a vanishing point on the horizon.

The sky's structure therefore has a subtle duality. As colour, its atmospheric composition envelops everything, and conditions or modifies the colour of everything. But beyond highly varying limits of transparency it becomes a soft and semi-opaque recessive surface in which linear properties can be detected. When, between the ground surface and this semi-opacity, the atmosphere condenses into identifiable cloud forms then the linear properties are greatly clarified. Of course, the sky's opacity is relative. If it were fully opaque we would live in perpetual darkness; it is its high but varying degree of transparency which enables sunlight to strike through.

Remember that the sun is so far away that its rays are parallel; when the rays of the setting sun seem to splay out in diagonals through cloud gaps it is because we are seeing parallel lines in perspective. Remember also that the colour of the sky immediately above the sky-line is frequently (and increasingly) conditioned by man-made 'smog'. This may envelop everything, or may sometimes be identified as a wall of colour over a distant urban area, from which the immediate landscape is comparatively free.

Most important, have in mind always that sky has properties of colour and structure which allow it to be translated in paint as part of the total picture.

J M W TURNER 1775–1851
*Thames near Walton Bridge c.*1807
Oil on panel 371 cm × 731 cm (14$\frac{5}{8}$ in. × 29 in.)
Tate Gallery, London
Turner's set pieces of classical mythology and marine
drama were informed in their conception of
landscape not merely by the stylistic conventions of
older masters, but by an assiduous and unceasing
study of nature. This is one such study, in which
Turner seems akin to Constable in his reaction to
visual experience. The outdoor tones are reduced to a
small, carefully adjusted range of warm and cool
values. The linear intervals and directions are
expressively disposed in the format, and it may be
noted that the sky, though freely painted, is as
carefully designed as the ground features

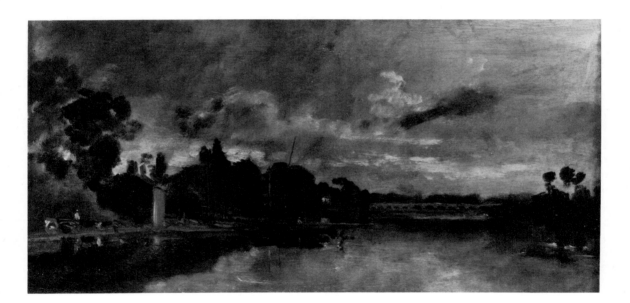

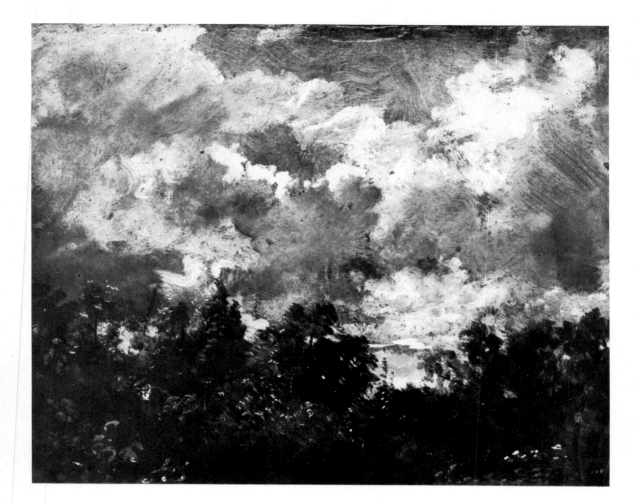

JOHN CONSTABLE 1776–1937
Sky study
Victoria and Albert Museum, London
Landscape paintings are commonly seen in which the
'sky' is a mere backdrop to the subject. Constable
understood how the sky has its own many forms and
substances with every turn of wind and weather, and
perhaps no painter has made such a deep study of
these forms. This is one of many sky studies he made
throughout his life

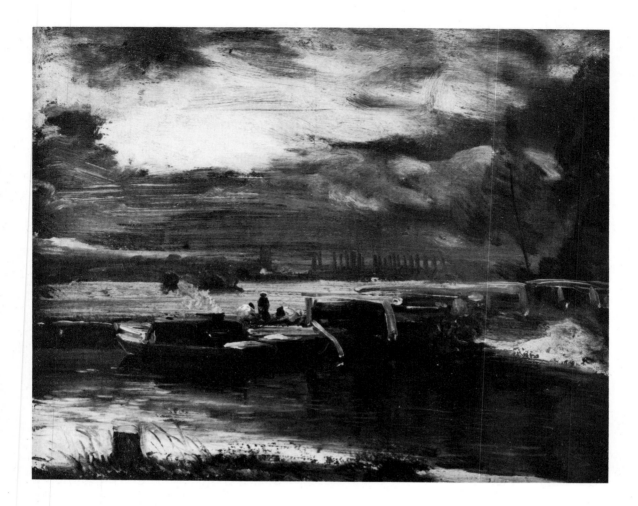

JOHN CONSTABLE 1776–1837
*Barges on the Stour c.*1811
Oil on paper 26 cm × 31 cm (10¼ × 12¼ in.)
Victoria and Albert Museum, London
This brilliant sketch shows how Constable, like
Cézanne after him, could evoke reality out of a few
broad oppositions of warm and cool values. The
blues and whites are swept across a golden umber
ground: a few darker and lighter accents are enough
to suggest the material substance of the forms

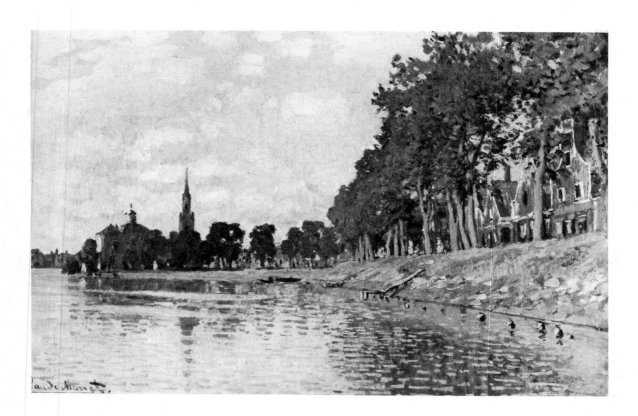

CLAUDE MONET 1840–1926
View of Zaandam 1871
Oil on Canvas 45 cm × 72 cm (18 in. × 28 in.)
Louvre, Paris
Although painted a little before the term came into
use this canvas may properly be called Impressionist.
While it does not employ the full fragmentation of
colour developed shortly afterwards by Monet
himself, together with Renoir, it has the
characteristics which distinguish it from earlier
realism.

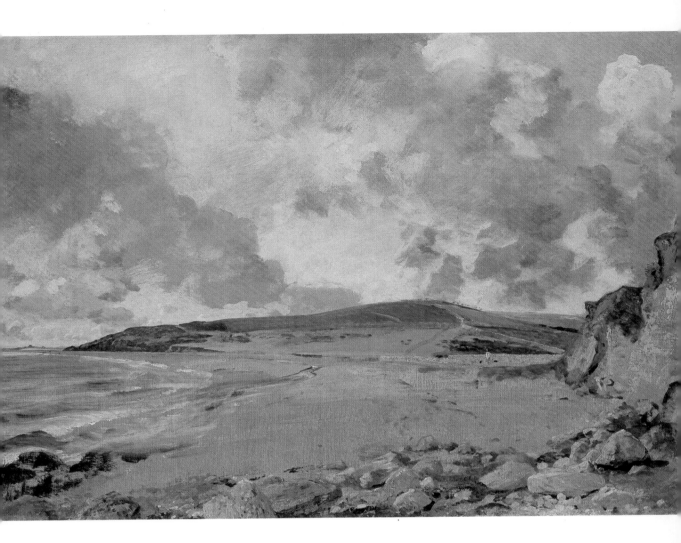

JOHN CONSTABLE 1776-1837
Weymouth Bay 1816
Oil on canvas 53 cm x 75 cm (21 in. x 29½ in.)
National Gallery, London
Of this well known painting it needs to be reiterated that a
master of landscape can realise all the separate colours
and lively characteristics of sky, land and water, and yet by
a chromatic and compositional organisation combine all
these elements into a pictorial unity of surface

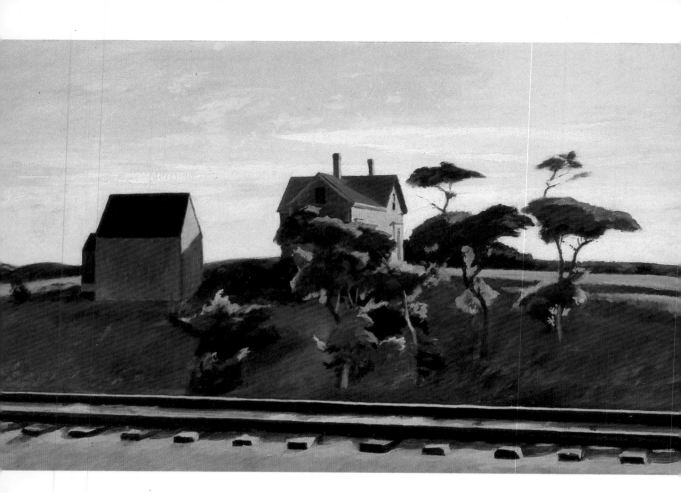

EDWARD HOPPER 1882-1967
New York, New Haven and Hartford 1931
Oil on canvas 81 cm x 127 cm (32 in. x 50 in.)
Indianapolis Museum of Art,
Emma Harter Sweetser Fund
This most impressive of American landscape painters was
adept at evoking the strongest sense of place out of the
simplest elements. The embankment, the farm buildings
with their one strong accent of colour, the rail road tracks
striking across the foreground, combine to make a symbol
of isolation without any sentimentality. Behind the
harshness of style lies pictorial sensibility. A lesser artist
might have made much of the departing perspective of the
rail sleepers to establish the foreground plane. It is enough
for Hopper simply to hint at it, so preserving the overall
sense of chromatic silhouette

Colour

Colour should not be thought of as an entity separate from structure, tone and atmosphere, or as a problem in landscape painting which can in some way be considered at a later stage when matters of structure and tone have been settled, a factor to be imposed as a self-contained stage in the process of painting.

Colour is rather the full amplification of tonality. The colours that we see are the united results of the tints of surfaces ('local colours'), of light, and of atmosphere: this unity we may call 'colour value'. Colour values are the perceived colours of surfaces in their spatial positions. A yellow house in the foreground may be painted with the same 'brand' tint of exterior wall paint as another in the distance, but what we see will not be defined by the label on this tin; differences of distance, of angle to the source of light, and of surrounding colours, will make each house a different colour value. What is true of two yellow houses is also true of a single one. The yellow on the shadowed parts of a house will not be that of the sunlit parts. When the sun goes in both yellows will change. So colour is not a simple matter of decoration. Because it is modified by the direction of surfaces (that is, by forms) in relation to light, colour can in itself become the revealer and explainer of forms and light.

It is sometimes supposed that nothing can be learnt about pictorial colour, and that some are just born with a better 'sense of colour' than others. The latter may or may not be true, but there is no doubt that there are things that can be learnt about colour behaviour which should inform rather than harm any natural gifts which exist. The landscape painter can learn much from quite simple study of the colour he perceives. Codified 'scientific', psychological and mystical theories of colour have been successively propounded over the last two hundred years and more; some elements of them have made contributions to the

development of painting, but probably few painters have been dependent on a deep adherence to any one of them. (Even Kandinsky is hardly an exception to this, since he propounded his own colour theory.)

Perhaps the first characteristic of colour behaviour that a painter, (particularly a landscape painter) should understand is the way in which light sorts colour into 'warm' and 'cool' values. This is a matter of perception, not just a theoretical system, and it is a natural phenomenon which has been a traditional basis for organizing and simplifying colour in painting.

The landscape painter can very readily notice nature demonstrating this. Let us take the example of a sunlit evening landscape. A late sun usually throws a warm light on surfaces which face it so that all these surfaces, irrespective of their local colours, move towards orange, red and yellow – that is, towards 'warmth'. Indeed this condition will clarify for the painter just which surfaces are facing towards the sun, and therefore have to some degree a common aspect.

Surfaces facing away from the sun are of several kinds. We may expect that many of them will be facing a blue or 'cool' sky. We may think of these surfaces as 'in shadow', but in fact they are illuminated by a light source which moves all their values towards blue, violet and 'cold' green, that is towards 'coolness'. Then there are deeper shadows in caves of form where there is a greater absence of illumination. These may be lit by reflections partly from warm surfaces, partly from cool surfaces and will shift accordingly. Some surfaces facing the sun have cast shadows from other forms thrown across them and will be cool in the shadow areas, warm in the illuminated ones. There will be surfaces which turn gradually out of the sun's view and which will often shift to a marked apparent coolness or blue quality just where the form turns away because here it is in closest proximity to the warmth of the sunlit facet. As such surfaces turn right away from the sun their coolness may be given some interior shift back to warmth by reflections from sunlit areas. In very bright sunlight these 'reflected lights' can be dramatic; it must be observed, however, that these reflections are never really as bright or as warm as the sunlit areas which cause them.

We see that all surfaces have their 'local colours' affected according to their particular aspect or position in relation to the source of light, and that in a broad way all these various conditions of form and illumination may be sorted out into those colour values which are warm and those which are cool. Of course, natural appearances do not often make all this as simple as it sounds. In landscapes of

74

exceptional aridity, in deserts for instance, where there are few contrasts of local colour, the contrasts of warm and cool may be sharply displayed and easy to 'read'; lusher scenes with man-made elements will in practice present us with values whose positions in the warm to cool range are difficult to define, and many such middle values will exist. Nevertheless it may be true to say that a painting which becomes dominated by values which cannot be defined as either warm or cool is likely to end up confused and muddy in colour, however bright the tints of the paint.

The landscapes of both old and modern masters provide ample evidence of how a painting may be designed, not only in terms of tonal masses but of warm and cool masses as well, one or the other usually dominating.

Colours also respond to and influence one another when they are simply thought of as tints of paint on a flat surface. All colours will tend to shift in apparent value when placed in different contexts; bright colours will especially alter the values of duller and more reduced colours when they are placed in juxtaposition. This effect is known as 'simultaneous contrast', and the best possible way in which to find out how colours behave towards each other in this way is by personal experiment. If you place on a canvas several separate strokes of a muted grey and surround each with a different bright colour you will see that each grey apparently alters its value; each in fact will take on some of the opposite or complementary value to the bright colour next to it. Thus orange will give the grey a blue tinge, yellow will give it a violet tinge, and blue will give it a warm orange tinge. If you are trying this experiment for the first time you will be surprised at the extent of these apparent alterations; it can be difficult to believe that the strokes of grey are really all the same tint. It is not only greys and very neutral values that are influenced in this way; all values are to some extent mutually dependent when they are placed in juxtaposition, and much frustration can be avoided if this is understood. You may wish to respond to a passage in a landscape with a particular luminous grey which seems just the equivalent to your vision of nature when you put it down on the canvas. Half an hour later it may be transformed into lifeless mud by the brighter colours you have assembled round it. Quite strongly saturated tints will often have their values shifted by juxtaposition.

This is one of the main reasons why the colours in a painting must always be considered together, and related to each other; the colours will affect each other in any case, so this may as well be in ways that the painter wants. Just as a simple large relationship of linear proportion can be used as

a measure of the proportions to follow, so it is possible to create some measure of colour values by stating two or three strong and closely placed tints on the canvas as soon as the development of the painting allows it.

I do not suggest this as any kind of necessary method — hard and fast systems should be looked on with suspicion — but as one way of providing a 'yardstick' against which following values may be judged. If from such a measure a series of colour values is built up, each relating to what has already been developed, a stage may be reached where the necessary value of a particular passage becomes in a sense inevitable, that is to say, the preceding colours will dictate what it must be.

The process of colour development must of course depend in detail on the way the painting as a whole is conceived and developed. There may be good reason for resolving a particular object or related group of objects to a high degree of completion before much else work is done. The painter should only be deterred from a heterodox attack upon his landscape subject if he feels he cannot thereafter control the course of the work; certainly he should not be deterred by orthodox rules. But in most cases he will be wise to make sure that the colour he initiates provides at least a strong clue to what should follow. Colour needs controlling as much as any other attribute of painting.

It may seem over-simple to say that uncontrolled colour is often due to too many different colours. Yet landscape painting seems to suffer peculiarly from the temptation of the inexperienced to use every available colour on the palette. In order to gain a sense of control over the colour scheme of a painting, it is almost certainly best for the student to start with a simple palette, perhaps of no more than five or six colours. This means working in a restrained key (most of the masters started in this way), but it also compels the painter to discover equivalents for the colours of nature instead of trying to imitate them. We work with paint, not with rainbows, and although clever artists of *trompe l'oeil* may give the effect of having imitated nature, literal imitation is impossible. Introduce new colours onto your palette when you cannot do without them, rather than in order to find a use for them. Experience will enable you to keep control of a progressively wider and more brilliant colour range.

The old adage that light excludes colour often puzzles beginners; but it is particularly important for the landscape painter, who is working under the strongest of light conditions, to understand what it implies.

Since we are considering landscape, let us assume that the source of light, directly or otherwise, is the sun. Now very

brilliant mid-day sunlight will not only emphasize light and shade but will reduce the contrasts between local colours. (It has been said of the tropical sun at noon that 'it puts the colours to sleep'.) In these conditions tonal contrast will be at its maximum, while the differences of the local tints of separate objects will tend to be at their minimum. Even the direct light of sun gradually loses this power as it sinks towards evening, when tonal contrast becomes reduced and local colour (even if warmed up) begins to assert itself. This is much more apparent on a bright grey day, where the flatter and softer light will largely exclude cast shadows and will allow objects even in the middle distance to display their differences of local colour to the maximum. Beyond a certain distance, of course, the unifying effect of atmosphere will enforce its own reduction of colour contrasts.

All this means that the painter should be wary of trying to combine very strong contrasts of light and shade with equally strong contrasts of local colour. A brilliant light source may emphasize one colour, but in nature it is usually at the expense of the other. A combination of heavy 'chiaroscuro' and a multiplicity of bright colours is an invitation to a contradictory harshness of effect. Some early Monet landscapes seem to succeed in this combination, but even in these there is a harshness which we do not find in his more truly Impressionist work which followed. Landscape painters such as Matisse and the Fauves, and Bonnard, working in a high colour key, may be seen to follow the Impressionists in substituting colours for dark tones in rendering shadows.

However, this adage that light excludes colour, remains an adage, not a rule; the best way for the individual to test its truth for himself is by experiment.

It is very difficult to discuss the question of colour without seeming to impose rules: I must emphasize that I do not suggest that there is any particular 'right' way of setting about the development of colour in a landscape painting. While I have said that it may be a good idea to start by stating one or two strong relationships of colour, the examples of 'Pointillism' and 'Divisionism' point to a quite different approach. The development of colour in a Seurat landscape is an almost infinitely subtle combination of 'system' and sensibility: we can see perhaps more clearly in a follower such as Signac or Luce that it is possible to assemble with small marks all the properties of one colour, say, red, that the different elements of a landscape share. Interposed may follow marks showing all the properties of blue, yellow, green and so on, until a luminous network of values emerges where each surface contains in its juxtaposed marks some colour quality of all its neighbours.

This is a crude simplification of a subtle process, and it is certainly not a process which absolves the painter from the need for control. Pointillism is not the language which will suit many, but some exercise in it can be very revealing about the inter-relationships of landscape colour.

The painter should be on guard against over-equality in a painting's colour balance. Equal amounts of warm and cool and equal amounts of strong local colours will make a work seem indecisive. It is very well to discover, like the Impressionists and their followers that the colour of a shadow contains the complementary of a colour in the light. But direct complementaries, stated as strongly as the major colours which are supposed to generate them, can be dangerous and likewise lead to a look of indecision. Even the brightest tints can cancel each other out if none is given any dominance.

Conceive the colour design of your landscape as much as you conceive its linear and tonal composition. Colour may be a matter of mood, but mood must find concrete form in paint.

Perspective

Perspective systems have been invented to codify various
ways in which the third dimension can be expressed and
read on a flat surface. All perspective systems are
distortions of visual perception. The reason for this is that
we do not perceive upon a flat surface. If you imagine
that you are tracing what you see in front of you in depth
on a sheet of glass from a fixed eye-point, then it is clear
that the sheet must be also fixed at right angles to your line
of vision both horizontally and vertically. But it can only
be truly 'normal' to your line of vision at one point;
everywhere else you will be seeing through the glass at an
inclined angle which is ever steeper towards its edges. This
does not matter very much if you are only tracing what is
nearly in front of you, in other words you are restricting
yourself to a narrow angle of vision. But as you look
further round or up and down it will be clear that to go on
tracing an almost true linear image you will have to shift
the glass sheet to preserve its frontality. An infinitely large
number of infinitely small sheets, each oriented to be at
right angles to the line of vision, and all joined together,
would form the concave interior surface of a sphere. It is
upon such a 'sphere of vision' that we actually perceive,
and it is an axiom that a spherical surface cannot be bent,
twisted, stretched or compressed into a planar or flat
surface without distortion. It is important for a
draughtsman to understand that no form of perspective
abolishes distortion, but only systematizes it.

'Central Perspective' is a system largely adopted by
European 'realist' painters, because within reasonable limits
of vision it most nearly projects onto a flat surface our
natural perception.

The base of Central Perspective is the Horizon line. The
viewer selects one point on this Horizon (his own
horizontal level) which is the Centre of Vision. He assumes

that everything else that his sweep of vision includes can be seen in sharp focus. The system propounds that all parallel lines in nature converge on the flat to common Vanishing Points will be at some appropriate level above the Vanishing Points will be on the Horizon. If they slope upwards in nature away from the viewer, their Vanishing Points will be at some appropriate level above the Horizon; if they slope downwards, below the Horizon. The exception is any set of parallel lines which is both horizontal and 'flat on', or at right angles to the Line of Vision (leading to the Centre of Vision). These are assumed to remain horizontal on the drawing surface. In its simplest form this is often known as 'One Point' perspective.

This assumes that if we are looking flat on at a rectangular house, the side of the house will 'vanish' to the Vanishing Point, while the facing wall will remain horizontal.

But since, if we can see the side wall, we cannot be truly facing the front wall 'flat on', there is an inconsistency here. The more visually sophisticated 'Two Point' perspective recognizes this and assumes that if a wall on the left is receding to one Vanishing Point, then the wall on the right must be receding to another. Normally in Central Perspective, vertical lines are assumed to remain vertical in a drawing: but sometimes the view, up a tower or down a shaft, is so elevated that this assumption evidently is in contradiction with the visual evidence. We then have the development of 'Three Point' perspective, in which the vertical lines of nature converge upwards or downwards, as the case may be, to their own Vanishing Points. These Vanishing Points will usually lie outside the limits of the painting or drawing, as indeed those of Two Point perspective will frequently do also. There exists a fairly elaborate system of overcoming this problem by constructing within the picture limits in order to discover what the convergences should be, but the landscape artist will do better to learn how to estimate the necessary slopes to external Vanishing Points by eye: what matters is that a direction should look right for the structural needs of the painting, not that it should conform to the demands of a geometrical system.

In fact if we were to follow Two or Three Point perspective always to its logical conclusion we should continually come up against distortion and inconsistency in relation to Natural Vision.

For instance, if we were to face the opposite facade of a wide street of identical terraced houses, and then started drawing the departing view to the left in Two Point perspective we would find the departing horizontals converging off to the left. Similarly those on the right

would converge to the right. If we then produced these lines to the middle, they would all meet in shallow points (except on the Horizon Line). But clearly in fact they are all continuous straight directions. We must either revert to One Point perspective in order to say so, or abandon the rules and represent these continuities as shallow curves.

The next problem we shall consider is the matter of equal intervals departing in depth. Consider a flat plain surface covered in a rectangular grid like a giant chess board. We can see that the departing intervals become narrower and narrower. It would be a long-winded thing to try to measure all these different gaps by eye, and in fact if we estimate by eye as nearly as we can the ratio of width to depth of the nearest square in the picture surface, seen in perspective, then the rest can be found with the use of Vanishing Points. This depends on the fact that the diagonals running through the squares of a grid system will themselves form two sets of parallel lines, vanishing to left and right points.

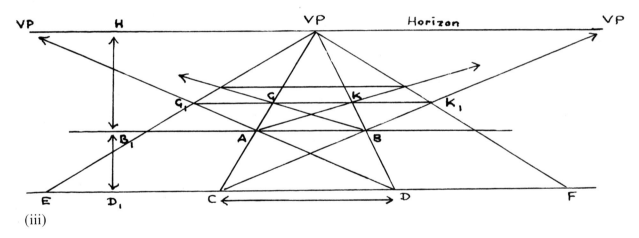

(iii)

Supposing that you are actually looking at a flat horizontal chessboard landscape so that one side of the grid is at right angles to your line of vision, then one set of square-sides will all remain parallel to the horizon; the others will all vanish to a point on the horizon at your Centre of Vision. Now if you take a square which will be in the foreground of your picture, and measure carefully the ratio between its nearer and further side, and between the further side and the horizon, this can then be transferred to your picture. In diagram (iii) this is shown as the vertical proportion $D_1B_1:B_1H$. Then the proportion between the depth and width of the square must be as carefully estimated by eye ($D_1B_1:CD$). When the square ABCD has been established

in perspective in the picture then mark off on CD produced points EF to the left and right respectively so that EC = CD = DF. You now have the nearer widths of the squares to each side of your first square. Join E and F to the Vanishing Point. Draw diagonals DA and CB, producing them to the horizon to form two more Vanishing Points. These lines will cut through EVP and FVP respectively, and where they cut at G_1 and K_1 will be the interval for your next square backwards in depth. The diagonals of the square ABGK will provide the interval for the next square, and so on towards the horizon. I have already referred in chapter I to the way in which a line of poles diminishes into the distance. The point is easily demonstrated in this chessboard diagram by raising verticals from the departing corners of the squares. If you extend this perspective chessboard too far into the foreground, or too far to either side, its inherent distortions become apparent.

Circles Unless these are seen flat on, they appear in Central Perspective as ellipses. To find the ratio and tilt of an ellipse representing a circle (arches, clock faces and so on), draw first in perspective the square in which it can be thought to lie. (A circle can be inscribed in a square so that the centre of each side is tangental to the circle; this remains true in perspective.) The ratio of an ellipse is the ratio between its major and minor axis, that is, its longest and shortest diameter. Find the perspective centres of each side of the square: these will be the tangential points. From the perspective centre of the square (discovered by drawing the diagonals), draw a line out in perspective as if it were a spindle piercing the square at right angles. This line is the minor axis of the ellipse. From the points where it cuts the square divide this in half. The half-way point is the centre of the ellipse, which is always nearer to you than the perspective centre of the square (diagram iv). Draw another at right angles (not in perspective) to the minor axis, and you have the major axis. The limits of these axes will be discovered as you proceed to inscribe an ellipse. Practise doing this 'free-hand'. Remember that the widest limit of the ellipse will be along the line of the major axis, even though it will not touch the square at either end. The ellipse only touches the square tangentially at the four half-way points of the sides. There are methods of constructing ellipses from axial proportions, but it is better, and the result livelier, if you can learn to make them by eye. By far the most important factor in getting an ellipse to look like a circle lying in its own plane in perspective is to get the directions of the axes right. If you do not do this, the circles will appear to be falling backwards or forwards.

(iv)

If you meet a Gothic Arch, realise that in its simplest form it is made from the arcs of two circles cutting each other (diagram iv).

These are but the simplest devices of Central Perspective. Many more elaborate methods exist for constructing curves, various polyhedrons and so on. But I think that there will be few problems the artist will meet which cannot be worked out from first principles, combined with intelligent observation. Perspective systems are perhaps of their best value in helping the artist to understand the problems of structure he meets: they should not be a substitute for understanding, nor impose their rules on expressive need.

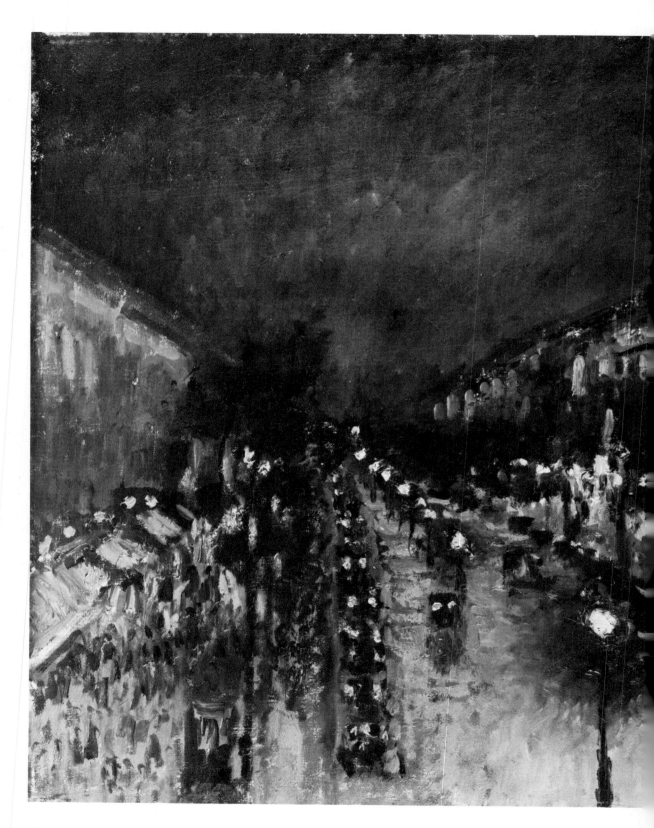

84

CAMILLE PISSARRO 1831–1903
Boulevard Montmartre 1897
Oil on Canvas 54 cm × 65 cm (21¼ in. × 25½ in.)
National Gallery, London
Pissarro developed his art in terms of a deep and solid
understanding of the countryside, but was no less
able to transfer his sensibilities to the urban scene.
This is a piece of direct observation, painted from his
hotel window

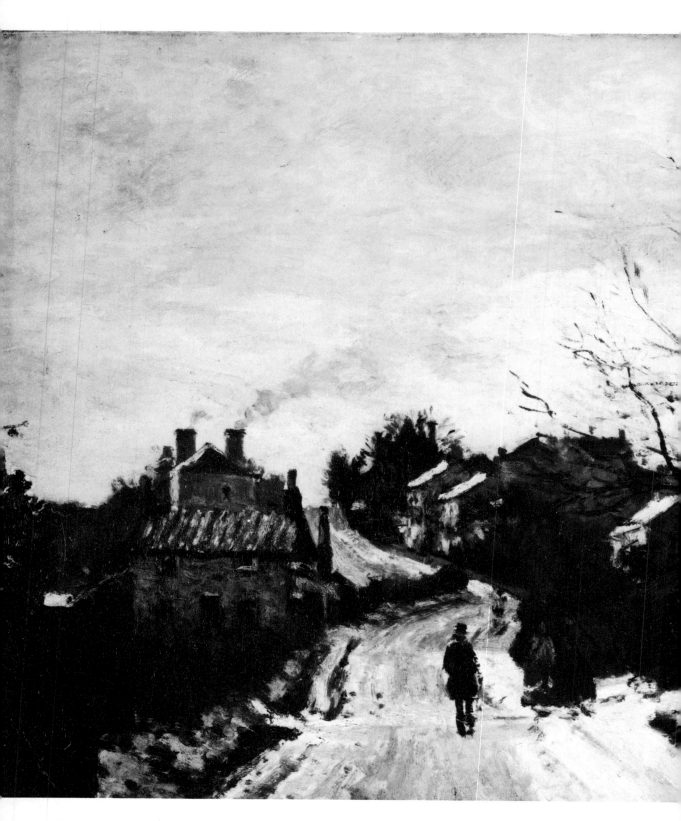

CAMILLE PISSARRO 1831–1903
Lower Norwood 1870
Oil on Canvas 35 cm × 45 cm (13⅞ in. × 18 in.)
National Gallery, London
The big contrasts between the static and the active
give this painting its sense of variety, and this is
where its exactness lies. Detail here would be
obtrusive: but in his use of the paint Pissarro shows
the difference between the vital equivalents which he
discovers and the mere sketchiness which he avoids

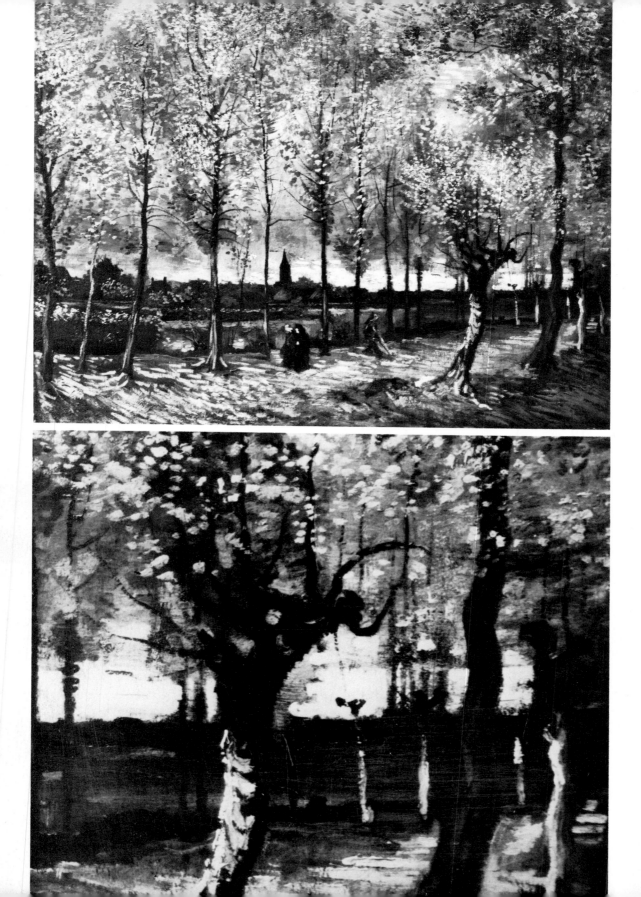

VINCENT VAN GOGH 1853–90
Populierenlaan bij Neunen
Oil on Canvas 78 cm × 97.5 cm (30¾ in. × 38¾ in.)
Boymans Museum, Rotterdam
This early Van Gogh was painted before he came
under the influence of Provençal light: he is still here
employing the chiaroscuro of the Realist period. The
focus is on the steeple and the figures grouped under
it in the foreground: the perspective Vanishing Point
of the path lies outside the picture to the right, and
does not distract from the centrality of the scene

ANDRÉ DERAIN 1880–1954
The Pool of London 1906
Oil on Canvas 63 cm × 99 cm (25 in. × 39 in.)
Tate Gallery, London © by ADAGP, Paris 1980
Derain's Fauve period paintings, of which this is an
example, lack the subtlety of Matisse, but in their
more rudimentary colour constitute a simpler visual
manifesto of Fauve art. The two dominant bright
local colours, red and blue, also double respectively
as light and shade, while the reserved half-tones of
nature are heightened into greens and violets to meet
the key of the dominants. The viewpoint of Thames
shipping is chosen (as so often in Fauve painting) to
produce the maximum of raked diagonal shapes with
the necessary vigour of graphic movement to contain
the violent colour

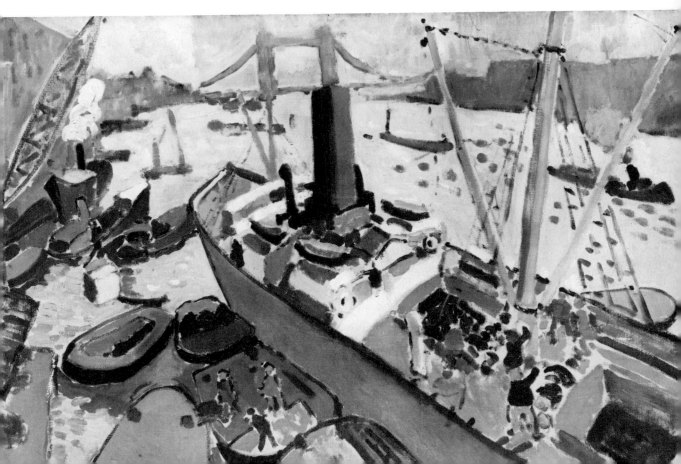

Symbol and
Expression

If symbols may seem of little direct relevance to the art of perception, yet their characteristics should not be altogether overlooked by the representational landscape painter.

The word 'symbol' derives from a Greek word meaning a token. We often use it so loosely that its meaning in art becomes confused, but we may perhaps most simply understand a visual symbol as being a shape conveying an idea or message to those with access to the necessary code. Symbolism is an instrument for recognition, however esoterically it may be used. Symbols may hide their meaning to all but a small and select circle, but yet be clear to that circle. Such have been many religious, magic and cult symbols. Other symbols convey their meaning as widely as possible to all. Such, usually, have been those of heraldry, science and urban signs.

Some form of symbols are abstract – squares, circles, bars sinister and so on, and have only a coincidental bearing on the representation of observed forms. But other symbols, whatever their import, are themselves representational; and it is their nature to be instantly recognizable. Symbolic forms of a man, a horse, a tree, a leaf or any familiar shape must show them in a simple way which reveals their characteristic silhouettes as clearly as possible. The front view of a man, the side of a horse, the top view of a moth, are in turn the most immediate revelations of each form: the successful symbol requires a kind of perceptual appreciation of each form's typical aspect.

So there is a lesson from symbolic art even for the perceptual landscape painter.

Trees, for instance, however different individually, have within their types characteristics which distinguish them from other types. Oaks greatly vary, just like men and horses, but they never look like ashes or chestnuts or pines. Each tree, however individual, is a potential symbol of its

90

own family: this is particularly relevant when we consider the problems of distance unique to landscape. The objects in an interior, whether still-life or figures, will reveal something of their identity readily enough with their details as well as with their general shapes. But details are soon lost in landscape distance: the artist who wishes to reveal the identity of an oak or a beech a mile away must discover the equivalent of an oak or beech symbol to explain them. It is in fact a good test of drawing shapes and forms always to ponder on the most characteristically revealed aspect of a particular object; it is an especially good test for a landscape painter. How can this test be applied in practice?

Let us stay with the example of trees, since they are both a recurring feature of landscape and fortunately in most cases present a similar characteristic shape from any horizontal direction: they do not have back views and side views.

They are made of trunks, branches, twigs and leaves, and when they are close up we can if we choose describe their total forms with paint as a sum of these details. We may omit some details, emphasize others, but we need not substitute some generalized equivalent or a formalized sign to convey the image of an oak tree with leaves.

We can actually count and draw as many perceived leaves and twigs as will imply the others.

But in the middle distance we can no longer count leaves, indeed we cannot see separate leaves, although knowledge tells us they are there. Our expression of the tree must now use different means. 'Pure' symbolism is not usually concerned with the problem of explaining space: where we find subject paintings whose purpose is symbolic narrative (as in many Indian miniatures) then we will often see the distant tree explained by its having fewer leaf shapes than a foreground one. This kind of explanation which symbolically uses some typical element of a form like a leaf to identify it, is appropriate in a painting whose intention or pictorial is that of symbols. It is right in the Indian miniature; it also seems altogether valid in the Douanier Rousseau, and in that late series of Matisse interiors where views through windows show trees expressed in just such a way.

But as landscape painting approaches the expression of perceived and directly experienced realism, this method of symbolizing things which in fact distance makes imperceptible, becomes less and less appropriate.

In the language of realism we should be cautious of enumerating on canvas what we cannot visually count. We may still in a sense 'symbolize' but we must look for explanatory symbols which distance itself provides.

The oak leaf and twig disappear, but they are replaced by a visible clump made up of themselves. This clump is still typical of an oak tree; we can still cling to its 'oaky' nature no less than to that of a single leaf, and the expression of the trees is now to be discovered from the totality of these clump shapes.

Similarly in the far distance even these clumps become indiscernible; we must find the shape which immediately expresses the whole oak tree, and which makes it yet different from other trees. The realist must employ a kind of symbolism in reverse. For him, a single leaf will not stand duty for a distant tree; yet the total shape he finds to express that tree must in some degree symbolise the leaves of which it is made. Landscapes by such masters as Rembrandt and Constable had not perhaps a direct symbolic purpose; yet how well could their drawings of trees be used as symbols, such is the expressive clarity of their shapes.

I have defined symbolism very crudely: but sometimes the term is used to cover almost any departure from direct visual experience, and it should not be so over-worked as to deprive it of meaning. The landscape painter may find himself moving far from the 'facts' in ways that are matters of expressive mood rather than symbolic necessity. The 'Fauve' painters are examples. Although historically some of their adherents may have had associations with French Symbolism, the characteristic invention of heightened colour and dynamically simplified drawing in Fauve painting arises out of the need to express visual mood in the face of visual experience: the inventions are not essentially those of literary symbolic reference. The Fauves were referred to in their time as 'frenzied Impressionists'.

Of course since it is impossible to imitate nature literally, all painters have to invent equivalents, and the possibilities of heightening and altering objective facts are so limitless as to defy category. Attempts to codify expression are usually codifications of school and style. There is a Venetian 'School'; the young Turner modelled himself often in his landscapes on Claude's style. Yet two painters could hardly have been further apart expressively than Veronese and Tintoretto, while in Turner's most 'Claudian' landscapes there is a sense of disturbance at an opposite pole from the French master.

If the possibility of expressive alteration of the visual world is so limitless and so idiosyncratic, can anything much be said about it to help the landscape painter? Perhaps not much: Matisse complained that his attempts to teach ended in his pupils demanding rules for self-expression which he could not give them.

I would make only two points. The first is one that the student landscape painter often raises himself. How far, in the face of the observed subject, may we leave things out which are there, and indeed put things in which are not there? I can give no easy answer, only offer a word of caution. Of course the painter, as potential master of his painting, can leave out or put in what he likes. But sometimes the less experienced landscape painter may be properly arrested by the possibilities of a subject without then pausing enough to realise just what combination of its components have arrested him. There is a danger of omitting some element for an extraneous reason – it is 'ugly', or difficult to draw – when in fact it forms an essential part of the visual structure that caught one's eye in the first place. Leave out anything which is irrelevant to your idea, but be quite sure that it really is irrelevant. The same may be said of adding things. If you put a figure in a landscape remember it is likely to have a strong focal power. Observe if possible, however transiently, where a passing figure will best provide that focus for the idea as a whole: it may have an equal power to distract from it. Secondly, where expression is a matter of heightening or dramatically altering colour, or of 'distorting' the forms of a landscape, the artist will generally be well guided by the precept (not the rule) of consistency. It may be very well to paint a blue sky red, but it will also be well that all the other colours in the painting follow the same order of transformation. Equally important is the relation between colour and shape. If a colour is expressively transformed, then it is unlikely that a literally drawn silhouette will hold it, and a violently wrought distortion of shape will probably overpower a directly observed passage of quiet tonal colour. Whatever the language of expression, a painting is the more likely to succeed in its purpose if its various attributes of colour, drawing and design are mutually consistent. Because landscape, like other forms of painting, is anti-nomian, we should be careful not to elevate such precepts to the status of regulations. There may sometimes be good purpose in 'inconsistent' pictorial language; what is necessary is that the purpose should be there.

GOERGE FREDERIC WATTS 1817–1904
Freshwater in Spring 1974–5
Oil on Canvas 71 cm × 91 cm (28 in. × 36 in.)
Private Collection, Rochester, New York; Fine Art
Society
Much of Watt's work is characterized by a tonal
harshness which might hardly seem to lend itself to
landscape. Yet perhaps that very quality lends
expression to this scene. The thatched cottage and
the floral foreground have the ingredients of the
sentimental, yet it all remains strangely sinister

94

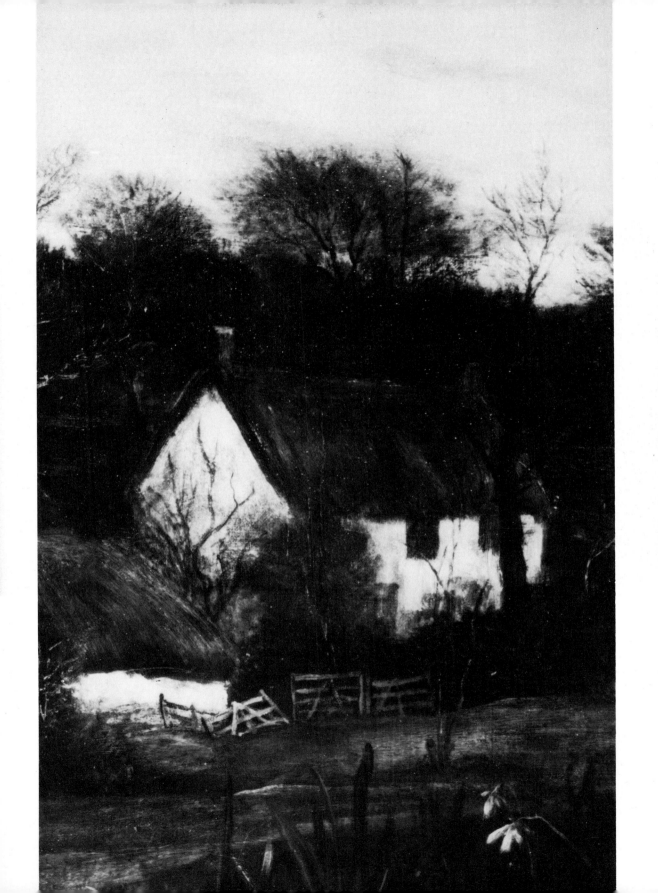

PAUL CÉZANNE 1839-1906
La Montagne Sainte-Victoire 1900-02
Oil on canvas 54.6 cm x 64.8 cm (21½ in. x 25¾ in.)
National Galleries of Scotland

This painting is a summation of particular experience, as it is probably Cézanne's last depiction of the mountain from this viewpoint. Shortly after his death one of his disciples wrote of him that he painted with abstractions that resided in the character of the objects represented. The reflection is well borne out in this painting. The apparently simple notations of line and colour copy no detail, yet combine to create a unified sense of the place and of its total light. The paint is an interaction of warm and cool values; it is the cool planes which control the design

FRANK SPENCER GORE 1878-1914
The Cinder Path 1912
Oil on canvas 69 cm x 79 cm (27 in. x 31 in.)
Tate Gallery, London
Painted from his friend Gilman's house looking towards
Baldock. This work shows Gore applying an awareness of
Cézanne's ideas of colour to an essentially English
landscape. The relationships of reddish and green values
are both abstract and actual

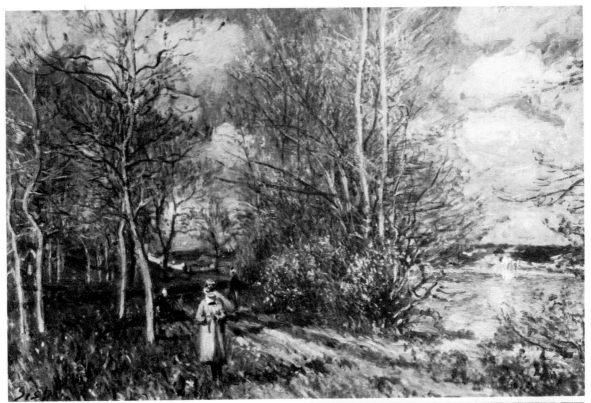

ALFRED SISLEY 1839–99
Les Petits Prés au Printemps
Oil on Canvas 56 cm × 74 cm (21¼ in. × 28¾ in.)
It is not easy to populate a landscape painting. Too
often painters, if they include figures at all, do so as
an afterthought. Figures are not likely to 'belong'
unless they are considered as part of the initial idea.
The leading impressionists, so often thought of as
preoccupied with landscape per se, were adepts in the
art of introducing authentic presence.

 The figures in this Sisley are altogether believable;
even though the girl in the foreground may seem to
be posing for the painting. Both she and the further
figures are part of the overall tonality and part of the
design; there is the feel of observation about them

HENRI MATISSE 1869–1954
Notre Dame 1902
Oil on Canvas 46 cm × 37 cm (18⅛ in. × 14¾ in.)
Tate Gallery, London © by SPADEM, Paris 1980
This small painting, one of several by Matisse of this
subject, was a response to a scene which he must
thoroughly have absorbed, for it was the view from
his studio window. It heralds the Fauve period which
he was about to enter, and already has about it a
feeling for colour which represents the mood
summoned by the *genius loci* as much as by direct
visual reaction to the facts. It is an object lesson in
how to paint a valid sky without imitation. As with
the older masters of landscape, Matisse derives his
sky colours from the development of the whole
painting, keeping it both distant yet securely part of
the picture surface

MATISSE
Paysage Montalban 1918
Oil on Canvas 73 cm × 88 cm (28¾ in. × 35¾ in.)
© by SPADEM, Paris 1980
Included because it is one of my favourite
landscapes. What I said of his *Notre Dame* may be
said of this painting, but it shows sixteen years more
experience in the art of resolving the complex visual
components of value and shape with a unit of
deceptive simplicity. The sense and Provençal mood
reveals deep feeling in its conception. There is an
equally deep intelligence in its execution

99

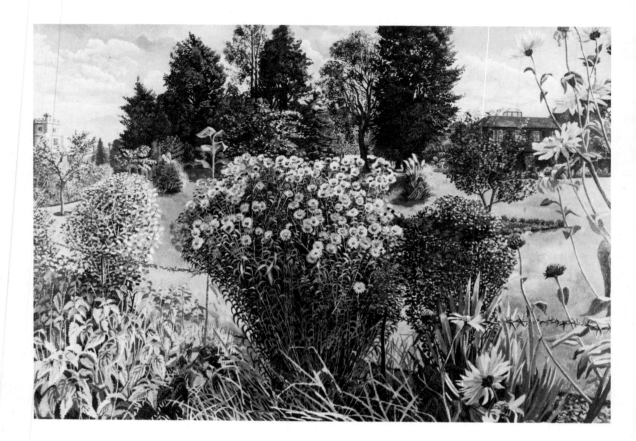

STANLEY SPENCER 1891–1959
*Bellrope Meadow, c.*1915
Oil on Canvas 66 cm × 130 cm (26 in. × 51 in.)
Rochdale Art Gallery
The assiduous detail of most of Spencer's landscapes
in no way marks him as a 'primitive'. He was a
thoroughly trained draughtsman and painter whose
eccentricity was to swim against the Post
Impressionist and Fauve stream of his youth. The
unity of this work is sustained by an unflagging
energy in revealing the contrasting patterns of
characteristic detail in every passage. The simplifying
lies in the careful massing and containing of the
silhouettes. This commitment to detail involves a
special approach to breadth and sacrifices others. It
is worth comparing this Spencer with a typical
impressionist landscape to notice what he did not
attempt.

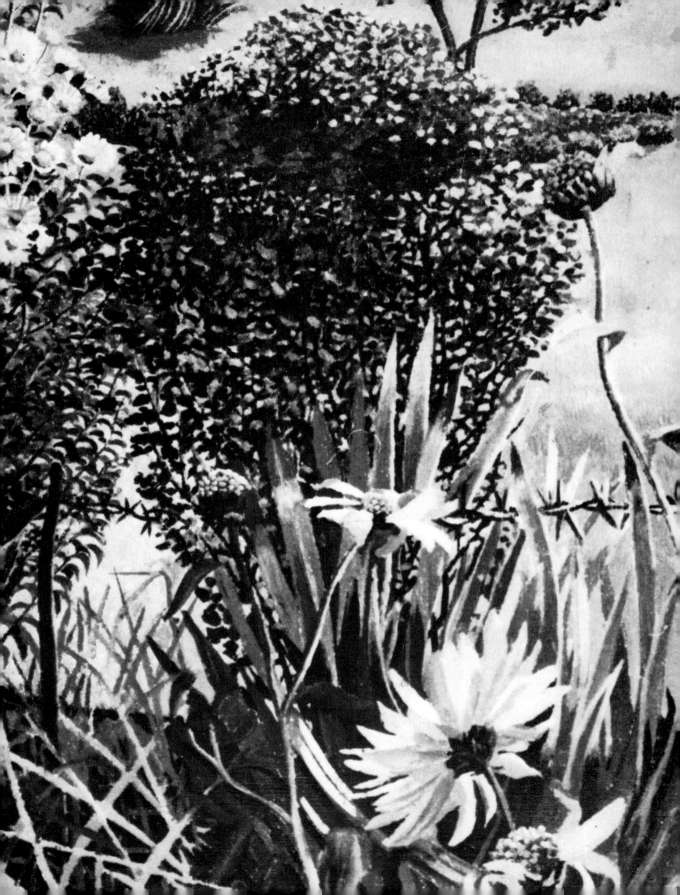

Materials and Equipment

The materials of the landscape painter are no different from those of the studio painter – with one important proviso: they must be portable. The subject does not come to the landscapist, like a portrait sitter; he must go out and find it.

Unless you choose to paint only what you can find within a few yards of your transport, you will have to carry your materials to your subject, and it is only common sense that they should be no more than necessary. This section, therefore, will not consist of a compendium of all the materials you could possibly use, but rather of suggestions about how little you can reasonably do with. They can, of course, be no more than suggestions which every painter will vary to suit his needs. Each medium needs to be considered, but one essential is common to all: a light chair. Nothing is more frustrating than to find an exciting subject which has everything you want except somewhere to sit. Even if you are painting in oils or acrylics at an easel, when you may expect to stand, you may yet find that your subject only presents itself at its best from a seated position.

The traditional wooden tripod sketching chair with a leather seat has one advantage for which there seems no ready substitute: being three-legged it will always rest steadily on uneven ground. This is a good point in its favour; but it is comparatively heavy and folds into a bulky shape which is not the easiest thing to carry, and it has, of course, no back rest. I have personally come to prefer one of the light metal types of camping stool or chair with a canvas seat, and like to use one with a back: I find the extra restfulness well worth the marginal extra weight. Of the varieties on the market, pick one which is light and which folds flat, so that it can be strapped to a box or portfolio.

DRAWING MATERIALS

Drawing materials are likely to be the least cumbersome, and for drawing you may allow yourself to carry perhaps more than you may in fact use.

Paper and sketch books

For drawing with pencil or pen a good quality cartridge paper will usually serve best. Avoid cheap quality paper with an over-shiny or over-soft surface. A hard but matt surface is more sympathetic, and it should be thick enough to stand up to whatever treatment you are likely to give it. The more expensive hand-made papers made for watercolour can be used, but they are (apart from probably having more permanence) not really necessary.

A number of papers are made up in sketch-book form, and this is clearly the most convenient way to carry paper. Choose a sketch-book of good quality sheets and if possible, one with a strong enough card backing to act as its own drawing board. Books with gummed spines are apt to come unstuck as the sheets are used: stitched books (if you can find them) do not have this disadvantage but have to be held open as a 'double spread': this can be inconvenient in a wind. The 'ring-back' type overcomes both these problems, but they allow the sheets to rub a little sideways against each other, so that your book of drawings can easily become smudged. This is overcome by 'fixing' each drawing as you make it, or as soon as you get home: on the whole I prefer the ring-back book, as it folds back on itself.

Drawing boards and portfolios

These are necessary if you do not use a sketch-book. Drawing boards are heavy, so do not choose one larger than you really need. It can be conveniently carried in a cardboard portfolio which will also contain your stock of paper. The advantage of equipping yourself in this way, despite the extra weight, is that you can carry with you a variety of papers, both of surface and format, to suit whatever unexpected needs may arise. This avoids the disadvantage of the sketch-book, which is of the same format all through, and tends to encourage the same format of drawing even when the subject demands something different.

A number of types of clip for securing paper to boards are obtainable: I have found nothing more practical than the drawing pin, with which all four corners of the paper can be secured whatever its size. An alternative is pieces of thin masking tape. paper may also be damped and

stretched: this is not usually necessary unless a wash is to be employed.

DRAWING IMPLEMENTS
Pens
I have found the most flexible implement to be the traditional 'school' pen knib, or 'Indian' knibs. In these days of ball-points they are becoming hard to find, but an artist's colourman or good stationers can still be persuaded to find a box of them.

The smaller 'mapping' type of knib is suitable for fine linear work but is much less flexible.

Some draughtsmen make excellent use of 'home-made' pens. The cutting of quills is an expert operation to be learnt by demonstration rather than description, but interesting qualities can be got simply from cutting sticks and reeds to points. You must be careful with such tools only to take a little ink on them at a time, or they will blot.

Pencils
Graphite pencils, often still called 'lead' pencils, should be of good quality. They vary from the almost needle-like hardness used by topographical and engineering draughtsmen to the very softest heavy black. They are normally designated in this degree from 'H' to 'B', a 6H being very hard, a 6B extremely soft. The softer the pencil, the heavier and smoother running will be the line: the softest pencils will not stay sharpened for long, and smudge very readily.

The hardness must be a matter of choice and need: I like to carry a B, a 2B, and 3B with me for various needs. The draughtsman must find what best suits him, and he may find it necessary to use more than one strength of pencil on a single drawing. It is not always necessary to employ 'artists' materials: I often use flat carpenters' pencils for a fat line.

Chalk, carbon, crayon, charcoal
Numbers of such pencils are available, such as the Conté range. They vary in substance from dry to greasy, and in general give a fatter and blacker or denser line than pencil.

OIL PAINTING MATERIALS
Historically, oil paint is a development from the various forms of tempera emulsion which preceded it. Egg yolk, the most famous vehicle of 'pure' tempera, is a natural emulsifier whose oily content can be extended with water. The practice of building up emulsions with more oil, an invention attributed to the early Flemish painters, evolved

to a point where the emulsifying process, in effect the water content, was dropped altogether; and powder pigments were mixed simply with oil. Of the various oils used, linseed has been found the most generally reliable, though poppy is sometimes used in the tube manufacture of paints, being a slower drier.

It happens that the use of oil paint as a normal material by the seventeenth-century painters accompanies the development of landscape painting as a subject matter in its own right, and along with water colour and various graphic materials oil paint has been the vehicle for the main body of landscape painting.

It is perfectly possible for the artist to make his own oil paints: the raw materials can be readily obtained. Works of much chemical research and scholarship have been published giving numbers of formulae for all the traditional media. But a degree of romanticism about the past can arise from this. It is very good that a student should try on occasion getting to the roots of his chosen media, whether paints or grounds, by making some for himself. But he should not be led to suppose that the buying of ready prepared paints and grounds is merely a lazy substitute for the practice of the old masters. Before the manufacture of commercial colours, most painters went through a stage of apprenticeship when they learnt to make materials. But when they established themselves as craftsmen able to earn a living from their art, they lost no time in getting apprentices of their own to do this job for them. In a sense, since the virtual disappearance of the apprentice system, commercial colourmen have taken on the apprentices' work: we support the colourmen instead of the apprentice for the time-consuming business of manufacture.

The resources of modern manufacture have presented the painter with a much larger range of materials, perhaps bewilderingly large. The reputable firms distinguish the qualities of their various products, and in spite of the great choice that faces us we can still know which ranges of colours are made of the best pigments, which are the more permanent and which the relatively fugitive.

The painter must come to make his own choice of what suits him best. He will learn that he does not need everything which is on offer: probably the best way to establish a personal range of material and equipment is to start with modest basics and to enlarge as the needs arise. The following list suggests such possible basic materials: it must not be taken as a prescription.

Supports
These are the various surfaces on which oil paintings are

carried out. No painting, unless it comes to be thought worth the labour of highly skilled restoration, is more permanent than the support on which it is painted: supports, therefore, must be appropriate to their medium, and not made of slipshod material.

Panels

Wood panels were traditionally used for tempera painting and also for oil painting. They are satisfactory if the wood (many varieties are suitable) is well seasoned, thick enough to withstand warping, and free of knots and cracks. Hard woods serve best: panels must be washed clear of surface resins and thoroughly dry.

Good seasoned wood is not easy to come by, and often the best panels now are those retrieved from old doors and furniture which have stood the test of time.

For a landscape painter the disadvantage of the wooden panel is clearly weight: it is most suitable for small works.

Hardboard

Good quality hardboards of the Masonite or Prestwood types make excellent substitutes for wood. Small panels are strong enough not to warp, larger ones may need backing with wooden supports. Hardboard has shown itself to be a permanent material. The edges and corners need protection, but it need not be elaborately 'cradle'; a frame should itself be sufficient protection.

Card and paper

The best quality cards and heavy rag papers have proved themselves to be strong oil supports, though a work of any size on these materials will need further backing on some form of heavier board. However, this does not exclude card and paper for the landscape painter: the backing can be carried out when the painting is dry. In the meantime they are a light and portable form of support.

Metal

Panels of various metals have been used for oil painting, but weight militates against their use in landscape work.

Canvas

This is the most generally used support for oil painting. It is not inherently stronger than others, but it combines so many advantages. It has a sympathetic surface for oil paint: in fact with various combinations of weight, weave and priming, the painter can obtain virtually any surface he needs. The 'tooth' which is characteristic of canvas weave is especially responsive to the oil-loaded brush. Then, canvas

106

is light and easy to cut. A painted canvas can if necessary be rolled for transport and storage.

The best canvas is made of linen and should be of close tight weave. Most other materials are either too soft or too liable to stretch and wrinkle; though cotton and silk can be safely used if they are stuck onto boards, which are then given the woven texture they otherwise lack. Heavy sailcloth makes a suitable support, though it has, compared to linen, a somewhat furry surface. It is, however, much cheaper.

Canvas can be bought ready 'primed': this is expensive, if time saving, and it is possible to buy lengths of good unprimed canvas (not necessarily from a colourman) and prime it one's self.

Stretching canvas

Canvas is normally stretched on loose jointed wooden frames. Unless you have adequate woodworking equipment it is a mistake to try and make your own stretchers. The mitred corners of each length must be slotted so that the resulting rectangle will lie flat and the surface facing the canvas must be bevelled inwards so that the inner edges of the stretcher do not touch the stretched canvas. Lack of this bevelling almost invariably creates ridges on the picture surface. The cheapest way to buy stretchers is in some quantity, as interchangeable lengths.

The stretcher should be assembled with the mitres knocked tight together. Make sure all the bevels are on the same side and that the assembly is a true rectangle. Allow about 50 mm (2 in.) overlap of canvas and lay the stretcher (bevels downward) on the canvas piece. Use tin-tacks or staples to secure the canvas at the centre of each side, stretching the material as you do so tautly but without straining the weave. The tacks should be on the outer edge of the stretcher. Then, on one side, pull back the canvas overlap about 50 mm (2 in.) to the left or right of the centre tack to a similar tautness and knock in another tack. Do the same on an adjacent side, then on the next and the next (a). Proceed to the first side and knock in another tack 50 mm (2 in.) further out, and so on until one half of each side is tacked up to the point where the mitreing starts (b). Then reverse the procedure and in this cyclical way tack the other half of each side. At every tacking or stapling you should pull the canvas back to a constant tautness. Canvas pliers (upholsterer's pliers) can be bought to make this work easier on the fingers. At this stage only the corners remain loose. At each corner, take the protruding corner of the canvas and pull it back over the stretcher until it is in line with the mitre junction. Tack it down on the back of the

(v)

(a)

(b)

107

stretcher on each side of this line. At each corner there will
then be two loops of canvas sticking up (c). These should
be folded down and superimposed on the secured canvas
corner, and themselves similarly tacked. A little practice
will secure the minimum of bulging canvas at each corner.
Practice will soon enable you to gauge the necessary pull to
obtain an even and unwrinkled stretch. An alternative
method is to tack out from each side of the centre as you
proceed round the stretcher. These are well-tried methods:
attempting to secure the whole of one side before moving
to another will amost certainly result in a wrinkled 'stretch'.

(c)

Wooden wedges are supplied with stretchers, or can be
bought in quantity. These are carefully knocked into the
inner gaps in the mitres, two to each corner, the right-angle
of each wedge facing outwards (d). But try to stretch your
canvas so that the minimum of extra wedging is necessary.

(d)

If I dwell on stretching, it is because it really is a necessary
simple skill to acquire. Buying ready stretched canvas is of
course the easiest thing, but is very expensive, and the
canvas of your preference is not always to be found ready
stretched. Nor will it always be primed as you prefer: to
the matter of priming and sizing we now turn.

Sizing and priming
Size is the layer of glue necessary to protect most supports
from the oil priming which is to follow, and prevents the
priming from sinking in.

The best size is made from rabbit-skin glue, but good
quality joiners' glue crystals will serve.

Size clippings or crystals should be melted down in clean,
warm (not boiling) water and stirred until completely
liquid. The best test of proportions of size to water is made
by letting the liquid become cold. At this stage it should
resemble a very light, shaky meat jelly, just, but only just,
solidified.

A firmly glutinous or hard jelly means too much size. The
object is to obtain a fine sheen of sized surface on the
support, not a hard skin of glue on top of it: this will easily
crack. The size should be applied warm and liquid, not too
hot, with a broad house painter's brush and allowed to dry
thoroughly. Wood panels and porous card may need more
than one coat, but rather too little than the danger of
cracking with too much.

With canvas one coat of the right consistency is best.
Properly, canvas should be sized and primed before it is
stretched, and this is how it is done professionally and
commercially. But this is not always feasible for the
individual. If you size a stretched canvas it is important to

do the stretching very lightly, as the drying of the wet size will itself shrink and tauten the surface, and may easily warp the stretcher besides straining the weave. In sizing stretched canvas I interpose strips of cartridge paper between the canvas and the stretcher during drying, as even with a bevel the canvas can easily become stuck to the stretcher piece. These strips should be removed as the canvas becomes taut.

It is often recommended that the dark varieties of hardboard with a strong content of oily resinous binder should not be sized, as the resin will repel the water leaving a non-adhesive skin of glue. I have found that a thin preliminary coat of primer (a subject we now come to) forms an adequate seal for most hardboards.

Primers

A primer is the undercoat of paint, usually white, on which the painting is made, and which prevents the brush marks sinking into the support. Since oil paint tends somewhat to darken with time in varying degrees and whites tend to 'saponify' or become slightly transparent, a solid white priming helps to preserve the key and brilliance of a painting.

The less oil there is in a priming the more absorbent it will be: on the other hand it will have less tendency to darken. The traditional priming pigment (for house-painters as well as artists) has been white lead, which has a solid strong body and does not crack as readily as zinc. Both have been largely overtaken by titanium white, which has shown itself to be highly inert and possesses a very strong 'cover' or opacity. It is also a very brilliant white. Unlike white lead it is not toxic. Titanium oil primers are generally obtainable, often made up with a 'thixotropic' jellified oil binding which has very quick drying powers. With all primers, old or new, the traditional rule holds good – three thin coats are better than one thick coat. A thick coat is not only susceptible to cracking but will form a surface dry skin with chemically wet paint remaining under it, the worst condition for a priming. Two or three thin coats, each left to dry, will in fact produce a quicker drying result, especially with modern primers, and a much stronger surface.

The artist can make up his own primings if he wishes, from absorbent half-oil to non-absorbent full oil: recipes are to be found in standard textbooks such as Doerner, Mayer and Hiler. But remember that while a hard panel will retain a 'chalky' ground with little oil, a flexible canvas needs a primer with enough oil content to prevent cracking.

Priming should be brushed on with a broad brush, each

layer brushed at right angles to its predecessor.

I recommend at least two layers: make sure the first is dry before applying the second. Surplus ridges and lumps of paint should be brushed out or lightly scraped down with a palette knife. If a smoother surface is required the whole final layer may be lightly knifed over. But it should not be flattened down to form a surface skin; this will delay the drying of the paint underneath.

It may be pointed out that a primed canvas can be pinned to a board and thus used by the landscape painter. The work can be stretched at a late stage when it is thoroughly dry. This can be expedient if the painter does not want to cart numbers of stretchers about on a painting trip: he must only remember to leave an adequate overlap for subsequent stretching.

Pigments

Good colourmen now provide catalogues explaining the actual content of their listed oil paints, and assigning greater or less permanence to each colour, and such literature should always be consulted.

What follows is a very basic list of suggested colours which may provide a jumping-off point, as it were, for greater invidual choice.

Whites

Flake white Made from white lead, it is very strong and is the best white with which to build up impasto, having a solid body. It is poisonous, and should not be used with French Ultramarine or Rose Madder.

Zinc white Intense, but has a bad reputation for cracking in oil.

Titanium white An excellent primer, and also an excellent painting pigment. Its disadvantage is that having such an intense cover a little goes a long way: it is apt to swamp tints, and this makes it less suitable than Flake for rich impastos.

Yellows

Lemon Yellow The best has a slightly greenish tinge.

The Cadmiums Worth paying the price for their clarity. Do not mix with Emerald Green or Naples Yellow.

Yellow Ochre A natural ferric pigment. A basically useful colour which will mix with any other. Variations are Brown and Golden Ochre. The last is more transparent.

Naples Yellow A very opaque pale earthy yellow.

Reds

The Cadmiums Orange, red, and scarlet. Very reliable,

though expensive.

Rose Madder A delicate crimson which is now made in 'permanent' form.

Alizarin Crimson Stronger than Madder: one of the oldest synthetic colours. May crack in thin glazes.

Light Red Like Yellow Ochre, this is a basically useful and permanent pigment.

Venetian Red Richer and usually darker than Light Red. Very powerful tint.

Indian Red Very heavy and opaque. Permanent.

Blues

Cobalt A pure permanent blue. Very useful.

Cerulean Of similar content, but greener. Useful but easily looks over 'pretty'.

French Ultramarine A rich blue with a reddish tinge. Does not mix with all pigments and should be used with care.

Monastral Blue An artificial pigment of greenish tinge. A strong 'Cyan' tint: one of several blues in this range of tints which have largely supplanted the technically suspect Prussian Blue.

Greens

Viridian Permanent pure cold green. Very useful and mixes readily to form a variety of other greens. Transparent.

Emerald Green (artificial) The original Emerald Greens are very poisonous. The artificial substitutes can be very useful for obtaining light strong opaque tints.

Terre Verte A very delicate traditional earth green. Transparent and useful for underpainting and drawing as its tinting power is very slight.

Browns, Blacks

The Umbers Raw and Burnt. Both useful permanent earth colours, the first cool, the second warm.

Burnt Sienna A brilliant red brown. Permanent.

Ivory Black Permanent. Dries slowly.

Lamp Black Also Permanent, but warmer than Ivory Black.

Violets

Cobalt Violet A pure delicate violet. Transparent and without much strength.

Mars Violet An example of the useful Mars range of colours. They are all permanent and of very solid opaque body.

The above is a very small selection: it is unlikely that a landscape painter would need more colours than these on

111

his palette, and he might be wise to make do with fewer. But he will not, of course, necessarily choose the same list. It is not necessary, however, to carry about tubes of tints which are simply mixtures of what the painter already has in his box. This is why, for economy and for weight's sake, it is worth consulting colourmen's lists.

I have omitted many of the newer chemical colours, some of great brilliance, not because they are necessarily suspect in permanence, but because their choice is so much a matter of personal taste.

Media
All tube paints already contain oil, linseed or poppy, and this must be borne in mind when adding more.

Linseed oil
The most generally reliable oil medium. Very strong. It is said to have a tendency to darken to a slight degree. In sun-dried form it is a quick dryer.

Poppy oil
Mixes readily with linseed. Held to be a somewhat slower drier, and is a useful vehicle in the tube.

Turpentine
A spirit made from distilled resin. It is an essential thinner, reducing the oily content of pigments and needed for thin underpainting. On the old principle of 'starting lean and ending fat', the presence of turpentine should be greater in thin underlying layers. Care should be taken not to overlay thick oily paint with turpentine washes; these will simply tend to sink in. Do not over-extend paints with pure turpentine: it is a solvent, not a binder. Use genuine distilled turpentine: 'turpentine substitute' is not a good substitute for the painter.

Petrol
An alternative to turpentine. It evaporates very rapidly, and is something of a fire hazard when stored. A very powerful solvent. I personally prefer turpentine. It is said that the additives in motor fuel petrol (gasoline) are injurious to some pigments.

Varnishes
These are used either as protective skins on dry paintings or as elements in painting media. Varnishes used on their own as media tend to become brittle and crack, though Copal Oil Medium is claimed to be sound.
Mastic, Copal and Damar are the commonly used varnishes. One or the other is best employed as a medium

in conjunction with oil and turpentine. Such mixtures are sometimes called *megilps*. They shorten the drying time of paint and help to retain the brilliance of tints. Both Mastic and Copal tend to shininess: a mixture of two parts linseed and one part Damar with appropriate addition of turpentine gives a quality of brilliance which avoids gloss.

Brushes
Oil painting brushes, like pigments, come in a greater variety of shapes and sizes than any one painter is likely to need.

Of this variety there are two main categories: hog hair and sable.

Hog hair brushes
Most oil painters use 'hogs' in some form as their normal brushes, using sables for fine detailed passages.

With all painting brushes, it is worth spending money on the best quality. Good hog brushes should be made of the finest bristle with its natural end preserved, not clipped into shape. Brush making is a craft; the bristles should be gathered, tied and set in their ferrules so that their natural curves form and preserve the shape of the brush.

Hogs are made in three main shapes, 'rounds', 'flats' and 'filberts'. I have always found that 'rounds' are enough for myself, doing their own job and that of the other shapes as well: but this is a matter of preference. Some 'flats' (square shaped brushes) are made of very short bristle: I advise the kind with bristles long enough to hold a reasonable amount of paint clear of the ferrule. 'Filberts' are set in flat ferrules, but are shaped to come to a point.

Sables
These are similar to watercolour brushes, except that they have long handles. Sables, too, are made up as 'rounds', 'flats' and 'filberts'. Cheap quality soft hair brushes, not much use for watercolour, are useless for oil painting. Sables are soft enough to preserve a paint and produce a fine, smooth stroke, but yet strong and springy enough to release the siccative body of oil paint.

Some painters prefer to work entirely with sables: again, a matter of preference.

All brushes, hog or sable, must be meticulously cared for and cleaned to preserve their life and shape. They should be cleaned after each session (certainly every day) in soap and warm water till the pigment is cleared out right up to the ferrule, otherwise they will soon take on a splayed shape. They should not be left resting point down in containers of media: long periods in turpentine will rot the bristle. If a

brush is left until the paint has hardened, it can be restored with a mild paint solvent: but this is to be avoided if possible by regular washing.

Other shapes of brushes for special purposes, such as riggers and blenders, are also made: the painter need not buy them as necessities, but only if he finds he cannot do without them.

Easels and boxes

The landscape painter must always remember portability: equipment must be carried.

Landscape and sketching easels are made in a number of forms. The best combine simplicity, lightness and strength. It is well not to sacrifice too much strength to lightness: nothing is more irritating than a wobbly easel, or one which blows over in the lightest breeze. There are some good, light, strong, metal tripod easels on the market: it is important with tripod easels, either wood or metal, that they should have an added bracing arm which holds the top of the canvas and will enable the landscape painter to tip the canvas forward from the vertical to avoid shine.

Of boxes, it need be said only that they must be a compromise between capacity and lightness, should have secure fastenings, and a broad handle: thin metal handles make painful carrying.

An alternative to separate easels and boxes, and one which I have always used, is the combined box-easel. This is widely manufactured in various forms and sizes. Essentially it is a paint box with a drawer, the container of which carries folding tripod legs and an expanding frame which unfolds vertically to hold the canvas. The canvas can be carried in this frame against the box when the legs are folded up. Box-easels are somewhat heavy, or rather they concentrate the weight on one handle, but this can be distributed on a shoulder strap. They have the great advantage of providing not only an easel and paint box, but also table space to the rear of the canvas, while the extended drawer can be used to rest the palette on.

Palettes

Separate palettes are an extra clumsy nuisance in landscape painting. Best are those which will fit neatly into the box or box-easel. They can be bought made of wood, plastic or metal: I have always found a square wooden palette the easiest to handle and the most sympathetic surface.

Other equipment

A canvas haversack is useful to hold any extras. I usually carry turpentine, oil and dipper in this instead of trying to

squeeze everything into the box. Enough palette rag should be carried in it. I also carry a tin in which brushes can be rinsed out in turpentine. Do not use the dipper holding your painting medium as a wash basin for dirty brushes.

A light sketching stool can be carried strapped to a box-easel: it is possible to carry all you need in this way and still have one hand free.

Acrylics

Acrylic paints have become an established medium over the last twenty years. They have much, though not all, of the property of oil paint. They are best regarded as a medium in their own right, and not as rivals to oil paint, In the tube form in which they are generally available they are most useful to the landscape painter; it is simply the best form in which to carry them. The equipment needed is not markedly different from that of oil paint as far as 'furniture' is concerned. The same range of easels, chairs, palettes and brushes serves. But of course there are differences in its use. On the simplest level acrylic resembles tempera in that it dries very quickly to an impervious surface.

While various media are used as thinners apart from plain water, they all dry so quickly and so hard that a constant watch must be kept on brushes and palettes. Brushes must be constantly and repeatedly washed and rinsed in water, and palettes must be rubbed clean frequently. Acrylic affords no latitude of the sort one expects from oil paint or watercolour.

The rapid drying of acrylic has its particular advantage for the landscape painter. Probably no medium, even water colour, allows the painter to work more rapidly. Acrylic has less 'body' and resonance than oil paint, and lends itself to the artist who wants a relatively flat and matt surface. Once established and dried, acrylic cannot be wiped off like oil, but the test of time by now suggests that technically the medium will accept the superimposition of layer after layer without harm.

Supports

Acrylic supports correspond to those of oil paint – canvas, board and so on. One of the attractions of acrylics is that not only do the paints dry quickly, but so do the primers. Supports primed with two or three layers of acrylic primer can be ready for use in twenty-four hours or sooner. Acrylic paints can be applied direct to any suitable support without priming: they can be, in effect, their own size and primer, though without a strong white undercoat it is probable that acrylic shares with oil paint the same risk of darkening over a period of time.

Suppliers

Great Britain
Art Base, 88 North Street, Hornchurch, Essex
Art Centre – Madonna and Gwent Galleries, 24 St Mary Street,
 Chepstow, Gwent
Art Shop (A Hughes), 30 Duke Street, Darlington, County
 Durham
Art Shop, 40 Castle Street, Guildford, Surrey
The Baker Street Art Shop, 54 Baker Street, London W1
Brentwood Arts, 106/108 London Road, Stockton Heath,
 Warrington, Cheshire
Burnley Drawing Office Services, 39 Hammerton Street, Burnley,
 Lancashire
Cass Art, 13 Charing Cross Road, London WC2 and 11
 Knightsbridge Green, SW1 and 2 West Arcade, Underground,
 Knightsbridge, SW1
Crafts Unlimited, 11–12 Precinct Centre, Oxford Road,
 Manchester 13 and 202 Bath Street, Glasgow G2
L Cornelissen and Sons, 22 Great Queen Street, London WC2
I Davey and Sons Ltd, 70 Bridge Street, Manchester M3 2RJ
Drayton's Art and Craft Shop, 103a Middle Street, Yeovil,
 Somerset
East Anglian Art Shop and Haste Gallery, 3 Great Colman
 Street, Ipswich, Suffolk
Fine Art, 25 the Broadway, Cheam, Surrey
Gough Bros, Bognor Regis Art Centre, 71 High Street, Bognor
 Regis, West Sussex
Fred Keetch Ltd, 48 Bridge Street, Taunton, Somerset
Langford and Hill Ltd, Graphic House, Warwick Street,
 London W1
Clifford Milburn Limited, 54 Fleet Street, London EC4
Miller's (Art and Craft) Ltd, 54 Queen Street, Glasgow G1 3DH
C and W Nicholson, 10 Bernards Wynd (off High Street),
 Lanark, Lanarkshire
Reeves and Sons Limited, Lincoln Road, Enfield, Middlesex
Reeves-Dryad Limited, 178 Kensington High Street, London W8
Richmond Art Centre, 181 City Road, Cardiff
Roberson and Company Limited, 11 Parkway, London NW1
George Rowney and Company Limited, 12 Percy Street,
 London W1

Spectrum, 20 Colemore Row, Birmingham, B3 2QD
Russell and Chapple Ltd, 23 Monmouth Street, WC2H 9DE
Winsor and Newton Limited, 51 Rathbone Place, London W1

United States
Arthur Brown and Bro Inc, 2 West 46 Street, New York, NY
 10036
A I Friedman Inc, 25 West 45 Street, New York, NY 10036
Grumbacher, 460 West 34 Street, New York
The Morilla Company Inc, 43 21 Street, Long Island City, New
 York and 2866 West 7 Street Los Angeles, California
New Master Art Division California Products Corporation, 169
 Waverley Street, Cambridge, Massachusetts
Stafford-Reeves Inc, 626 Greenwich Street, New York, NY 10014
Steig Products, PO Box 19, Lakewood, New Jersey 08701
Winsor and Newton Inc, 555 Winsor Drive, Secaucus, New
 Jersey 07094

See Yellow Pages for your nearest Artists' Colourmen

Index

poulet

POULET

More than 50 Remarkable Meals That Exalt
the Honest Chicken

by Cree LeFavour
Photographs by France Ruffenach

CHRONICLE BOOKS
SAN FRANCISCO

ACKNOWLEDGMENTS

This book is for my father and mother, Bruce and Pat LeFavour, and my sister, Nicole. I get so nostalgic about these three when I write about food. Maybe that's because it was with them—as a family we revolved around eating purposefully long before it was fashionable to do so—that I came to recognize the power of cooking, eating, and sitting down to meal after meal together. This recognition would be meaningless were it not for the family my husband, Dwight Garner, and I made for ourselves and our two children, Penn and Hattie. I have them to thank for many months of taste-testing the recipes in this book. They were always cheerful—even when, I suspect, all they really wanted for a change was a big fat steak instead of more *poulet*.

Many other people have applied their time, intelligence, and talent to the making of this book. Before anyone else, I am indebted to my estimable agent, David McCormick, for his unwavering faith in *Poulet*. David got the book long before it was a reality, and it was he who found its perfect match in Bill LeBlond at Chronicle Books. I thank Bill for having the vision to turn my manuscript into such a beautiful book. I'd also like to thank Sarah Billingsley for so gracefully seeing the manuscript through from its inception, and Carrie Bradley Neves for her meticulous editing. I'm also grateful for Sara Schneider's outstanding design and France Ruffenach's gorgeous photography.

Finally, thank you to my friends and family. There's nothing I'd rather do than sit down at the table for a meal with you and drink wine, smear butter on crusty bread, and talk, argue, and gesture until the carcass of a big roast chicken in the middle of the table is picked clean. Vegetarians not excepted, you know who you are.

Text copyright © 2011 by

— CREE LEFAVOUR —

Photographs copyright © 2011 by

— FRANCE RUFFENACH —

Library of Congress Cataloging-in-Publication Data available.
ISBN: 978-0-8118-7969-9

Manufactured in China

Designed by

— SARA SCHNEIDER —

Food styling by

— GEORGE DOLESE —

&

— ELIZABET NEDERLANDEN —

10 9 8 7 6 5 4 3 2 1

— CHRONICLE BOOKS LLC —
680 SECOND STREET
SAN FRANCISCO, CALIFORNIA 94107
WWW.CHRONICLEBOOKS.COM

TABLE OF CONTENTS

INTRODUCTION

— FLAVOR AND STYLE: —
MY KITCHEN TO YOURS

I wrote *Poulet* by cooking chicken the way I like to eat it, with the side dishes I dream about—lots of vegetables and salads and starchy profundities like potatoes, rice, and couscous. Anyone who has eaten my cooking more than once will see me in these recipes. Exotic curries, crazy-spicy soups, elegant French sauces—I'm there. You'll also recognize me by what's not in the book, notably, the absence of a lot of tedious instructions and fussy, unnecessary steps. Because dinner is always getting started later than it should at my house, I need to be efficient. I rely on great ingredients, simple techniques, and surprising combinations to make my food taste fresh and vigorous.

Think of the no-knead bread revolution that swept home baking in the past decade. You can get great flavor, an amazing crust, and a perfect crumb at home, as it turns out, without the fuss, bother, and time required to knead the dough, and without even covering it to keep the draft off. Bread-making didn't need to be so hard!

Along the same lines, cooking chicken, rice, or vegetables often doesn't need to be as hard as you may have thought, either. A lot of silliness has crept into recipes over the years—Rube Goldberg-like steps that make no sense for the home cook trying to get dinner on the table or deal out an awesome meal at a dinner party.

So think of what sounds delicious and cook it, whether it's a spicy Thai sandwich or a Japanese stew or a big pile of fried chicken. What I crave is all right here: bright, assertive flavors that come from spices like coriander, cardamom, cumin, and mustard seeds. I crave chiles of all kinds—sweet, hot, and a little of both. I crave butter, fresh herbs, the taste of raw shallots, and the spicy crunch of a radish. I crave perfect lettuce and the sting of green, unfiltered olive oil mixed with fresh lemon juice. I dream about crispy, salty skin clinging to fatty chicken thighs. You'll find all these things in abundance in *Poulet*. Producing big flavors is my ambition in the kitchen. Make it yours.

I grew up in a restaurant family that did a lot of traveling. My father was an accomplished chef who taught me—in the kitchen and at tables around the world—to be a fearless eater and an equally fearless cook. Food was always fun and always worth talking about in my family. I hope that ease and enthusiasm comes across in my recipes, inspiring your results in the kitchen to taste better than you thought possible.

A central part of the idea behind *Poulet* was to have it be appealing and useful to the loyal cooks who put dinner on the table

every night—specifically those countless devotees of chicken's versatility and afford-ability as a source of organic protein. With chapters organized to reflect how culinary traditions encompass broad geographic regions and the flavors that define them, I've interpreted combinations and appro-prated ingredients, kitchen styles, and traditions from Asia, Africa, India, Europe, the Americas, and the Middle East. Despite the title, the aesthetic that defines *Poulet* is American—we have a knack for absorbing, churning, and redefining diverse flavors and styles from around the world. From a spicy Sichuan Chicken Hot Pot (page 152) to the luxurious restraint of Truffled Roast Chicken (page 95) eaten slowly and washed down with an earthy Rhône red wine, *Poulet* has it all for chicken lovers—and that means wherever you come from and whatever you like to eat, you can cook it yourself, usually in under an hour.

Every recipe in *Poulet* is rooted in my belief that anyone can cook—and cook well. This conviction makes for an ideal marriage, in the kitchen and elsewhere, between the practical (what we know we can make) and the dreamy (what we want to eat but aren't sure we're up to cooking). Despite my desire for the fresh, the new, and the most deli-cious, I'm still very attuned to the prac-tical necessity of getting dinner on the table quickly amidst the chaos of crazy, overbooked lives.

A few words to keep in mind: Don't be intimi-dated by long lists of ingredients. In most of the recipes here, everything goes in one pot with minimal preparation and a method that will be familiar to many. I'm unapolo-getic about my basic adherence to simple French kitchen techniques; I like them because they work and because that's how I learned to cook. I've also worked to devise methods to make complicated flavors easier

to achieve, putting them within reach of beginners and everyone else who's pressed for time. If you can be vigilant about every ingredient, your food will show it. A lot of chicken recipes are hurt by less-than-fresh ingredients. Why use dried herbs, canned tomatoes, or frozen vegetables when you can do better—and without much more effort.

Whether it's summer or winter, a big dinner for eight or a weeknight family meal around the kitchen table, what we choose to eat is a growing part of how we define our place in the world. I see that world, and the wealth of flavors and ingredients in it, as a complex reality that can become—with the help of a good recipe, a sharp knife, and an engaged mind—the perfect meal. And that is what I hope will make *Poulet* a trusted resource in your kitchen.

— EATING SEASONALLY —

In rural Idaho in the early 1970s, I lived with my family on a dude ranch that we had transformed into a restaurant. We grew our own vegetables and herbs; raised chickens, pigs, and rabbits for slaughter; cured bacon; milked cows; made butter; and raised geese, goats, and ducks for their livers, milk, and meat. I slopped the pigs, milked the cow and the goat, plucked the freshly killed chickens, played with the baby rabbits, and collected the eggs from our flock of layers. I understand that fresh ingredients aren't a gimmick and that local, sustainable eat-ing is an ethical choice we make every day. The ingredients we use, when combined with simple kitchen methods and attention to detail, make the difference between just okay and surprising, memorable results. I know; not everyone is lucky enough to have access to the resources that make these

choices possible. There's not a Whole Foods on every corner. Do the best you can. Every little bit helps.

I support local farmers as much as possible. I go to the farmers' market, visit farm stands, and, whenever I can, I buy pork, chicken, and beef from small farms nearby. Do I buy bananas? Yep, and where I come from they are never in season and never local. But I don't buy berries flown in from South America in the middle of a January snowstorm, no matter how tempted I might be. Without being a fanatic about it, I believe that food is seasonal. I choose to eat fruit that grows closer to home in its proper season. Satsumas are to January what raspberries are to August—the perfect fruit.

These choices we make every day are political ones. They're driven by the conviction that we shouldn't be flying berries halfway around the world. In part, these are economic decisions; those January berries cost twice what they do in July. High-minded reasons aside, I choose not to buy raspberries that have been shipped halfway around the world because they often taste more like airplane food than fresh fruit. My reasons, then, are in turn pragmatic, practical, aesthetic, political, and purely whimsical. Perhaps the simplest answer is that I don't buy berries—or most fruits and vegetables—out of season because I so look forward to popping the first one of the year into my mouth. I'd hate to cheat myself out of that pleasure!

— SUSTAINABLE EATING: — SMALLER, ORGANIC, HUMANE-CERTIFIED PORTIONS OF PROTEIN

Americans eat too much meat. I'm definitely part of the problem—I've written not just this chicken book, but a steak book as well! I'm not apologetic about being an omnivore. I'd like to think I'm flexible but conscious of the choices I make when it comes to eating meat. I've kept a small flock of layers for more than a decade. They live a pretty happy life. I've killed and eaten a few especially aggressive roosters over the years— the kind that attack little kids right at eye level—because that's what you do if you keep livestock. I don't much like the process of slaughtering, bleeding, plucking, and eviscerating a chicken, but I think it would be a good thing if more of us were forced to look dinner in the eye before we ate it (at least once in a while).

— THE CHICKEN — REVOLUTION THAT IS *POULET*

If this book weren't called *Poulet*, I might have titled it, simply, *Thighs*. The thigh is dark meat at its most intense, flavorful best. Novelist Jim Harrison once wondered what happens to all the glorious thighs in America. All restaurants seem to serve is white meat. Do we send them all to Russia? he asked. "God, what I'd do for a plate of thighs," Harrison wrote. "You know, grilled

in *paillard* form with a sauce made of garlic that has been roasted with olive oil and thyme, then puréed and spread on the crisp thigh skin." I think Harrison would be happy to see all the thighs in this book—and not a boned breast in sight. Tired chicken recipes almost invariably call for boneless chicken breasts. Ask the chickens—they're tipping over from the weight of the giant breasts they've been bred to develop. To go with them, we're drowning in equally imbalanced and bland recipes: chicken *piccata*, chicken cordon bleu, chicken "Parm." If I never see another recipe for breast meat, never mind stuffed breast meat, I will die happy. Why eat breast meat when you can eat a thigh? Why?

When I'm not asking you to cook thighs, I'll be suggesting you cook a whole bird. Despite my dislike of breast-centric chicken recipes, I do love to buy a whole chicken, which (of course) happens to come with two breasts. As you might guess, writing a book like the one you're holding requires eating a lot of chicken. To prevent family mutiny, I needed to accommodate everyone. My daughter, Hattie, loves breast meat; my son, Penn, likes the Barney Rubble attitude of a leg; I confess to a weakness for crispy wings. (My husband, Dwight, is an equal opportunity chicken-part-eater.) A whole bird offers all these tastes and, as a bonus, provides a carcass for making stock. So when I call for thighs, feel free to cook a whole chicken cut into eight pieces (don't be daunted; see page 14)—or vice versa. Just please don't use a boneless breast.

— SHOPPING FOR — CHICKEN

WHAT THE LABELS REALLY MEAN

You want to buy a chicken that has lived its brief life behaving like a chicken—with plenty of room for scratching, flapping, pecking, grazing, preening, and roosting in and outdoors. Chickens raised this way taste better and are healthier to eat. Besides, looking for birds that have lived what I call "a chicken's life" makes good ethical sense.

Short of raising your own or buying your chicken from a local farmer at the farmers' market, the best chicken you can buy is both Certified Organic and Humane Certified. It's also air-dried. Once you read through what the various terms really mean, you'll understand why you don't, unless you have to, want to look the other way and settle for a "natural" chicken. If you can't afford to buy Certified Organic chicken, spend extra on an antibiotic-free Humane Certified bird. It's a significant step up from "natural."

Here are brief explanations of the various claims you'll see on supermarket and natural-foods market poultry labels, along with tips on which words to look for if you want to find the tastiest, healthiest, most ethically raised chicken.

FREE-RANGE VS. PASTURED VS. GRASS-FED: Unfortunately, these terms are defined by the United States Department of Agriculture (USDA) in a way that makes them fairly useless to consumers. For example, a "free-range" chicken must simply be given access

to the outdoors with no stipulation as to density or the ratio of birds to outdoor space. As you might guess, an open door to a cement slab used by thousands of chickens does not amount to the bucolic ideal of a scratching, grazing, happy chicken hunting and pecking under sunny skies.

"Pastured" and "grass-fed" are not legally defined terms. That means that by definition these claims are not verified or certified by a third party. If you want a chicken that has been outdoors, you'll need to find a producer you trust or buy a Certified Organic chicken. This is the only label that guarantees a chicken has meaningful access to anything that can rightfully be called pasture.

NATURAL
This label means that a chicken has not been injected with artificial colors, flavors, or other ingredients and that it has been "minimally processed." But it's essentially a worthless designation, since it does not reflect a chicken's living conditions, antibiotic use, access to pasture, or the quality of its feed! You don't want to cook and eat a chicken that has lived its brief life in a crowded, dusty, dimly lit battery of 20,000 birds while being fed antibiotic-laced feed. Conditions for industrial chicken production in the United States aren't healthy for you nor humane for the chicken. Don't be a part of this broken system. Eat chicken less often or eat less of it when you do have it, if you must, so that you can afford to buy better-quality chicken.

USDA PROCESS VERIFIED
Don't be fooled by this label. It's essentially a marketing gimmick meant to confuse consumers into thinking that "cage free" means "free roaming." It doesn't. These chickens are raised and processed just like the "natural" chickens. The only modest improvement guaranteed by this label's claim of an "All Vegetarian Diet" is that chicken feathers and other animal by-products have not been added to these chickens' feed. Let's just say it's an underwhelming improvement.

NO ANTIBIOTICS
The claim that chickens have been raised without the use of antibiotics—which in theory promotes growth and prevents disease—is regulated by the USDA. That means producers who label their chickens "antibiotic-free" must submit documentation to the USDA to prove their claim. If I can't find an organic chicken, I look for this label. Raising chickens without antibiotics requires healthier conditions, period. This is a big step in the right direction.

RAISED WITHOUT THE USE OF GROWTH HORMONES OR STEROIDS
The term "hormone-free" is not allowed by the USDA because it is in fact against the law to feed growth hormones or steroids to chickens. Labels must make this clear if they mention growth hormones.

CERTIFIED ORGANIC
Who wouldn't want to put an organic chicken—or two—in their grocery cart upon hearing the USDA's definition of "organic" as a set of "cultural, biological, and mechanical practices that foster cycling of resources, promote ecological balance, and conserve biodiversity"? We all want to do the right thing when it comes to the food we buy and eat. When it comes to chicken, Certified Organic is a good start. From the second day of its life, each chick destined to become a Certified Organic broiler is fed

pesticide-free organic food, given age-appropriate access to the outdoors (until they feather, chicks must be kept cozy indoors), sunshine, fresh water, shade, and the other accoutrements of a chicken's life. In addition, organic poultry must be processed in organic-certified slaughterhouses. Best of all, these claims are certified by a third party. You're getting what you pay for.

HUMANE CERTIFIED

When you see this label, you can be assured the chicken you're about to eat has been far more humanely treated than its unfortunate cousins without the label. With plenty of space to move around, clean litter, access to roosts, fresh water, and wholesome (although not necessarily organic) food, these birds live a pretty decent existence. In addition, you can be assured that the chicken was transported and then slaughtered in a way that causes the least trauma and suffering. The Humane Certified label does not require that birds be given access to the outdoors, but even indoors, they are kept in coops with adequate light and fresh air. Humane Certified chickens are worth looking for; when combined with the Organic Certified label, this is the gold standard for commercially raised chicken.

FARMERS' MARKETS

The chicken you buy at a farmers' market isn't going to carry any label at all. But what you are buying is usually a chicken that has been raised on a much smaller scale, most likely with access to pasture, weeds, bugs, and plenty of fresh air and water. Because of its diet, this chicken will have more flavor than intensively farmed birds; it might also be a little tougher because of all that exercise. Perfect for a braise left in the oven just a little past what you might normally think of as done.

KOSHER

When it comes to chicken, *kosher* is an indicator of how the bird was slaughtered and processed. According to Kashrut, or Jewish dietary law, chickens must be quickly and humanely killed by hand and all blood must be removed from their flesh. As Joan Nathan explains in her classic book *Jewish Cooking in America*, "to rid the animal of blood after the kill, the meat is put through a process called *melihah*, which consists of first soaking it in water for one half hour and then covering with coarse kosher salt for one hour." Kosher chicken is, as a result, saltier than non-kosher chicken. I find kosher chicken very tasty—in no small part because of the salt—but keep in mind that Jewish dietary law does not specifically govern the use of antibiotics, access to pasture, or quality of feed. If you're planning on making a sauce with drippings from a kosher chicken, take the salt content down a notch by rinsing the chicken before you cook it.

AIR-CHILLED VS. WATER-CHILLED CHICKEN

To defeather a chicken, you usually dip it in scalding water, a process that opens up the follicles so that the feathers can be more easily plucked. (I've done it—it's an essential if unpleasant step.) Afterward, the chicken is quickly cooled to control bacteria. Most of the chicken we buy has been chilled in a water bath—that is, chilled in an icy soup of water and chlorine. This seems like a bad idea. Not only does bacteria that might have contaminated one bird mix with the other birds in the bath, it means the chicken that ends up on your plate has absorbed some of that chlorinated water and lost some of its own juices.

The smarter, better way to cool a chicken is to air-chill it. This keeps any bacteria from spreading while allowing each chicken

to maintain the undiluted integrity of its own juices. It also makes for a crispier skin when it comes out of the oven. Look for brands that air-chill their chickens—it's a bit more expensive but increasingly popular with consumers, so you'll usually see it advertised. As much as the poultry industry doesn't want to hear it because of the expensive equipment required, there is a definite difference in flavor and texture between air- and water-chilled chickens.

WHAT'S IN A NAME?

COMMERCIAL MEAT BIRDS
The chicken you buy at the supermarket is usually some variation on what are known as Cornish Rock, Cornish Cross, Plymouth Rock, White Rock, or Leghorn breeds. That supermarket chicken might also be simply—and a little scarily—designated by an industrial number. These breeds have been selectively bred over decades to pack on the pounds like sumo wrestlers, efficiently converting every calorie of feed they consume into body weight—in proportions that would do Dolly Parton proud. Chickens bred to mature so quickly with such large breasts do poorly if allowed to live beyond their limited life span. As a kid on our ranch in Idaho, I remember raising these behemoth Cornish Rocks for meat. Under the most pampered conditions, these birds went lame as they outpaced the strength of their own legs, prompting our ranch hand, Hester, to humanely kill more than a few.

BROILERS, FRYERS, ROASTERS, AND CAPONS
Most of the chicken we buy is only about a month and a half old—49 days on average. That means tender chicken, no stewing required. Commercial chickens are bred to put on weight quickly and efficiently.

Chickens slaughtered at 6 to 7 weeks of age are sold as "broilers" or "fryers." "Roasters" are slaughtered at the ripe age of 10 to 12 weeks. They can weigh more than 10 lb/4.5 kg—I've seen some that could give a small turkey a fight. A "capon" is a male chicken neutered before sexual maturity—the castrato of the chicken world. A capon lacks the rooster's drive and energy, growing very large (up to 15 lb/6.8 kg) and very fat in the 3 to 4 months before slaughter. It's worth noting that caponizing is not allowed in Humane Certified production. The process is much less common than it used to be.

CORNISH GAME HENS, SPRING CHICKENS, POUSSINS, AND COQUELETS
It's a stroke of marketing genius to call a young Rock-Cornish cross a "game hen." What is that diminutive bird? Just that—a very young male or female chicken, slaughtered before it's 30 days old and weighing somewhere around 2 lb/910 g. In Great Britain (and sometimes in the United States), you'll find these young, small, breast-heavy chickens sold as "poussin" or "coquelet." Feel free to use "game hens" by any of these names in place of a standard chicken in any recipe. They are excellent. Just remember to adjust the cooking time according to size.

SPECIALTY BREEDS
As the public demand for better-tasting chicken grows, the diversity of chicken breeds raised for meat will grow, too. The chicken of all chickens is the famed French *poulet de Bresse*. (The only A.O.C., or *appellation d'origine contrôlée*, chicken, this bird can only be raised in the Bresse region of France.) Efforts have been made to duplicate the succulent *poulet de Bresse* in England and the United States. Look for a knock-off called Poulet Bleu, or Blue Foot Chicken.

Specialty markets, butchers, and farmers' markets also sell less common breeds, including Poulet Rouge, Barred Rocks, Jersey Giants, and Silver Wyandottes. These older varieties are the Kate Moss or Agyness Dynes of chickens—you'll be surprised at how long-legged and modest at the breast they are when compared to most commercial broilers.

FOOD SAFETY AND CHICKEN

Don't fool around with food safety when it comes to chicken. Even the most pampered chicken can be infected with dangerous bacteria, including *E. coli*, *Listeria*, *Salmonella*, and *Campylobacter*. Here's what you need to know.

First, think carefully before you rinse your chicken. Rinsing doesn't so much remove the bacteria as potentially splatter it around the kitchen. I never rinse air-chilled chicken. If you do have a traditionally processed, non-air-chilled bird or a kosher chicken, you might carefully put it under a stream of cool water in the sink. Be sure to dry it carefully afterward.

Always use soap and water to wash all surfaces and utensils that touch raw chicken. This includes the plate you used to carry the chicken to the grill or barbecue and the tongs you use to turn the chicken while grilling. Third, cook your chicken to 160°F/71°C to safely kill all bacteria. Use a digital thermometer to be sure (see "Knowing When It's Done," page 17, and "Notes on Equipment," page 20).

FRESH, RANCID, OR SOMEWHERE IN BETWEEN?

As Harold McGee, the guru of food science, explains in his book *On Food and Cooking*, unsaturated fats, like those in poultry and fish, are broken down by light and oxygen much faster than the saturated fats in beef. This chemical process results in "small, odorous fragments that define the smell of *rancidity*." Worse, it isn't just light and oxygen that will turn your expensive chicken into a putrid mess. As he puts it, "bacteria and molds break down cells at the meat surface and digest proteins and amino acids into molecules that smell fishy, skunky, and like rotten eggs."

If that's what chicken should *not* smell like, what does fresh chicken smell like? Really fresh chicken smells of nothing so much as air—it smells clean; it's *odorless*. No matter the date on the package, use your nose to decide how fresh what you're about to eat really is. I get right up close and take a good sniff. If I don't like what I'm getting—if I smell ammonia or a trace of an "off" scent—out it goes. Who doesn't have a box of pasta sitting on the shelf for just such a crisis? If you aren't certain or have never smelled rancid chicken, feel the meat. That slippery feel is the feel of bacteria and their by-products; it is not the feel of your dinner.

STORING CHICKEN

Don't leave uncooked chicken out on the counter for long periods or let it sit in a hot car. Keep it cold until just before you're going to use it. (I do ask you, in the recipes here, to let your chicken sit at room temperature for a half hour or so before cooking, to take the chill off, or "temper" it, but this is not the same as being careless with it before you use it.) Store your chicken for no more than a few days, depending on the packaging, sell-by date, and where it came from. It should be in the coldest part of the refrigerator, tightly wrapped in plastic wrap. Do be sure to set your refrigerator to a temperature lower than 40°F/4°C. Meat actually keeps best at close to 32°F/0°C.

If you buy frozen chicken, keep it for no more than two months. After that, you may begin to get rancid flavors, and you will certainly have a diminishment in the quality of the texture. Never refreeze chicken once it has been thawed.

THAWING CHICKEN

When thawing a frozen chicken, do it in a bath of ice water on the countertop. Water conducts heat much better than air does, speeding up the process to a manageable afternoon job. (Yes, it would be considered heat if the chicken is well below freezing.) Never thaw a chicken by setting it out on the kitchen counter. The bacteria will happily reproduce on the warm exterior while the interior remains frozen solid. If you don't use a water bath, thaw your chicken in the refrigerator. Just know that it'll take more than 24 hours.

— HOW TO PREPARE — CHICKEN FOR COOKING

HOW TO CUT UP A WHOLE CHICKEN

You knew we'd get to this eventually, right? Okay, let's do it together. Cutting up a whole chicken takes minutes. Don't be intimidated! What's the worst thing that could happen? You might end up with a breast that has a few cuts in it. And . . . so what?

What you need, above all, is a sharp knife. If you don't own a knife that's sharp—if you tap it on your thumbnail, it should put a ding in the nail—then you might

want to get one. (For my favorite solution for dull knives, see "Notes on Equipment," page 20.)

Begin by setting the chicken breast-side up on the counter. Grab a leg and, with the knife in your other hand, cut around where the thigh meets the body, lifting and turning the whole chicken as you work. Feel for the joint way in against the body. If you can't feel it, give it a little twist when you've cut almost all the way around, and you'll hear the joint pop. You might even see it stick up through the meat. Cut through it and any last bit of skin and the leg and thigh will be free. Now cut off the wing, using the same method of cutting around it at the base, working your knife as close to the body of the chicken as you can go. Do the second thigh, leg, and wing before you tackle the breast.

You'll be cutting the breast meat off of either side of the breastbone. To do this, cut straight down just to the side of the breastbone. Once you're through the skin, keep your knife as close to the center bone that the breast meat is attached to as you can. Rather than sawing at it, use quick, small motions to detach the breast meat from the bone and cartilage. Your goal is to get as much of the breast off the bone as possible without shredding the meat. As you work, you'll see the breast come away from the carcass. You'll know you're finished when your knife hits the cutting board. Slice through the last bits of skin, retaining as much of the skin and pink flesh as you can. Repeat with the second breast half, cut the legs from the thighs and you're done. See? That was easy.

HOW TO BUTTERFLY A CHICKEN

A chicken that's been butterflied (or "spatchcocked") lays flat on the grill. To do this,

cut all the way through the cartilage on either side of the vertebrae so that you can remove it along with the wishbone at the breast. To do this, you'll need to slice around it and pull. Break out the legs by flattening them or by simply twisting them until they snap. When you're done, you should be able to open your chicken like a book; press down on it gently until it will lay flat on the grill, unweighted.

BRINING

Salt is critical to flavor. The time-tested and trendy technique of soaking poultry in a solution of salt with water or beer or cider or myriad combinations, plus herbs, spices, and aromatics like thyme, bay leaf, peppercorns, and onion, does get the salt and other flavors into the cells of your chicken. Some cooks argue that soaking equals loss of crispness for a brined bird. I don't think this is a significant factor and I wouldn't let it deter you from brining your chicken if that's what you want to do. Having said that, I tend to roast my chickens without brining only because I don't usually plan far enough in advance. If you do, great—brine away! Use the brine recipe for my Edna Lewis-Inspired Fried Thighs on page 48; it's a classic, versatile blend of sugar, salt, and herbs.

DRYING

A kitchen rule to live by: Meat of any kind needs to be dry before it will brown. So, if your chicken feels wet or if you've decided to rinse it, use a couple paper towels or a clean kitchen towel (put it in the wash right away) to pat the chicken dry before you cook it.

BROWNING

When chicken reaches a high enough temperature to turn that lovely, nutty brown, it's not just good looking—it's also delicious. Chicken that has undergone high-temperature heating does more than caramelize, it undergoes what is known as the Maillard reactions, a set of exchanges between a carbohydrate molecule and an amino acid. These reactions, responsible for the flavors of bread crusts, coffee beans, and dark beers, as well as perfectly roasted chicken, carry flavors that are chemically identical to caramel, sherry, butterscotch, roasted nuts, and chocolate, to name a few. When you bite into the browned exterior of a chicken thigh, you're tasting those amino acids, sugars, and other chemical compounds (not to mention the fat) that have been transformed into molecules your tongue and nose will read as rich and complex beyond words. In fact, that flavor you can't get enough of is rich and complex beyond science. We haven't even identified the wild mix of chemicals that make up the flavors in browned chicken, but we do know that they're irresistible.

TO TRUSS OR NOT TO TRUSS?

A trussed bird is a pretty sight. It looks neat and professional. But do you need to truss a whole chicken before roasting it? Not really. You might argue that by tying the chicken's legs tight to the side of its breast, you give some cover to the breast, allowing it to cook more slowly and stay moist in the hot oven. Maybe. But the truth is that tying the legs and thighs tightly against the body of the bird will slow down the cooking of the thighs by inhibiting the circulation of air around them; and, as anyone who has ever roasted a chicken knows, the thighs are the last part of a chicken to cook. I don't truss my chickens, there's no need for you to do it, either.

When you're reading my recipes and I ask you to brown the meat before you proceed to cook it, I'm not being pointless or fussy—I'm trying to make sure your food is as delicious as it is beautiful.

— COOKING METHODS — FOR CHICKEN

GRILLING

As much as I worship a perfectly roasted whole chicken, the virtues of a smoky, crispy chicken thigh fresh off the grill has a primal appeal that's difficult to surpass. I believe in grilling chicken slowly to get a gorgeous, crispy skin and a perfectly done interior. If you put a thigh on a very hot grill, you will sear the skin immediately, the outer layer of the meat will cook very quickly, and before you know it, the skin will be burned but the interior will still be raw. Take your time, enjoy the air outdoors, and your chicken will be perfect.

Know your grill. I cook over a wood fire and I've learned what works—from moving the chicken around to avoid flare-ups and hot spots to adding tiny sticks when the fire begins to die. A few pointers: No matter what kind of grill or barbecue you're using, make the fire on one side or in a ring around the edges or light one side of a gas grill and cook the chicken over indirect heat. It will take longer but taste better in the end. Close the lid on your grill if you need to—whatever you do, don't turn your back and blacken that delicious skin. Your fire is definitely too hot if you can't hold your hand right at the level of the grill for 3 seconds without moving it away from the heat.

Hardwood charcoal, like actual hardwood, will give your meat that irresistible smoky flavor. Gas is convenient but you have to work harder to get real wood flavor. (Soaking hardwood chips in water and setting them in an aluminum foil pan in a corner of the grill to smoke is one method.)

ROASTING

Roasting a whole chicken is a deeply satisfying act. Unlike so many things in the kitchen—or in life—the rewards far exceed the effort required. From the lovely fragrance that fills the air to the crispy, salty skin and succulent meat, setting a whole roast chicken on the counter to be devoured by an eager crowd is an experience not to miss.

A 12-in/30-cm diameter or larger cast-iron frying pan or a 5-qt/5-l or larger Dutch oven is perfect for roasting chicken. Why not a roasting pan? Because all the drippings and all the moisture from the chicken dry up and burn in a roasting pan's wide-open bottom. Unless you're cooking two chickens at once, or a turkey, I see no reason for such a jumbo-size pan.

When you roast a whole chicken, you have a problem: the breast cooks faster and is done sooner than the thigh or leg. Why? Not just because it's exposed to the dry heat of the oven without obstruction, but because the breast is leaner and its texture is so different from dark meat that it tastes done and feels done at 160°F/71°C—a full 15°F/9°C less than it takes for the dark meat to taste and feel cooked. What this means for you as the cook is that the minute the thigh is cooked you need to get the chicken out of the oven, because your breast meat was almost certainly done cooking some time ago and is now becoming drier by the minute. One of the ways I get around the problem is by braising

a whole chicken (see the following section). As hard as it is to come by, perfectly cooked breast meat is a pleasure—juicy, tender, and slightly pink. Do what you can to get it that way.

BRAISING

For braising, or slow cooking in the oven with liquid in the pan, you'll want an extra-large cast-iron frying pan or a large, wide-mouth Dutch oven like I recommended for roasting. Be sure your pan has sides high enough to hold 3 to 4 cups/720 to 960 ml of liquid.

As you move around this book, you'll be doing plenty of braising—using fragrant, spicy liquid in the oven to cook the chicken on the bottom while the top gets blasted by the circulation of dry heat, crisping up the skin to lusty brown perfection. This is a simple method for cooking all kinds of chicken. You get a terrific sauce with no effort and tender, plump chicken, and all it involves is putting the pot in the oven. I'm a huge fan because it's so easy and the results are stunning. If you choose to braise a whole chicken instead of roasting it, because the pan liquid conducts heat far more efficiently than air, it speeds up the cooking of the thighs, giving you a more evenly matched cooking time with the breast—the thighs will be fully cooked and the breast will still be tender and juicy. That's chicken nirvana.

FRYING

It's a nice idea to have an electric deep fryer if you're frying often, because you know it can take the heat and the thermometer is built in. But the truth is, I don't use mine all that often. I prefer to use a large Dutch oven filled just one-third of the way up with oil. A big pot holds more oil and more chicken per batch. Dragging the fryer out, setting it up, and cleaning it constitute the sort of kitchen hassle I try to avoid.

Frying is messy and uses a lot of oil, but it's worth doing if you love fried chicken—and who doesn't? Keep your oil very hot (365°F/185°C) and keep a lid ready in case you have a flare-up. (Never put water on a grease fire—it'll just spread the flames around.)

Buy smaller pieces of chicken when you're frying. They cook faster, yielding cooked-through chicken with a golden brown crust.

KNOWING WHEN IT'S DONE

All chicken must be cooked to a temperature of 160°F/71°C to kill food-borne bacteria. An instant-read thermometer, preferably digital, is the easiest way to tell if you've reached this safety zone—but it's not the only way. Happily, breast meat is not only safe to eat at 160°F/71°C, it's also perfectly cooked at that temperature. Try to cook your breasts to *just* done or precisely 160°F/71°C. (If you're confident, take them off the heat at 155°F/68°C, since the temperature will rise just enough as the chicken rests.)

Unfortunately, judging the doneness of dark meat is more complicated. While it's safe to eat at 160°F/71°C, it needs another 15°F/9°C or even 20°F/11°C to reach the texture most of us experience as fully cooked. If you have an instant-read thermometer, you want your thighs to come in somewhere around 175°F/80°C. There is plenty of variation in how people like their chicken—most people like it well-done. I prefer it a little wet at the bone. Cook it the way you like.

If you don't have a thermometer, judging doneness is a little trickier. I have two words for the anxious: look and feel.

LOOK:

Dark meat is underdone when its juice runs bloody, when it appears bright pink, and when it has a slippery (raw) texture at the bone. When a piece of chicken is done, the juices that run out when you insert a knife into the thigh should run clear, not red or pink. The meat of a perfectly cooked breast is ever so lightly pink at the center, but the texture there will be granular, not smooth or slippery.

FEEL:

Cooked chicken thighs have a bouncy give when you poke them, they are not squishy. Fully cooked breast meat will feel *just* soft but it won't have much movement or resilience when you poke it.

> ### NOTE ON OVEN TEMPERATURES AND COOKING TIMES
>
> As much as the cooking times printed in a recipe are a comfort to the cook, keep in mind they are only loose guidelines. When it comes to estimating how long it will take to, say, roast a whole chicken, there's inevitably going to be some judgment required on the cook's part. Why? To begin with, your oven is different than my oven—it might be a convection oven, in which case it will cook everything faster, or it might be an over-the-hill electric oven in need of a retirement party, in which case it will probably take longer to cook your chicken. What about the size of your chicken and its temperature when you put it in the oven? It's different every time, of course. Whatever the size, your chicken starts its cooking at a different temperature every time depending on how long it's been sitting out and how warm the room is where it sat out. So don't blindly rely on the cooking times I give; go by look, feel, and smell and you'll know when it's time to eat.

CARVING A WHOLE CHICKEN

If you can cut a whole chicken into eight serving pieces before you cook it, you can carve a whole cooked bird beautifully. It's all about knowing where to cut and what kinds of pieces you're trying to create. To get the meat off the carcass efficiently and in neat pieces, use a sharp knife—you want to cut, not shred, your chicken. Begin by cutting deep into the base of the bird's body to remove a whole leg quarter—the leg and thigh—together. Cut the leg and the thigh apart and then again cut in deep to remove the wing. Repeat on the other side. When you carve the breast, first consider the size of your bird. For a big chicken, cut each whole breast off the bird in one piece, lay them down on the cutting board, and then carve into slices. However you cut the breast, don't leave those delicious little fillets, or "tenders," tucked under the breastbone. They, along with the nubbins on the very bottom of the chicken, are the best parts!

— YOUR PANTRY —

At the start of each chapter in this book, you'll find a summary of key items you'll need to have on hand to accompany the food of that region. Your ease in finding these ingredients depends on whether or not you have well-stocked food stores in your neighborhood. If you don't, there's always that great shopping mall in the sky (the Internet) or even good old-fashioned mail order. If you live somewhere where the shopping isn't great, ordering is an easy way to get what you need in almost no time.

Whatever you're cooking, there are some basic items you'll want to have on hand.

SALT

I go relatively easy on the salt in the recipes here and then sprinkle a pinch of flaky salt on top of the food before it goes to the table. Home-cooked food has relatively little salt, so this decision is a matter of taste. I like this method because everyone has a different feel for what is too much or too little salt. I would caution you not to undersalt your food—it's a common home-cook mistake.

I use kosher salt for everything but that finishing pinch before serving—which I invariably call for. For the salt that goes on top of food, I like to use flaky salt. Maldon sea salt from England and the gray sea salt from France called fleur de sel are my favorites.

OLIVE OIL

Olive oil is a crucial ingredient in my kitchen. I keep two grades on hand at all times. The first is my casual cooking oil— less expensive extra-virgin olive oil. For salads and drizzling on vegetables, I keep a bottle of special olive oil on hand. This good stuff is usually estate-bottled oil, with a date on the label.

PEANUT OIL

I call for peanut oil (called "groundnut oil" in the United Kingdom) in many recipes that require high-temperature cooking like frying, grilling, or browning. You can substitute vegetable oil if you like.

SUGAR AND SPICE

I'm a big advocate of using whole spices. If you're like a lot of people, your spices are probably hanging around a spice drawer a lot longer than they should. Heat is crucial to getting the most out of your spices—it releases their flavor and fragrance. That's why there's a lot of toasting, roasting, and frying of all kinds of spices in this book.

I call for a range of sugars in my recipes. I prefer raw sugar for most applications because it has a rich, caramelized flavor. Also, it's not bleached, a chemical process that is less than desirable when it comes to anything edible. (Unbleached flour, for the same reason, is preferable to bleached.) Palm sugar is traditional in Asian cooking, but because it's so hard to find I often substitute raw sugar.

A WORD ON STOCK

One of the things I was told early in the process of writing *Poulet* is that most people won't go to the trouble of making their own stock. It overwhelms them, and no matter how heartily you cajole, entreat, or beg—they just won't do it. Okay. I won't spend my time lecturing. Instead, I'll beg you not to use store-bought stock that contains MSG or its various yeasty, malt- or soy-derived cousins. (Even the innocent-looking organic stocks sold in a carton often contain yeast extracts.) The problem is, they impart *too much* flavor, and of the wrong kind. Think canned soup, processed tortilla chips, or mediocre Chinese food. You don't want this flavor in the food that comes out of your kitchen. So if you're not going to make your own stock, just use water. (Yes, water.) Your recipes will turn out fine with all those spices and the chicken juices to impart flavor. Most important, the food you cook will taste infinitely fresher and better for the absence of that manufactured chicken flavor.

— NOTES ON EQUIPMENT —

LARGE CAST-IRON FRYING PAN OR DUTCH OVEN

Many of my recipes call for an open-braise method that keeps the chicken skin crisp while cooking the meat in a rich liquid. I cooked many of these recipes in a 12-in/30-cm cast-iron frying pan. These pans aren't expensive, they're super durable, and they hold the heat beautifully. Besides, they're easy to clean (don't fuss—a little soap and hot water will not damage well-cured cast iron). If you use a frying pan to braise, be sure the sides are high enough to hold the chicken along with as much as 3 cups/720 ml of liquid.

When I'm not cooking in my trusty frying pan, I am usually using my big, beautiful 5-qt/5-l enamel-coated Dutch oven. Plain cast-iron is terrific for Dutch ovens too, but I confess I do love the enamel-coated variety for the simple reason that they're pretty (mine is that wonderful classic burnished orange) *and* useful. Whichever pot or pan you use, it is crucial that a whole chicken not be touching the sides. If it is, there's not enough room for the hot oven air to circulate, which is how your skin crisps and browns.

SPICE GRINDER OR MORTAR AND PESTLE

As charming and useful as they are, the mortar and pestle is a rare item in the modern American kitchen. If you don't have one, consider buying a spice grinder or dedicating an old coffee grinder to the job of grinding your spices. If you have neither, you can always wrap your spices in a clean dish towel and crush them with the side of your biggest knife or any heavy, unbreakable object (such as a small cast-iron frying pan or a meat pounder) you happen to have handy. (See "Toasting, Crushing, and Grinding Spices, Seeds, and Nuts," on the facing page.

INSTANT-READ THERMOMETER

A thermometer with a digital display that gives you an almost instantaneous reading is one of the handiest tools you can own. From being sure your chicken has exceeded the food-safety threshold of 160°F/71°C to testing to see if your thighs are almost done (175°F/80°C), you'll get a lot of use out of this gadget.

FAT SEPARATOR

When you're trying to get as much of the fat out of your delicious braising liquid as you can, a fat separator is useful. This ingenious gadget has a spout that takes liquid from the bottom of the container, allowing you to pour the bottom juices out and avoid the fat, which rises to the top. You can do without it, but having one will make your sauces cleaner and you'll speed your way past the tedious scooping and careful pouring that are required without one.

KNIFE SHARPENER

Alas, in most places it's very difficult to find a professional knife sharpener. If you, like most people, lack this service in your area, be assured that you can do it yourself. I'm not a fan of the electric knife sharpeners sold at gourmet stores; I like sharpening stones that can be bought straight from the manufacturer. I got my whetstone from DMT in Arkansas (www.dmtsharp.com). Just be sure to follow the provided instructions word for word.

— NOTES ON TECHNIQUES —

HOW TO BLANCH AND PEEL SHELL BEANS

All shell beans and peas are encased in a pod that breaks away easily. But with some larger bean varieties, the individual beans inside the pod are in turn encased in a kind of hull, or inner skin. Most of the fava beans you buy will need to be relieved of this skin; very large lima beans will as well. Here's how I handle shell beans: First, find some extra hands, and get them to work opening all the pods to collect the individual beans inside. Meanwhile, prepare a big bowl of ice water and bring a pot of water to a boil. When all the beans are shelled, dump them in the boiling water. Wait for the water to return to a simmer, then drain the beans in a colander and transfer immediately to the ice water to stop the cooking. Gather those hands around again and peel off the outer hull of each bean. Now they're ready to cook, but remember, they're already halfway there!

TOASTING, CRUSHING, AND GRINDING SPICES, SEEDS, AND NUTS

Many recipes call for toasting spices, seeds, nuts, and coconut because their taste comes alive when heated. This is because they're full of both flavorful oils and complex chemical compounds that are released when heated. (All that oil also means they go rancid quickly—keep all your nuts and seeds in the refrigerator.) You can easily smell and taste the difference between untoasted and toasted nuts, seeds, and spices, so don't be lazy—the process couldn't be simpler.

I tend to do all my toasting in a cast-iron pan right on the stove top. That way, I run less risk of burning because I can see the subject—once again, all that oil makes these items very easy to burn. One key to fail-safe toasting when you're in a busy kitchen is to heat the pan first. Once it's so hot that a drop of water sizzles in it, throw in your nuts or seeds and *stand there*, stirring or swirling the pan around until you can smell them. Once you can smell them, and in some cases see them starting to change color, get them right off the heat by transferring them to a plate.

If you prefer to use the oven, set a timer and keep the heat on the low end—300°F/150°C is good. That way they won't go from raw to burned before you even notice—about 5 minutes for seeds and 10 to 15 minutes for nuts and coconut.

CHAPTER 1 AMERICAN CHICKEN

AMERICAN CHICKEN

Historian Waverley Root observed in *Eating in America* that the
United States is "perhaps a political melting pot, perhaps a cul-
tural melting pot, perhaps an ethnical melting pot, but it is not
a culinary melting pot." This statement is happily less true today
than it was in 1976 when Root wrote it. What, then, is "American"
food? These days, the definitions are more gloriously slippery and
all-encompassing than ever. All the recipes in *Poulet*—despite its
French title—are American in terms of what I believe constitutes
a meal, how food should be seasoned, prepared, served, and eaten.
France comes in because of my roots—I am French Huguenot and have
great respect for that country's long culinary tradition. After
all, a stir-fry is easily as American as barbecued chicken, just as
a spicy curry has as much of a place in America as does a chicken
pie. The recipes in my Latin Chicken chapter are as American as
food gets—particularly if you live in the Southwest or Texas. So
why have an American chapter at all?

It's here to stake out a polyglot version of American food that sits
well within the zone of what most Americans would recognize as
their own simple cooking. So you will find in this chapter plenty
of food that's driven by the great ingredients that go into the
recipes. You'll also find comfort foods like battered, deep-fried
chicken, crispy roast chicken, and barbecued chicken with a spicy,
almost sweet sauce.

You don't need anything out of the ordinary to cook the recipes
in this chapter—just some great olive oil and a source for fresh
produce, from lettuce to garlic, herbs to chiles. A basic pantry of
dried spices will also keep you from running to the store: corian-
der, mustard seeds, paprika, cayenne, and red pepper flakes. I even
call for onion powder and celery salt in one recipe—ingredients
I don't usually use. I made an exception because they give just the
right flavor to the all-important fried chicken dredging flour. Be
sure to buy a brand that's just dried onion, without MSG or salt.
Finally, don't forget to find some excellent chicken. Shop around
and be sure to at least try the most pampered bird in the cooler
(see page 11)—it's still cheaper than steak.

DRINKS

With summer grill food, an Austrian Grüner Veltliner goes with
everything—it's a crisp, unobtrusive, and affordable white (the
one I drink comes from Broadbent). In winter and fall, I generally
drink more red wine. My favorites usually come from a Pinot Noir
grape. There are a lot of great ones out there from Oregon, France
(Burgundy), and New Zealand. Bubbly or still water with a cucumber
float is an asset to any table.

ON THE TABLE

Don't forget the obvious: flaky salt and a pepper grinder stocked
with fresh peppercorns. (I especially like Tellicherry pepper; and
don't forget, the flavor of the corns will fade over time, so refresh
them every few months.) Some people lust after salt; others find
that salt gets in the way of experiencing other flavors. That's why
it's best to let each person at your table salt his food as much or
as little as he pleases. I never take offense if someone tastes my
food and then adds a pinch of salt.

I adore bread of all kinds—and I like it even better with butter
still chilly from the refrigerator. A whole-grain loaf with plenty
of seeds and sprouted grains is my favorite.

SWEETS

Make ice cream—whip together a custard with eggs, cream, milk,
sugar, and vanilla; add a filling or fillings from any number of
tempting ideas you can dream up; and pour it all into your ice-
cream maker. If you don't have an ice-cream maker, no problem—you
can freeze the mixture in a pie pan and cut it into wedges any way
you like. It'll be fresh, delicious, and all yours.

CRISPY ROAST CHICKEN
WITH WATERCRESS VINAIGRETTE, CORIANDER GREEN BEANS, AND WILD RICE

SERVES 4

One of the first and best (and most primal) things I learned to do in the kitchen was to roast a chicken. In high school it was also one of the few experiences that my sister, Nicole, and I could share without a fight. We'd push a few pats of butter under a chicken's skin, stuff a bunch of fresh herbs in the cavity, and roast it in a hot oven until golden brown, by which time the smell drove us crazy. We'd devour it standing up, burning our fingers and tongues as we pulled at the hot, crackling skin, eating it right down to the nubbins.

— CRISPY ROAST CHICKEN —

ONE 2- TO 4^1/$_2$-LB/1- TO 2-KG CHICKEN

2 TBSP BUTTER, AT ROOM TEMPERATURE

1 SMALL BUNCH OF FRESH HERB SPRIGS SUCH AS THYME, BASIL, OR PARSLEY OR ANY COMBINATION

1/$_2$ TSP KOSHER SALT

Set the chicken in a 12-in/30-cm or larger cast-iron frying pan or a 5-qt/5-l or larger Dutch oven. Using your fingers, gently work 1 tbsp of the butter under the breast skin, pushing the butter in as far as you can reach to the front of the breast and down into the thighs. Try not to tear the skin. Rub the remaining 1 tbsp butter all over the breast and leg skin on the outside. Put the bouquet of herbs in the body cavity and sprinkle the chicken all over with the salt.

Preheat the oven to 450°F/230°C/gas 8. Set the chicken on the counter-top for 30 minutes or so to take the chill off before cooking.

Put the chicken in the oven and roast for 30 minutes before either inserting an instant-read thermometer into the thickest part of a thigh or cutting into a thigh with a paring knife. The thermometer should register 175°F/80°C. If using a knife, look for clear, not red or pink, juices running from the spot where you pierced the meat and opaque, barely pink flesh at the bone. If the chicken isn't done, roast for 5 to 10 minutes longer and check it again.

When the chicken is done, remove it from the oven and let rest for 5 minutes before you carve (see page 18) and serve.

— WATERCRESS VINAIGRETTE —

It may come as a surprise to many chicken lovers, but a simple vinaigrette is one of the best sauces for poultry, as the acidity drives home the richness of the meat. This glowing green sauce enlivens the already irresistible roast chicken with a splash of white wine vinegar, a little olive oil, and *a lot* of watercress. Paired with Coriander Green Beans and Wild Rice, you'll find yourself tempted to lick your plate.

4 CUPS/115 G WATERCRESS, TOUGH STEMS REMOVED

1/3 CUP/75 ML OLIVE OIL

1 TBSP WHITE WINE VINEGAR

1 TBSP DIJON MUSTARD

1 TSP KOSHER SALT

1 SHALLOT, MINCED

Reserve a few pretty sprigs of watercress to garnish each plate and wrap in a damp paper towel or kitchen towel and place in the refrigerator.

Coarsely chop the remaining watercress and then stuff it all into a blender or food processor. Add the olive oil, vinegar, mustard, and salt and pulse until smooth. Depending on your blender or food processor, you may need to stop the machine and use the handle of a wooden spoon to push the leaves down once or twice so the blades can do their work.

Transfer the sauce to a bowl or small pitcher and stir in the shallot. Cover until ready to serve.

— CORIANDER GREEN BEANS —

Look for brightly colored, unblemished beans. Just because
beans seem to hold up for weeks after they're picked doesn't
mean we should eat them that way.

10 OZ/280 G GREEN BEANS, TRIMMED

2 TBSP BUTTER

1 TBSP CORIANDER SEEDS,
LIGHTLY CRUSHED (SEE PAGE 21)

1/4 TSP KOSHER SALT

Have ready a bowl of ice water. Bring a medium saucepan three-
fourths full of water to a boil over high heat. Add the green
beans, and cook for 3 to 6 minutes, or until just tender. They should
still have some snap. Drain the beans and immediately transfer
them to the ice water to stop the cooking and preserve their color.

Set the saucepan you cooked the beans in over low heat. Melt the
butter with the coriander seeds. Don't brown the butter, but do
allow it to get quite hot—the idea is to heat the seeds until they
become fragrant.

Drain the beans again, return them to the pan, and toss with the
hot coriander butter. Raise the heat to medium and stir until the
beans are warmed through. Stir in the salt. Taste, add more salt if
needed, and serve.

— WILD RICE —

Start the rice when you put the chicken in the oven and it'll be done in plenty of time. The sautéed onion adds sweetness and depth. Toasting the rice in the hot butter doesn't hurt, either.

2 TBSP BUTTER, PLUS MORE FOR FINISHING (OPTIONAL)

1/2 SWEET ONION SUCH AS VIDALIA, CHOPPED

1 CUP/170 G WILD RICE

3 1/2 CUPS/ 840 ML WATER

1/2 TSP KOSHER SALT

FLAKY SALT FOR FINISHING

Melt the 2 tbsp butter in a heavy-bottomed pot with a tight-fitting lid over medium heat. Add the onion and cook for 3 to 5 minutes, or until soft but not colored. Add the rice and reduce the heat to medium-low, stirring to coat the rice with the butter and to give it a slightly toasty flavor. Add the water and kosher salt and stir well.

Cover and cook over low heat for 40 to 55 minutes, or until the grains are tender. Wild rice ranges widely in cooking time, depending on its age, grain size, and other factors. It should still have some backbone (a little body) when cooked. Add more water, a little at a time, as needed if the pot begins to dry out before the rice is done.

Finish with a pinch of flaky salt and, if you're feeling decadent, an extra pat of butter before you put it on the table.

"BACON" CHICKEN WITH FRESH HERBS, GRILLED SUMMER VEGETABLES, AND HOBO CORN

SERVES 4

This is as good and as simple as chicken gets. Despite its name, there's no pork in "bacon" chicken. It's just crispy, smoky, awesome chicken. Chicken cooked slowly and well on an outdoor grill over hardwood or charcoal does taste and smell uncannily like bacon. It's the slow cooking that produces that crispy deliciousness, which calls to mind nothing so much as what a friend of mine calls "vitamin P" (mmm, pork). To get it right, you'll need to worry this chicken a little— that means you're going to stand there tending that meat with loving care. With a grilled tomato or summer squash, or whatever else you'd like to throw on the fire to grace the side of your plate, along with an ear of smoky, peppery corn to gnaw on, this medley feels like eating summer.

— "BACON" CHICKEN —
WITH FRESH HERBS

8 TO 10 BONE-IN, SKIN-ON CHICKEN THIGHS
PEANUT OIL AND KOSHER SALT FOR THE CHICKEN
¼ CUP/10 G CHOPPED MIXED FRESH HERB LEAVES

SUCH AS CHIVES, TARRAGON, THYME, OREGANO, AND/OR BASIL
FLAKY SALT AND BLACK PEPPER FOR FINISHING

Put the chicken thighs on a platter, rub with peanut oil, sprinkle with kosher salt, and set on the countertop for 30 minutes or so to take the chill off while you prepare the grill.

Build a medium fire in a charcoal or wood grill or heat a gas grill to medium-low. Use a clean, well-cured grate. If you are using charcoal or wood, you want hot embers, not flames.

Arrange the thighs, skin-side down, on the grill and let them cook for 5 minutes or so before you move them. After that, I like to flip the chicken every 5 minutes or so to keep it from sticking and to keep from burning the skin. Plan on standing, turning, flipping, and generally worrying the chicken for 30 to 40 minutes.

If your chicken is burning or the fat is igniting flames, turn the heat down or move the chicken to a cooler spot on the grill. (You can also douse the flames with a squirt bottle if there's no room to move the chicken out of the way.) Work slowly and the result will be a deep-mahogany-colored exterior concealing a well-cooked but juicy interior. That smoky flavor and crispy skin are worth the wait.

When the chicken is done, you will see that it has shrunk considerably. The meat should be firm but with a little give when you poke it with your finger. An instant-read thermometer should register 170°F/80°C. If you're unsure, cut into a piece and take a peek. Look for clear, not red or pink, juices running from the spot where you pierced the meat and opaque, barely pink flesh at the bone.

Platter the chicken, scatter the fresh herbs on top, and sprinkle with big pinches of flaky salt and grinds of pepper and serve.

— GRILLED SUMMER VEGETABLES —

Use the freshest, best-looking young vegetables you can find
for a gorgeous spread. Buy from a farm stand or your local
farmers' market, if possible. Grilling vegetables like this is
easy, but it takes time. I like to maintain a medium-hot fire
to accommodate the range of vegetables. Tomatoes, for example,
can take a very hot fire, but eggplant and fennel need to
cook slowly. Enjoy the air and have a summery cocktail like
a Hendrick's gin and tonic with a cucumber stirring stick.
Read the paper. Don't rush—everything from the tomato to the
fennel benefits from a little color if not a black spot or two.
Finishing what is certain to be a very pretty platter with
a drizzle of good olive oil, flaky salt, and fresh basil will
send you into summery raptures—if the gin and tonic doesn't.

I have a big grill, with room enough to create all the grilled
glory for this meal at the same time. If your grill isn't big
enough, you can use two grills, or cook the chicken first and
keep it warm in a low oven while you grill the vegetables. Or,
serve the chicken at room temperature.

1 FENNEL BULB CUT INTO WEDGES AND CORED

1 SMALL EGGPLANT,
CUT INTO THIN WEDGES AND SALTED TO
PROMOTE DRAINING

2 ZUCCHINI, CUT IN HALF LENGTHWISE

2 BELL PEPPERS, HALVED AND SEEDED

2 TBSP OLIVE OIL

1/2 TSP KOSHER SALT

2 TOMATOES, CUT IN HALF ON THE EQUATOR

BEST-QUALITY EXTRA-VIRGIN OLIVE OIL
FOR DRIZZLING

FLAKY SALT FOR FINISHING

1/4 CUP/10 G CHOPPED FRESH BASIL LEAVES

Build a medium fire in a charcoal or wood grill or heat a gas
grill to medium-low. Use a clean, well-cured grate. If you are using
charcoal or wood, you want hot embers, not flames.

Put the fennel, eggplant, zucchini, and bell peppers in a large
bowl. Add the olive oil and kosher salt and toss to coat. Brush the
cut sides of the tomatoes lightly with some of the oil mixture in
the bowl.

Place the fennel and eggplant on the grill first. Both of them
need extra time to cook thoroughly. After 10 minutes or so, add the
zucchini and bell peppers to the hottest part of the grill and cook

for 10 minutes or until they have some of that nice color. Hot and fast preserves the texture and flavor while adding color. The tomato should be cooked last. Place it on the hottest part of the grill, but leave it just long enough to blister so it stays fresh and intact. Use long-handled tongs to lift the pieces and peek for doneness; be sure to get a little black on the peppers, tomatoes, and zucchini.

Transfer the vegetables to a platter as they are finished, drizzle with the extra-virgin olive oil, and sprinkle with pinches of the flaky salt. Finally, scatter basil on top before serving.

— HOBO CORN —

Unless I'm camping, I'm not a fan of "hobo packs"—vegetables bundled up in aluminum foil and stuck directly into hot embers. But there is an exception: When it comes to corn, I'm always happy to bite into the buttery, peppery, ever-so-slightly-charred version that my husband, Dwight, cooks on the fire. Here it is.

4 TO 6 EARS FRESH CORN, HUSKS AND SILK REMOVED

2 TO 3 TSP BUTTER, AT ROOM TEMPERATURE

KOSHER SALT AND BLACK PEPPER

1 TBSP RED PEPPER FLAKES (OPTIONAL)

Build a medium fire in a charcoal or wood grill or heat a gas grill to medium. Use a clean, well-cured grate. If you are using charcoal or wood, you want hot embers, not flames.

Rub the corn with the butter, sprinkle with salt, and finish with *a lot* of black pepper. Add a pinch of red pepper flakes (if using). Wrap each ear tightly in a piece of heavy-duty aluminum foil and stick them in the side of your fire or, if that's not possible, place them right over the heat on top of the grill.

Cook until tender, 5 to 10 minutes, depending on the intensity of the fire and how fresh the corn is. Don't worry too much about whether the corn is "done" or not. Just remember that great super-fresh corn really only needs to be warmed up, not cooked, and older, more starchy corn should get some solid cooking time.

Serve the corn still wrapped in foil. That buttery, peppery juice in the foil? It's pretty good stuff to roll your corn in before you take your first bite.

BRICKHOUSE CHICKEN
OVER ORZO WITH TOSSED GREENS

SERVES 4

The burnished orange sauce that distinguishes this recipe (thank you, Spain, for your chorizo) matches that of the ivy-covered brick of the house where it was first made. The spirit of this house and its excellent hosts demand staying up absurdly late, drinking quantities of undeservedly good wine, and eating more than necessary. Wherever you are, whoever you're with, this is chicken for a crowd on a summer night when the fireflies are lighting up the edges of the dark world. Double or triple the recipe if you have a couple of big pots.

— BRICKHOUSE CHICKEN —

8 TO 10 BONE-IN, SKIN-ON CHICKEN THIGHS OR ONE 2- TO 4½-LB/1- TO 2-KG CHICKEN

1 TBSP PEANUT OIL, PLUS MORE FOR THE CHICKEN

KOSHER SALT FOR THE CHICKEN

4 OZ/115 G CHORIZO, CUT INTO SLICES ¼ IN/6 MM THICK

8 CIPOLLINI ONIONS, TRIMMED AND PEELED

½ RED BELL PEPPER, CUT INTO PINKIE-WIDE STRIPS

½ YELLOW BELL PEPPER, CUT INTO PINKIE-WIDE STRIPS

3 OZ/85 G FRESH WHITE BUTTON MUSHROOMS, BRUSHED CLEAN, TRIMMED, AND QUARTERED

½ HEAD OF GARLIC CLOVES, PEELED AND CRUSHED BUT LEFT WHOLE

3 GARLIC SCAPES, CUT INTO THIN ROUNDS (OPTIONAL)

1 CUP/240 ML DRY WHITE WINE

2 CUPS/480 ML CHICKEN STOCK

1 CUP/140 G SHELLED FRESH BEANS SUCH AS FAVA, CRANBERRY, OR LIMA, PEELED IF NECESSARY (SEE PAGE 21)

8 YOUNG CARROTS, PEELED, TOPS TRIMMED TO 1 IN/2.5 CM

LEAVES OF 3 FRESH THYME SPRIGS

FLAKY SALT AND BLACK PEPPER FOR FINISHING

Preheat the oven to 450°F/230°C/gas 8. Put the chicken on a platter, rub with peanut oil, sprinkle with kosher salt, and set it out on the countertop for 30 minutes or so to take the chill off before cooking.

Heat the 1 tbsp peanut oil in a 12-in/30-cm or larger cast-iron frying pan or a 5-qt/5-l or larger Dutch oven over medium-high heat. Lay the thighs, skin-side down, in the pan and cook for 8 to 10 minutes, turning frequently. (For a whole bird, brown the sides and bottom; no need to brown the top.) The chicken should be nicely browned and crusty in places but not burned. Transfer the chicken to a plate, pour off any excess fat, and wipe away any burned bits in the pan.

Add the chorizo, onions, bell peppers, mushrooms, crushed garlic, and garlic scapes (if using). Raise the heat to high and cook, stirring frequently, for 5 to 7 minutes, or until the vegetables are starting to color on the edges and the mushrooms are fragrant. Add the wine and cook for 1 minute, then stir in the stock.

Return the chicken to the pan, skin-side up (or breast-side up for a whole bird). The chicken should be in the liquid but the skin should not be submerged. Put the pan in the oven and roast for 25 minutes. Remove the pan from the oven, stir the shelled beans and carrots into the hot liquid, and roast for 5 minutes longer before either inserting an instant-read thermometer into the thickest part of a thigh or cutting into a thigh with a paring knife. The thermometer should register 175°F/80°C. If using a knife, look for clear, not red or pink, juices running from the spot where you pierced the meat and opaque, barely pink flesh at the bone. If the chicken isn't done, roast for 5 to 10 minutes longer and check it again.

When the chicken is done, remove it from the oven and let rest for 5 minutes. (Carve a whole chicken after 5 minutes and then platter.) Sprinkle with the thyme leaves and a generous pinch or two of flaky salt and a grind of pepper before serving.

— ORZO —

Stand-alone good, but a fine vehicle for getting more of that delicious Brickhouse sauce.

2 CUPS/400 G ORZO

2 TBSP BUTTER OR OLIVE OIL

1/2 TSP KOSHER SALT

1/2 CUP/15 G COARSELY CHOPPED FRESH PARSLEY, BASIL, OR OREGANO

Bring a large pot three-fourths full of water to a boil over high heat. Add the orzo, reduce the heat to medium, and cook until al dente, about 8 to 10 minutes, or per package directions. Drain well in a colander or mesh sieve (be sure the holes aren't too big!) and then return to the hot pan. Add the butter and salt and toss until evenly coated. Sprinkle the parsley on top and serve.

— TOSSED GREENS —

This is my basic salad, and I love it. The greens, whatever they are, should be in stellar condition—fresh, clean, unblemished, and thoroughly dry. I like weedy mixes that combine baby mustard greens, immature kale and bok choy, water-cress, arugula, and purslane, along with more conventional head lettuces. The olive oil should be fruity, peppery, and potent when you dab a little on your tongue. Salt, pepper, and lemon are pretty straightforward—although a Meyer lemon, if you can get one, adds a softer acidity and a sweet note.

4 CUPS/115 G LIGHTLY PACKED MIXED GREENS (SEE RECIPE INTRODUCTION)

2 TBSP OLIVE OIL

JUICE OF 1/2 LEMON

1/2 TSP KOSHER SALT

BLACK PEPPER

Tear the greens into bite-size pieces and put in a nice big bowl. Pour the olive oil and lemon juice over the top. Sprinkle on the salt and pepper, toss (the greens should be glistening, light, and airy), and serve.

OVEN-FRIED CHICKEN
WITH ROASTED YAMS AND RADISH-MINT SALAD

SERVES 4

Lightly coating chicken in flour before baking it in a very hot oven will give you delicious results with little mess and less fuss. This is comfort food for nights when you can't face heating up all that oil for the real thing. On the side, the creamy classic satisfaction of hot, sweet yams makes a nice contrast to the crisp spiciness of the radish salad fragrant with fresh mint.

— OVEN-FRIED CHICKEN —

1/4 CUP/60 ML MILK

1/4 CUP/60 ML OLIVE OIL

JUICE OF 2 LEMONS

1 TSP KOSHER SALT, PLUS 1 TBSP

8 TO 10 BONE-IN, SKIN-ON CHICKEN THIGHS

1 CUP/130 G ALL-PURPOSE FLOUR

1/2 TSP CAYENNE PEPPER

BLACK PEPPER

FLAKY SALT FOR FINISHING

1/4 CUP/10 G COARSELY CHOPPED FRESH CHIVES OR PARSLEY

In a large bowl, stir together the milk, olive oil, lemon juice, and the 1 tsp kosher salt. Add the chicken to the bowl and turn to coat on both sides. Marinate at room temperature for at least 30 minutes and up to 1 hour, or cover and refrigerate up to 24 hours. (If refrigerating, return the chicken to room temperature for 30 minutes or so to take the chill off before cooking.)

— CREAMY POLENTA —

Decadent. Rich. *Worth it*. It takes just about as long to make as your chicken takes to roast. While polenta seems to have acquired a reputation for being laborious, it's no harder than making porridge—something I learned to do at the ripe old age of eight.

5 CUPS/1.2 L WATER

1 TSP KOSHER SALT, PLUS MORE FOR FINISHING

1 CUP/140 G POLENTA

1 CUP/115 G FRESHLY GRATED PARMESAN CHEESE

2 TBSP BUTTER OR OLIVE OIL

In a large, heavy saucepan, combine the water and salt and bring to a boil over high heat. Using a whisk, stir in the polenta in a steady, slow stream. Reduce the heat to low, cover, and cook, stirring every so often and more as the time passes, for 40 to 50 minutes. You want a thick but soft enough texture that the bubbles are briefly trapped, finally popping and spattering in a mini explosion. Add a little water if the polenta gets too thick too soon. (How much water your polenta absorbs depends on the moisture—or lack of it—in the polenta itself.) When the polenta is smooth and thick, stir in the cheese and butter. Taste for salt and serve.

— ROASTED FENNEL —

Soft and ever-so-slightly caramelized, with hints of anise and a restrained bite: don't underestimate fennel.

2 FENNEL BULBS, TOPS REMOVED WITH A FEW FEATHERY FRONDS RESERVED, QUARTERED, AND CORED

1 TBSP OLIVE OIL

1 TSP KOSHER SALT

FLAKY SALT FOR FINISHING

Preheat the oven to 450°F/230°C/gas 8.

Place the fennel quarters on a baking sheet. Drizzle with the olive oil, sprinkle with the kosher salt, and toss to coat well.

Roast for 10 to 15 minutes, or until dark spots begin to appear. Transfer to a serving platter. Rip up a few of the reserved fronds and sprinkle on top. Finish with a pinch of flaky salt and serve.

— EDNA LEWIS-INSPIRED —
FRIED THIGHS

BRINE

1 CUP/240 ML WATER

1/2 CUP/100 G KOSHER SALT

1/4 CUP/50 G RAW SUGAR

5 BLACK PEPPERCORNS

10 BONE-IN, SKIN-ON CHICKEN THIGHS
(SMALLER IS BETTER)

JUICE OF 1 LEMON

PEANUT OIL FOR DEEP-FRYING

3 CUPS/385 G ALL-PURPOSE FLOUR

1 TSP KOSHER SALT

1 TSP BLACK PEPPER

1/2 TSP CELERY SALT

1/2 TSP ONION POWDER, PREFERABLY NATURAL

1/2 TSP SWEET PAPRIKA

1/2 TSP CAYENNE PEPPER

2 CUPS/480 ML WHOLE BUTTERMILK OR MILK

FLAKY SALT FOR FINISHING

To make the brine: In a small saucepan, combine the water, kosher salt, sugar, and peppercorns and bring to a boil over medium-high heat. Reduce the heat to medium-low and simmer, stirring, until the sugar and salt have dissolved completely, about 2 minutes.

Put the chicken in a large bowl and add cold water to almost cover. Add the hot brine to the bowl along with the lemon juice. Cover and let the chicken stand in the brine for at least 1 hour and up to 2 hours at room temperature or refrigerate up to 24 hours. (If refrigerating, return the chicken in its brine to room temperature for 1 hour or so to take the chill off before cooking.)

If you have a deep fryer—terrific; now is the time to get it out. Set the temperature for 365°F/185°C. If you don't have one, use a heavy stockpot or large Dutch oven. Fill it one-third full of peanut oil (or enough so that the chicken thighs will be fully covered but not so deep that there's any danger of the oil overflowing). Put the pot over medium-high heat and clip a deep-frying thermometer to the side of the pot, or use your instant-read thermometer. You want the oil at a steady 365°F/185°C. (It's always wise to keep a pot lid at the ready in case you need to put out a grease fire.)

Stir together the flour, kosher salt, black pepper, celery salt, onion powder, paprika, and cayenne in a large bowl. Pour the buttermilk into another bowl.

When the oil is hot, dunk a thigh in the buttermilk. Shake it off and dredge it in the flour mixture to coat on both sides. Dip it briefly in the buttermilk a second time and then toss it in the flour again before lowering it into the hot oil. Repeat with a few more thighs; work in manageable batches of four or five chicken pieces at a time. Adjust the heat as needed to return the oil to 365°F/185°C, but keep it low enough so that the chicken doesn't burn. The oil should not smoke. Cook each batch for 15 to 25 minutes, depending on the size of the thighs. Test for doneness by cutting into a piece; the meat should be barely pink and appear opaque all the way through. An instant-read thermometer inserted into a piece should register 175°F/80°C.

Transfer the cooked chicken to a plate lined with paper towels, sprinkle with a pinch of flaky salt, and place in a warm (175°F/80°C) oven while you cook the rest of the chicken. Serve warm.

— HORSERADISH-GREEN BEAN — POTATO SALAD

Horseradish and mustard add a kick to this amazingly delicious cold salad.

1 LB/455 G RED-SKINNED POTATOES, SCRUBBED

1 LB/455 G GREEN BEANS, TRIMMED

1/4 CUP/60 ML OLIVE OIL

2 TBSP DIJON MUSTARD

4 TSP GRATED HORSERADISH, FRESH OR PREPARED (JARRED)

1 1/2 TSP KOSHER SALT

1/4 CUP/10 G CHOPPED FRESH CHIVES

BLACK PEPPER FOR FINISHING

Have ready a bowl of ice water. Bring two separate saucepans three-fourths full of water to a boil over high heat. Add the potatoes to one pan and the green beans to the other. Reduce the heat under each to medium. Cover the potatoes partially and cook until soft but with a touch of resistance when a paring knife is inserted into the center of the largest tuber, about 20 minutes. Cook the green beans until just tender, about 3 to 6 minutes.

Drain the beans and transfer them to the ice water to stop the cooking and preserve their color. Drain the potatoes in a colander

set in the sink and let cool before cutting into bite-size chunks. Drain the green beans again.

In a large serving bowl, whisk together the olive oil, mustard, horseradish, and salt. Add the green beans and potatoes and toss to coat with the vinaigrette. Finish by sprinkling the chives on top along with a good dose of pepper.

— BUTTERMILK CORN BREAD —

I like buckwheat honey and butter with my corn bread—or even better, buckwheat-honey butter. Just mix them together ahead of time and put it in a ramekin to pass at the table.

2 EGGS, AT ROOM TEMPERATURE

1/2 CUP/100 G SUGAR

1/2 CUP/115 G BUTTER, MELTED

1 CUP/240 ML WHOLE BUTTERMILK, AT ROOM TEMPERATURE

2 CUPS/255 G ALL-PURPOSE FLOUR

1 CUP/140 G CORNMEAL

1 TSP BAKING SODA

1/2 TSP BAKING POWDER

1/2 TSP KOSHER SALT

KERNELS FROM 2 EARS FRESH CORN (OPTIONAL)

1 JALAPEÑO OR OTHER HOT CHILE, MINCED (OPTIONAL)

Preheat the oven to 400°F/200°C/gas 6. Place a 10-in/25-cm cast-iron frying pan in the oven to heat, or grease a round cake pan and set aside.

In a large bowl, using either an electric mixer or a hand whisk, beat the eggs and sugar together. They should change color from dark to light yellow. Mix the melted butter and buttermilk and add the egg mixture. Add the flour, cornmeal, baking soda, baking powder, and salt and mix briefly, but stop while there are still visible clumps of flour. Add the corn and jalapeño (if using). Use a rubber spatula, to fold everything together with a few turns, scraping the bottom, until just combined. Don't overmix.

Scrape the batter into the prepared pan, and bake for 15 to 20 minutes, or until a toothpick inserted into the center of the bread comes out clean. Let cool slightly, then cut it into wedges right in the pan and serve warm.

GRILLED THIGHS WITH BLISTERED BBQ SAUCE,
PURPLE SLAW,
AND CHEDDAR BISCUITS

SERVES 4

Most of us slather on the barbecue sauce when we cook chicken outdoors. I'm all in favor, but not if the sauce is sticky and too sweet. Make your own sauce—it's a snap—and you'll discover just how good that American barbecued chicken can really be. This recipe will make enough sauce to keep for a few weeks. Paint it on ribs, fish, or steak—it's good on just about anything.

— GRILLED THIGHS —
WITH BLISTERED BBQ SAUCE

8 TO 10, BONE-IN, SKIN-ON CHICKEN THIGHS

1 TBSP PEANUT OIL

1 TSP KOSHER SALT

BLISTERED BBQ SAUCE

2 TOMATOES, CUT IN HALF ON THE EQUATOR

1 YELLOW ONION, CUT INTO 2-IN/12-MM ROUNDS

1 GARLIC CLOVE, COARSELY CHOPPED

1/4 CUP/60 ML CIDER VINEGAR

1 TBSP PEANUT OIL

2 TBSP BROWN MUSTARD (I USE GULDEN'S)

5 ANCHOVY FILLETS

2 TBSP BROWN SUGAR

1 TSP KOSHER SALT

Put the chicken on a platter, rub with the peanut oil, sprinkle with the salt, and set on the countertop for 30 minutes or so to take the chill off while you prepare the grill.

Build a medium-low fire in a charcoal or wood grill or heat a gas grill to low. Use a clean, well-cured grate. If you are using charcoal or wood, you want hot embers, not flames.

Put the thighs skin-side down on the grill and let them cook for 5 minutes or so before you move them. After that, I like to flip them every 5 minutes or so to keep them from sticking and to keep from burning the skin. Plan on standing, turning, flipping, and generally worrying the chicken for 30 minutes. You want the chicken crispy and brown without burning.

While the chicken is cooking, make the BBQ sauce: Put the tomatoes and onion cut-side down on the hottest part of the grill (move the chicken over, if you need to) and cook until tender and blackened, turning them once to cook and color on the other side. The whole process will take 10 to 15 minutes, depending on the intensity of the heat. Let the tomatoes really cook and get nice and charred but don't let them disintegrate before you remove them from the grill. Transfer the grilled tomatoes and onion to a blender. Add the garlic, vinegar, peanut oil, mustard, anchovies, brown sugar, and salt. Blend until smooth. Transfer the sauce to a bowl, reserving about 1/4 cup/60 ml to set beside the grill.

When the chicken pieces have shrunk considerably and are a honey brown, use a pastry brush or sauce mop to paint on the sauce. Continue to grill and paint on the sauce for another 10 minutes or so. Before you take the chicken off the grill, cut into the thickest thigh to be sure it's cooked. The meat should be barely pink and appear opaque all the way through. An instant-read thermometer should register 175°F/80°C. Platter them and pass the extra sauce at the table.

— PURPLE SLAW —

I could eat slaw every night—particularly spiked with some
Raw Hot Sauce (page 112). Using your food processor to shred
the cabbage right along with the shallot makes this an
effortless side dish. Use homemade mayonnaise by following
the recipe for Herb Aioli on page 103, leaving out the herbs
and garlic. If you're in a hurry, use Hellmann's or (for you
Southerners) Duke's. There's no sugar in my slaw—don't you
go adding any.

1 MEDIUM HEAD RED CABBAGE	2 TBSP CIDER VINEGAR
1 SHALLOT	1/2 TSP KOSHER SALT
1/2 CUP/120 ML MAYONNAISE	BLACK PEPPER

In a food processor fitted with the shredding blade or using the
large holes on a box grater, shred the cabbage and the shallot.
Combine the shredded cabbage and shallot, mayonnaise, vinegar, and
salt in a large bowl. Season with pepper, and toss to mix well. Taste
and adjust the seasoning with more salt, pepper, and/or vinegar, as
you wish, before serving.

— CHEDDAR BISCUITS —

Salty, cheesy, and almost spicy. Somebody stop me
from eating another!

2 CUPS/255 G ALL-PURPOSE FLOUR

1 TSP BAKING POWDER

1 TBSP SUGAR

1 TSP KOSHER SALT

1/4 TSP CAYENNE PEPPER

1 CUP/225 G COLD SWEET BUTTER, CUT INTO
THUMBNAIL-SIZE CHUNKS, PLUS MORE FOR SERVING

6 OZ/170 G CHEDDAR CHEESE, GRATED

1 EGG

1/3 CUP/75 ML HEAVY (WHIPPING) CREAM, PLUS
MORE FOR BRUSHING

FLAKY SALT FOR SPRINKLING

Preheat the oven to 400°F/200°C/gas 6.

In the bowl of a stand mixer fitted with the paddle attachment
or in a large bowl, mix the flour, baking powder, sugar, kosher salt,
and cayenne. Add the butter pieces and mix on the lowest speed or
cut in by hand with a pastry cutter until there are no lumps of
butter larger than a pea. If the flour begins to stick together
or look at all wet or greasy, stop. Add the cheese and mix to coat
with flour.

Beat the egg and cream together in a small bowl, then add to the
dry ingredients and mix just enough for the mixture to come together
in a rough mass, but no more. Turn the dough out onto a lightly
floured work surface and, working the dough as little as possible,
form it into a ball. Scatter a little flour on top of the ball and
then use a rolling pin to flatten it as evenly as possible to a
thickness of about 2 in/5 cm. Using a round or square biscuit cutter
or a knife, cut out the biscuits. (It really doesn't matter what size
or shape you make them.)

Transfer the cut biscuits to a baking sheet. Brush with cream and
sprinkle with a tiny pinch of flaky salt. Bake for 12 to 15 minutes,
or until golden on the outside with cooked, not doughy, centers. (If
you hate to waste any dough, just cut the irregular dough shapes
left behind into manageable pieces and bake the same way. Serve
warm with plenty of sweet butter. You can reheat leftover biscuits
or biscuit bits for breakfast the next day.)

CHICKEN PIE
WITH PICKLED BEETS
SERVES 4 TO 6

Chicken pot pies have a bad reputation—they call to mind
the gluey, frozen things that you scooped up in front
of the TV as a kid while watching *Brady Bunch* reruns. Well,
here's a pot pie that's subtle, fresh, and—dare I say it?—
elegant. With layers of chicken, tarragon, mushrooms, and
leeks topped by crisp puff pastry, it's hard not to return
for a second helping. You can have it on the table in less
than an hour, even less if you have leftover roasted chicken
on hand. Use wild mushrooms if you have them. Morels will
transform this pie into a dinner party-worthy main course
or starter. Make your beets first so they're ready to eat when
the pie comes out of the oven. A salad of Tossed Greens
(page 37) is a perfect accompaniment.

— CHICKEN PIE —

5 TBSP/70 G BUTTER

2 TO 3 LEEKS, WHITE AND LIGHT GREEN PARTS ONLY,
CUT INTO THIN ROUNDS (ABOUT 1 CUP/115 G)

10 OZ/330 G FRESH CREMINI MUSHROOMS,
BRUSHED CLEAN AND SLICED (ABOUT 3 CUPS)

$^1/_4$ TSP KOSHER SALT

3 CUPS/600 G CHOPPED COOKED CHICKEN MEAT
(YOU CAN USE THE CRISPY ROAST CHICKEN ON
PAGE 27 OR, FOR AN ALL-DARK-MEAT PIE, USE
THIGHS AS DIRECTED IN LEMON CHICKEN, PAGE 42)

$^1/_4$ CUP/10 G CHOPPED FRESH TARRAGON LEAVES

1 SHALLOT, MINCED

1 TBSP ALL-PURPOSE FLOUR

$^1/_3$ CUP HEAVY (WHIPPING) CREAM

BLACK PEPPER

1 SHEET FROZEN PUFF PASTRY, THAWED PER
PACKAGE DIRECTIONS BUT STILL COOL

1 EGG, BEATEN

Preheat the oven to 450°F/230°C/gas 8.

Melt 2 tbsp of the butter in a large sauté pan over medium-low heat. Add the leeks and cook, stirring frequently, until softened but not browned. Transfer to a plate and set aside. Add another 1 tbsp butter to the same pan, add the mushrooms, and raise the heat to high. Sprinkle in the salt and cook for 5 to 8 minutes, or until the mushrooms release some of their liquid and begin to dry out in the pan. They should be partially browned and very fragrant. Transfer them to another plate and set aside.

Build the pie in layers in either a ceramic pie pan or, if you're feeling more rustic (or more macho) in a cast-iron frying pan. Gently press the chicken down in the bottom of the pan to form an even layer and scatter the tarragon and shallot on top. Next, add the leeks, and finally the mushrooms. Set aside.

In the same sauté pan you've been using, melt the remaining 2 tbsp butter over medium-low heat. When it's bubbling, use a wire whisk to mix in the flour. Cook for 1 minute, or until it begins to dry out. Add the cream, whisking all the while, and cook for another minute or so, or just until the cream bubbles. Pour the sauce over the pie, using a rubber spatula to scrape the pan and gently distribute the sauce. Add a healthy grind of pepper before laying on the puff pastry. Once the pastry is in place, cut it to fit the pan, poke it a dozen times with a fork, and, using a pastry brush, coat the top with the beaten egg.

Bake for 25 to 30 minutes, or until the top is beautifully browned and puffy. Let cool for 5 minutes before cutting. Bring this impressive-looking pie to the table and serve it there.

— PICKLED BEETS —

These beets and the chicken pie make a perfect marriage.

3 TO 5 BEETS,
SCRUBBED AND TOPS TRIMMED

1 CUP/240 ML WHITE WINE VINEGAR

1 TSP KOSHER SALT

Preheat the oven to 450°/230°C/gas 8.

Lay the beets on a large sheet of heavy-duty aluminum foil, drizzle on 1/4 cup/60 ml water, and then wrap them up very tightly by crimping the foil's edges together all around. Set the package on a baking sheet and roast for 30 to 40 minutes, or until the beets are tender when pierced with a knife.

When the beets are done, unwrap the package and let them cool enough so that you can peel the skins with your fingers. The skins should come off fairly easily; use a paring knife where they stick. Cut the peeled beets into six to eight wedges, depending on their size. Pack them into a quart jar and pour in the vinegar and 1 cup/240 ml water. Sprinkle the salt over the top. (If the beets aren't covered, add equal parts water and vinegar until they are, along with 1/2 tsp salt per cup of liquid.)

Let stand at room temperature for at least 1 hour before you serve. Store for up to 2 months, tightly covered, in the refrigerator.

CHICKEN-FENNEL MEATBALLS

ON ANGEL HAIR WITH FRESH TOMATO SAUCE AND ENDIVE-APPLE SALAD

SERVES 4

Meatballs are making a comeback in this country's hipster restaurants, and for good reason—they're primal comfort food. If that's what you're after, this mix, with bacon, plenty of fennel seed, and lots of dark-meat chicken, will thrill you. Paired with the freshest tomato sauce you'll ever have, angel hair pasta glistening with olive oil, and a crisp salad, there may not be a thing in the world you'll wish for—except maybe a decent bottle of red wine and some conversation.

— ANGEL HAIR — WITH FRESH TOMATO SAUCE

$^{1}/_{4}$ CUP/60 ML OLIVE OIL

2 GARLIC CLOVES, THINLY SLICED

$2^{1}/_{2}$ LB/1.2 KG RIPE TOMATOES, CUT INTO CHUNKS

$^{1}/_{4}$ CUP/10 G COARSELY CHOPPED FRESH BASIL

1 TSP KOSHER SALT

BLACK PEPPER

1 LB/455 G DRIED ANGEL HAIR PASTA

CHICKEN-FENNEL MEATBALLS (RECIPE FOLLOWS)

$^{1}/_{3}$ CUP/40 G ITALIAN PINE NUTS, TOASTED (SEE PAGE 21) AND LIGHTLY SALTED

FRESHLY GRATED PARMESAN CHEESE FOR SERVING

Bring a large saucepan three-fourths full of lightly salted water to a boil over high heat.

While the water is heating, pour the olive oil into a large, heavy sauté pan over medium heat. Add the garlic and cook, stirring, until fragrant, 1 to 2 minutes. Add the tomatoes and cook, stirring frequently, until reduced by about half, 8 to 10 minutes. (How long this process takes depends on the water content of the tomatoes.) When the sauce is reduced, add the basil, salt, and a grind of pepper.

Add the pasta to the boiling water, stir once or twice to keep it from sticking, and cook until al dente, about 2 minutes, or per the package directions. Drain well in a colander, then return to the hot pan and toss with half of the sauce. Divide the pasta among warmed bowls or pasta plates and top with the remaining sauce. Place the meatballs on top of the sauce. Sprinkle with the pine nuts and Parmesan and serve.

— CHICKEN-FENNEL MEATBALLS —

This recipe makes about 50 meatballs roughly the size of Ping-Pong balls. Shape them smaller or larger, as you like.

6 BONELESS, SKINLESS CHICKEN THIGHS, CUT INTO CHUNKS

8 OZ/225 G BACON, CUT INTO SMALL PIECES

2 SHALLOTS, PEELED BUT LEFT WHOLE

6 GARLIC CLOVES, PEELED BUT LEFT WHOLE

1 CUP/115 G FRESHLY GRATED PARMESAN CHEESE

1 EGG

1/4 CUP/10 G COARSELY CHOPPED FRESH HERBS SUCH AS PARSLEY, BASIL, AND/OR OREGANO,

1 TBSP KOSHER SALT

1/4 CUP/30 G DRIED BREAD CRUMBS OR MATZOH MEAL

2 TBSP FENNEL SEEDS

1 TBSP PEANUT OIL, PLUS MORE AS NEEDED

Combine the chicken, bacon, shallots, garlic, Parmesan, egg, herbs, and salt in a food processor. Process until uniformly and fully minced. Stop when you no longer can see big streaks of fatty bacon. Add the bread crumbs and fennel seeds and pulse until just mixed.

Using a tablespoon, measure out Ping-Pong-ball–size portions of the mixture onto a parchment paper–lined baking sheet. Roll each portion into a ball and set the pan aside.

Heat the peanut oil in a heavy saucepan over medium heat. When the oil is hot, drop as many of the meatballs into the pan as will fit without crowding. Sauté, turning as needed, until each one is nicely browned and thoroughly cooked through, 10 to 12 minutes. Turn the heat down if the oil starts to smoke. Transfer to a plate lined with paper towels to drain, and keep in a warm oven. Repeat to cook the remaining meatballs, adding a little more oil to the pan if it seems dry.

— ENDIVE-APPLE SALAD —

In this colorful salad, the radicchio, which can be bitter, is sweetened by the apple; the endive is brightened by the lemon and braced by the radicchio; the poppy seeds add texture and a pleasing look. And the cheese? Well, that's just delicious.

1 HEAD BELGIAN ENDIVE, CUT CROSSWISE INTO SLICES $1/4$ IN/6 MM THICK

$1/2$ HEAD RADICCHIO, CUT INTO FINE RIBBONS

1 GRANNY SMITH APPLE, CORED AND CUT INTO 8 WEDGES, THEN CUT CROSSWISE INTO THIN PIECES

JUICE OF 1 LEMON

1 TBSP OLIVE OIL

$1/4$ TSP KOSHER SALT

$1/3$ CUP/40 G FRESHLY GRATED YOUNG ASIAGO, PARMESAN, OR PECORINO CHEESE

1 TBSP POPPY SEEDS

Toss together the endive and radicchio in a large bowl. Add the apple, immediately adding the lemon juice to prevent browning, and then drizzle the olive oil on top. Sprinkle on the salt and toss to mix. To serve, scatter the cheese and poppy seeds on the top of the greens.

BISTRO CHICKEN

BISTRO CHICKEN

Classic, straight-up European cooking, mostly from France, is the foundation of much of the great food we eat today. From a roast chicken in a covered pot with herbs, as in Herbe Poule au Pot (page 78), to the cream-and-butter-mounted sauce with mushrooms in Chanterelle Chicken (page 87), these combinations scream for French wine, sweet butter, and a crusty loaf of bread. The French love their cream and their butter, and I love them for it. Even if you didn't grow up eating this kind of food, if you look closely, you'll realize that the foods you love to eat in a good bistro are just slightly more grown-up versions of the comfort foods you've always loved. Crispy potatoes. Cream mixed with drippings and transformed in a luxurious sauce. Noodles so slippery with butter it's difficult to get them on your fork. Risotto so rich and dreamy you eat it very, very slowly.

This chapter, like the previous one, is driven by comfort food, just from a different side of the Atlantic—and with a lot more cream. Don't be intimidated by the French names. The cooking methods here aren't any different than they are in the rest of the book. Language is the last thing that should get in the way of your pleasure.

A word on ingredients: ultra-pasteurized heavy (whipping) cream lacks flavor. Try to find cream that has been processed with flavor, not shelf life, as a priority. Use unsalted butter and taste it before you use it. It should smell and taste creamy and milky, not weird like the inside of an old refrigerator. Shallots are critical to the food in this chapter—onions are a poor substitute.

DRINKS

This is food that pleads to be eaten with a good bottle of red wine. The simple, slightly rougher country wines of France are under-appreciated in this country. These are table wines: you don't have to spend a lot of money on them, but their rustic layers were made to go with this food. Think of Côtes du Rhônes or earthy cabernet Franc from the Loire Valley's Chinon region.

ON THE TABLE

Put a baguette or a sliced loaf of good sourdough on the table when you serve the food in this chapter. Don't forget the sweet butter—I buy cultured butter for this purpose, like Kate's Homemade from Maine or a European brand.

SWEETS

Where to begin? With fruit, of course! Make a tart, if you like to bake, with the prettiest fruit at the market, whatever is in season right now. If you can't, don't, or won't bake, berries or peaches with heavy cream (there's no such thing as too much cream!) are always welcome after a meal. Don't forget the cheese. There are few plea-sures so often overlooked as sitting at the table with cheese and conversation. Try a round of lightly aged goat cheese, like a silky Pico Picandine from Saint-Astier, France.

SLOW-SAUTÉED THIGHS
WITH FRENCH LENTILS AND ENDIVE SALAD

SERVES 4

As much as I like the combination of the asparagus butter with gently sautéed chicken, the lentils push it over into brilliance. Try it. See if you agree.

— SLOW-SAUTÉED THIGHS —

8 TO 10 BONE-IN, SKIN-ON CHICKEN THIGHS

3 TBSP BUTTER

FRENCH LENTILS (PAGE 71)

FLAKY SALT AND BLACK PEPPER FOR FINISHING

ASPARAGUS BUTTER

1/2 LB/225 G ASPARAGUS

1 TBSP BUTTER

1 SMALL SHALLOT, COARSELY CHOPPED

KOSHER SALT

Set the chicken thighs on the countertop for 30 minutes or so to take the chill off them before you begin cooking.

When you're ready to cook, melt the 3 tbsp butter over low heat in your largest frying pan—cast iron is the best. Lay the chicken thighs in the pan, skin-side down. Cook, turning frequently, for 35 to 40 minutes. You want the thighs to cook very slowly, until

they're a lovely golden brown and an instant-read thermometer inserted into the thickest part of a thigh registers 175°F/80°C. You can also cut into a thigh to check for doneness—the juices should run clear, not red or pink, and the flesh should be opaque, barely pink at the bone.

Meanwhile, make the Asparagus Butter: Snap the woody ends off of the asparagus. Set aside four spears and cut the rest into 1-in/2.5-cm pieces.

Have ready a bowl of ice water. Bring a small saucepan three-fourths full of water to a boil over high heat. Add the asparagus (the pieces and the whole spears) and cook until just tender, about 6 minutes. Drain and immediately transfer to the ice water. Transfer the asparagus pieces to a blender or food processor, reserving the whole asparagus. Add the 1 tbsp butter, the shallot, and a pinch of kosher salt and process until smooth. Stop the machine and use the handle of a wooden spoon to work the asparagus into the blades as needed.

When the chicken is done and still hot from the pan, spread each piece with about 1 tsp of the asparagus butter.

To serve, put a scoop of lentils in the center of each plate and put two or three thighs on top of the lentils. Give the chicken a pinch of flaky salt and season with pepper. Place an additional dollop of the asparagus butter on top of the thighs. Using a vegetable peeler, cut the reserved asparagus spears into thin ribbons and scatter willy-nilly on top of each serving.

— FRENCH LENTILS —

Weirdly, the green of an uncooked French lentil reminds me
of the green crocodile tongues in the paper the crazy old
man places in young James's hands in the opening chapters
of Roald Dahl's magnificent *James and the Giant Peach*.
They are gorgeous.

1 TBSP BUTTER

1 SHALLOT, COARSELY CHOPPED

1 CUP/220 G FRENCH GREEN (PUY) LENTILS

3 CUPS/720 ML CHICKEN STOCK

1/2 TSP KOSHER SALT

Melt the butter in a saucepan over medium heat. Add the shallot and
sauté for 2 minutes. Add the lentils and stock and stir. Cover and
cook until the lentils are tender, about 60 minutes. Stir in the salt
and serve.

— ENDIVE SALAD —

The most elegant grown-up salad I know.

3 HEADS BELGIAN ENDIVE

2 TBSP OLIVE OIL

1 TBSP SHERRY VINEGAR OR WHITE WINE VINEGAR

1 TBSP MUSTARD

¼ TSP KOSHER SALT

FLAKY SALT FOR FINISHING

Cut the endives in half lengthwise and then cut each half crosswise
into thin slices.

Put the endive in a large bowl. In a small bowl, whisk together the
olive oil, vinegar, mustard, and kosher salt. Toss the endive with the
dressing just before serving, and finish with a pinch of flaky salt.

TUSCAN THIGHS
WITH WILD MUSHROOM RISOTTO
AND BRUSSELS SPROUTS RIBBONS

SERVES 4

This recipe was inspired by the mushroom risotto a dear
friend cooked for me on a winter night as I sat happily
watching, perched on a stool in her cozy kitchen, sipping
a glass of red wine. I'm pretty sure she was wearing her
pajamas as she puttered around the kitchen, chatting,
chopping, and worrying over what turned out to be the
most delicious mushroom risotto I've ever eaten. Here's
my spin on that memorable dinner. May it taste half as
delicious as hers did that night.

— TUSCAN THIGHS —

3 TBSP CHOPPED FRESH ROSEMARY

JUICE OF 2 LEMONS (ABOUT $1/4$ CUP/60 ML),
PLUS 1 LEMON FOR ZESTING

2 TBSP OLIVE OIL

1 TSP KOSHER SALT

BLACK PEPPER

8 TO 10 BONE-IN, SKIN-ON CHICKEN THIGHS

FLAKY SALT FOR FINISHING

In a large bowl, combine 2 tbsp of the rosemary, the lemon juice,
olive oil, and kosher salt. Season with pepper. Add the chicken
thighs, turn to coat, and marinate at room temperature for at least
30 minutes and up to 1 hour, or cover and refrigerate up to 24 hours.
(If refrigerating, return the chicken to room temperature for 30 min-
utes or so to take the chill off before cooking.)

Preheat the oven to 450°F/230°C/gas 8.

Remove the thighs from the marinade and place them skin-side up, in a 12-in/30-cm or larger cast-iron frying pan or a 5-qt/5-l or larger Dutch oven. Roast for 30 minutes before either inserting an instant-read thermometer into the thickest part of a thigh or cutting into a thigh with a paring knife. The thermometer should register 175°F/80°C. If using a knife, look for clear, not red or pink juices running from the spot where you pierced the meat and opaque, barely pink flesh at the bone. If the chicken isn't done, roast for 5 to 10 minutes longer and check it again.

Transfer the pieces to individual plates. Sprinkle on the remaining 1 tbsp rosemary, a pinch of flaky salt, and a grind of pepper. Finally, zest the lemon directly onto the chicken and serve.

— WILD MUSHROOM RISOTTO —

Don't stir and watch the risotto constantly. Enjoy yourself!

4 TO 5 CUPS/960 ML TO 1.2 L CHICKEN STOCK

2 TBSP BUTTER

2 SHALLOTS, MINCED

6 OZ/170 G MUSHROOMS;
3 OZ/85 G BRUSHED CLEAN AND CHOPPED,
3 OZ/85 G BRUSHED CLEAN, WHOLE OR CUT INTO
BITE-SIZE PIECES IF LARGE (REMEMBER THEY SHRINK
SUBSTANTIALLY WHEN COOKED)

1 CUP/215 G ARBORIO RICE

1/4 TSP KOSHER SALT

1 TO 2 TBSP BALSAMIC VINEGAR

1/4 CUP/30 G FRESHLY GRATED PARMESAN CHEESE

In a saucepan over high heat, bring the stock to a boil. Remove from the heat and set aside.

In a large heavy saucepan, melt 1 tbsp of the butter over medium heat. Add the shallots and sauté until soft, 3 to 5 minutes. Add the chopped mushrooms, raise the heat to high, and cook until the mushrooms release some of their liquid and begin to dry out in the pan, 3 to 5 minutes.

Add the rice to the mushrooms and stir to coat the rice with the butter and just barely toast the grains. Now you can begin to add the hot stock. Work slowly, but reasonably, without spending the whole evening over the pot. That means adding about 1 cup/240 ml,

stirring and watching while the liquid is absorbed, then adding another 1 cup/240 ml, and so on.

After 15 minutes or so, having added 3 to 4 cups/720 to 960 ml of the stock, slow down and taste the rice. You're seeking grains that are chewy without being crunchy; soft without being mushy. Add more stock if the risotto seems too firm.

While you're cooking the risotto, melt the remaining 1 tbsp butter in a large sauté pan over high heat. Throw in the whole (or bite-size) mushrooms along with the salt and cook until much of their liquid has been cooked off but the mushrooms are still shapely. Taste one. (I like to see a little color on the edges because a browned mushroom tastes so good.) Remove the cooked mushrooms from the heat and set aside.

When you think your risotto is nearly perfect, add 1 tbsp of the balsamic vinegar and half the Parmesan, stirring thoroughly after each addition. Taste a bite to see if it needs salt or greater acidity. Add a little vinegar or salt as needed. When it *is* perfect, transfer to serving plates or to a large bowl and scatter the whole (or bite-size) mushrooms over the risotto along with the remaining Parmesan.

— BRUSSELS SPROUTS RIBBONS —

Nobody really likes Brussels sprouts boiled or steamed. If you think you don't like Brussels sprouts, try this recipe. It might just win you over. Simply slice each one into thin ribbons and sauté.

1 1/2 LB/700 G BRUSSELS SPROUTS	1 TSP RED PEPPER FLAKES
1 TBSP OLIVE OIL	1/2 TSP KOSHER SALT

Trim the bottoms off the Brussels sprouts and pick off and discard any discolored leaves. Slice each one as thinly as you can, from the stem end up to the tip. When it becomes difficult to hold, lay it cut-side down on the cutting board and slice crosswise. Try to get consistently thin slices without driving yourself crazy.

Heat the olive oil in a large sauté pan over high heat. Add the Brussels sprouts, red pepper flakes, and salt. Sauté, stirring constantly, for 5 to 6 minutes, until the leaves color on the edges and serve.

POULET DUXELLES OVER JASMINE RICE
WITH CONFETTI PEAS AND CARROTS

SERVES 4

Duxelles are among those French inventions that remind me why the French were the undisputed rulers of the culinary world until—and don't repeat this in a bar in Lyon—quite recently. I'll still give the honor to the French, if only out of respect for their pastries, wine, and mushrooms.

The duxelles version here is simple, using butter, shallot, and mushrooms. You could muddy it with cream or vermouth, but I prefer to keep it uncomplicated. It's more versatile that way and keeps for almost a month in the refrigerator.

— POULET DUXELLES— OVER JASMINE RICE

ONE 2- TO 4$^{1}/_{2}$-LB/1- TO 2-KG CHICKEN

DUXELLES

1 OZ/30 G DRIED PORCINI MUSHROOMS

3 TBSP BUTTER

1 SHALLOT, MINCED

1$^{1}/_{4}$ LB/570 G FRESH WHITE BUTTON MUSHROOMS, BRUSHED CLEAN AND MINCED

1 TBSP BUTTER

1 SHALLOT, MINCED

2 CUPS/480 ML CHICKEN STOCK

1 CUP/240 ML DRY WHITE WINE

6 FRESH THYME SPRIGS

$^{1}/_{2}$ CUP/120 ML CRÈME FRAÎCHE

KOSHER SALT AND BLACK PEPPER

JASMINE RICE (PAGE 156)

Preheat the oven to 450°F/230°C/gas 8. Pat the chicken dry with paper towels and set it on the countertop for 30 minutes or so to take the chill off before cooking.

To make the duxelles: Put the porcini mushrooms in a small heat-proof bowl and cover with boiling water. Soak for about 20 minutes, then drain, chop, and set aside.

Melt the butter in a large, heavy frying pan over medium heat. Add the shallot and sauté for 2 minutes. Add the porcini and button mushrooms, stir to coat with the butter, and cook, stirring frequently, until the mushrooms shrink considerably and the pan is dry, 15 to 20 minutes. Do not brown. Remove the duxelles from the heat and set aside.

Work your fingers under the skin of the chicken, loosening it from the meat, all the way from the thighs across the top of the breast, without tearing it. Working under the skin, use a small paring knife to gently cut the cartilage attaching the skin to the top of the breastbone. Once the skin is loose, gently cut a slit in the breast meat parallel to the breastbone, forming a pocket along each side. Set aside 1/2 cup/85 g of the duxelles for the sauce. Stuff the remaining duxelles into the breast pockets. Press the skin on the outside to smooth out and reshape the breast. Be careful not to overstuff the pockets or the skin will rupture.

Melt the butter in a 12-in/30-cm or larger cast-iron frying pan or a 5-qt/5-l or larger Dutch oven. Set the chicken in the pan and cook over medium heat until nicely browned on the sides and bottom, about 10 minutes. No need to brown the top. Transfer the chicken to a plate and pour off any excess fat from the pan. Add the shallot, stock, and wine, then return the chicken to the pan. Tuck four of the thyme sprigs into the pan alongside the chicken.

Put the chicken in the oven and roast for 30 minutes before either inserting an instant-read thermometer into the thickest part of a thigh or cutting into a thigh with a paring knife. The thermometer should register 175°F/80°C. If using a knife, look for clear, not red or pink, juices running from the spot where you pierced the meat and opaque, barely pink flesh at the bone. If the chicken isn't done, roast for 5 to 10 minutes longer and check it again.

When the chicken is done, remove it from the oven and let rest for 5 minutes before you carve it (see page 18). Pour the liquid from the pan into a fat separator. (You can also use a heatproof jar and use a spoon to skim off as much fat as you can.) Return the defatted

liquid to the pot and cook over medium heat. Add the reserved dux-elles, the crème fraîche, and the leaves of the remaining thyme sprigs and whisk it all together. Taste and adjust the seasoning with salt and pepper.

Pile the rice on individual plates and arrange the chicken on top, giving each serving some of the duxelles-laced breast. Spoon the sauce over each portion and serve.

— CONFETTI PEAS AND CARROTS —

This is my take on an American freezer-section classic. I love the combination of peas and carrots, but I don't love fro-zen peas. Fresh, sweet shell peas are hard to come by outside of their limited growing season, at least in the Northeast. My solution? Snow peas cut into a dice to match cut carrots, all tossed together in butter with a little mint.

1 TBSP BUTTER

4 CARROTS, PEELED AND DICED

1 SHALLOT, MINCED

$^{1}/_{2}$ TSP KOSHER SALT

2 CUPS/280 G SNOWS PEAS, TRIMMED AND DICED

1 TBSP CHOPPED FRESH MINT

Melt the butter in a large sauté pan over high heat. Add the carrots, shallot, and salt and cook for 3 to 5 minutes, stirring frequently. You want the carrots to caramelize without burning. Add 2 tbsp water and the snow peas and cook until the pan is dry, about 3 minutes. The peas and carrots should be just tender. Sprinkle with the mint and serve.

HERBE POULE AU POT
WITH MUSTARD SEED-POTATO GRATIN AND FRISÉE-APPLE SALAD

SERVES 4

This Parisian-style roast is one of my favorite ways to cook
a whole chicken. In winter, consider stuffing the bird with
a handful of bread crumbs, sautéed bacon, chopped chicken
liver, and herbs. The stuffing will be especially welcome if
you're wearing wool or smelling wood smoke.

— HERBE POULE AU POT —

ONE 2- TO 4½-LB/1- TO 2-KG CHICKEN

5 TBSP/70 G BUTTER, AT ROOM TEMPERATURE

1 CUP/30 G LIGHTLY PACKED MIXED FRESH HERBS
SUCH AS MINT, TARRAGON, BASIL, THMYE, AND
CHIVES, COARSELY CHOPPED

3 CUPS/720 ML CHICKEN STOCK, PLUS MORE IF
NEEDED

FLAKY SALT AND BLACK PEPPER FOR FINISHING

Preheat the oven to 450°/230°/gas 8. Set the chicken on the countertop
for 30 minutes or so to take the chill off before cooking.

In a small bowl, mash together 4 tbsp/55 g of the butter with the
herbs. It will be a loose compound rather than a smooth butter—
that's fine.

Work your fingers under the skin of the chicken, loosening it from the meat, all the way from the thighs across the top of the breast, without tearing it. Working under the skin, use a small paring knife to gently cut the cartilage attaching the skin to the top of the breastbone. Once the skin is loose, gently cut a slit in the breast meat parallel to the breastbone, forming a pocket along each side. Stuff one-third or more of the herb butter into the breast pockets. Stuff the remainder around the thighs and on top of the breast. Press the skin on the outside to smooth out the bird and to help distribute the herb butter. Rub the remaining 1 tbsp of butter on the skin of the breast and legs.

Set the chicken in a 5-qt/5-l or larger Dutch oven or any heavy-bottomed ovenproof pot that has a tight-fitting lid. Add the stock, cover the pot, and put it in the oven for 15 minutes.

To finish, remove the lid and let the bird brown for another 15 minutes before either inserting an instant-read thermometer into the thickest part of a thigh or cutting into a thigh with a paring knife. The thermometer should register 175°F/80°C. If using a knife, look for clear, not red or pink, juices running from the spot where you pierced the meat and opaque, barely pink flesh at the bone. If the chicken isn't done, roast for 5 to 10 minutes longer and check it again.

When the chicken's done, remove it from the oven and let rest for 5 minutes before you carve it (see page 18). Pour the liquid from the pot into a fat separator. (You can also use a heatproof jar and use a spoon to skim off as much of the fat as you can.) Serve the cut-up chicken with the juices on top and finish each plate with a pinch of salt and pepper.

— MUSTARD SEED-POTATO GRATIN —

There are so many reasons to love a gratin—the creamy
potatoes with the sneaky possibility of a crispy bite from
the edges. A hint of mustard and the pop of the seed on your
tongue. The idea of just one more bite.

5 MEDIUM YUKON GOLD OR OTHER YELLOW-
FLESHED POTATOES, ABOUT 2¹/₂ LB/1.2 KG TOTAL
WEIGHT, SCRUBBED

1 TBSP BUTTER

KOSHER SALT AND BLACK PEPPER

2 GARLIC CLOVES, MINCED

3 TO 4 TBSP MUSTARD SEEDS

1¹/₂ CUPS/360 ML HEAVY (WHIPPING) CREAM

Preheat the oven to 450°F/230°C/gas 8.

Slice the potatoes as thinly as possible, stacking the slices as
you work to prevent browning. (Leave the skin on, unless you detest
it.) Use half of the butter to grease an 11-by-7-in/28-by-17-cm baking
dish with 2-in/10-cm sides—or something close—and begin laying
down circles of potato, overlapping them so each slice is about
halfway covered by the next. When one layer is complete, scatter on
a pinch of salt, some pepper, one-quarter or so of the garlic, and
about 1 tbsp of the mustard seeds. (Make sure you save 1 tbsp mus-
tard seeds for the top.)

Repeat to make more layers until either the dish is full or you are
out of potato slices. Don't worry if you run out of garlic—you'll
know it's there. When you complete the final layer, pour on the cream
and then scatter the remaining mustard seeds on top.

Bake until nicely browned on top, 30 to 40 minutes. Let the gratin
cool for 5 minutes before serving.

— FRISÉE-APPLE SALAD —

If Bibb is the Scarlett Johansson of lettuces, plump and alluring, then frisée may be the Helen Mirren, dry but substantial, with a solid wit. Take your prickly lettuce down to size by adding thinly sliced apples, shaved Parmesan, and by tossing it together with an apple vinaigrette. Who needs soft and approachable when you can have all this?

1 HEAD FRISÉE

2 GRANNY SMITH APPLES; 1 PEELED, BOTH HALVED AND CORED

1/4 CUP/60 ML OLIVE OIL

2 TBSP CIDER VINEGAR

1 TBSP DIJON MUSTARD

1/2 TSP KOSHER SALT

1/2 CUP/55 G PECANS, TOASTED (SEE PAGE 21), LIGHTLY SALTED, AND COARSELY CHOPPED

THIN SHAVINGS OF A FIRM OR SEMIHARD CHEESE SUCH AS TOMME DE SAVOIE FOR GARNISH (USE A VEGETABLE PEELER)

Discard the tough outer leaves of the frisée along with any browned leaves, and then rip the best leaves into bite-size pieces. Wrap the lettuce in a damp towel and refrigerate until you're ready to eat.

In a blender or food processor, combine 1 peeled apple half, the olive oil, vinegar, mustard, and salt and process to a purée. Pour half of the dressing into a salad bowl and set aside the rest. Put the remaining 3 apple halves, cut-side down, on a cutting board. Cut each half lengthwise into thirds, then, while holding the pieces together as if still whole, cut crosswise to make the finest slices you can manage. Add the apple pieces to the salad bowl and toss to coat with the dressing. When you're ready to eat, add the frisée to the bowl and toss to mix thoroughly. Taste a leaf and add more dressing, if you like; the greens should be lightly but thoroughly coated. Sprinkle the pecans and cheese shavings on top before serving.

SORREL CHICKEN TROISGROS
WITH PURÉE OF PEAS

SERVES 4

I remember this signature dish—made with salmon—from the first time I ate at Troisgros, the Michelin three-star restaurant in Roanne, France. It was 1978, or thereabouts. On a bike trip with a reservation for the Sunday afternoon meal, my family had to pedal hard to make it on time for our three o'clock table. We made it, even if we looked vaguely disreputable after a rushed change in the hotel room. Oh, but the sauce made it all worthwhile. My adaptation of the recipe features chicken, and is exquisite when matched with Tossed Greens (page 37).

— SORREL CHICKEN TROISGROS —

ONE 2- TO 4½-LB/1- TO 2-KG CHICKEN

4 TBSP/55 G BUTTER, PLUS MORE FOR RUBBING

KOSHER SALT

3 CUPS/720 ML CHICKEN STOCK

2 SHALLOTS, MINCED

1/4 CUP/60 ML DRY VERMOUTH

4 CUPS/225 G LIGHTLY PACKED FRESH SORREL LEAVES

1 CUP/240 ML CRÈME FRAÎCHE

1 TSP FRESH LEMON JUICE

FLAKY SALT FOR FINISHING

Preheat the oven to 450°F/230°C/gas 8. Rub the chicken with butter, sprinkle with kosher salt, and set on the countertop for 30 minutes or so to take the chill off before cooking.

Melt the 4 tbsp/55 g butter in a 12-in/30-cm or larger cast-iron frying pan or a 5-qt/5-l or a larger Dutch oven. Set the chicken in the pan and cook over medium heat until nicely browned on the sides and bottom, about 10 minutes. No need to brown the top. Transfer the chicken to a plate, pour off any excess fat, and wipe away any burned bits in the pan.

Add the stock, shallots, and vermouth to the pan, then return the chicken to the pan, breast-side up. Put the chicken in the oven and roast for 30 minutes before either inserting an instant-read thermometer into the thickest part of a thigh or cutting into a thigh with a paring knife. The thermometer should register 175°F/80°C. If using a knife, look for clear, not red or pink, juices and opaque, barely pink flesh at the bone. If the chicken isn't done, roast for 5 to 10 minutes longer and check it again.

While the chicken is cooking, remove the tough stems and thick central ribs of the sorrel, then tear each leaf half in half again. (If you have very young leaves, there may be no need to remove the stems.) Reserve a few leaves, rolling them into tight cylinders like a cigarette and slicing them across the roll into fine shreds. Set aside for garnishing the plates.

When the chicken is done, remove it from the oven and let it rest for 5 minutes before you carve it (see page 18). To make a sauce, pour the liquid from the pan into a fat separator. (You can also use a heatproof jar and use a spoon to skim off as much of the fat as you can.) Return the defatted liquid to the pan and cook over medium heat until reduced to about 1 cup/240 ml. Depending on the pan you're using and your heat source, this may take as little as 5 minutes or as long as 15 minutes.

Reduce the heat to low and whisk in the crème fraîche, then the lemon juice. Taste the sauce and add a little more kosher salt, if needed.

Divide the sorrel among the plates. Spoon the hot sauce over the sorrel and then a portion of the carved whole bird. Before serving, top with another spoonful of sauce, a pinch of flaky salt, and a scattering of the reserved sorrel shreds.

— PURÉE OF PEAS —

Not unusual but unusually delicious if made with freshly
shelled peas.

2 CUPS/280 G FRESHLY SHELLED GREEN PEAS

1 TBSP BUTTER

1 SHALLOT, COARSELY CHOPPED

1/4 CUP/60 ML HEAVY (WHIPPING) CREAM

1/4 CUP/10 G COARSELY CHOPPED
FRESH MINT LEAVES

1/2 TSP KOSHER SALT

FLAKY SALT

Have ready a bowl of ice water. Bring a medium saucepan three-
fourths full of water to boil over high heat. Add the peas and cook
for 3 to 5 minutes or until just tender. Drain and transfer the peas
to the ice water while you use the saucepan to melt the butter over
medium heat. Add the shallot and sauté, stirring frequently, until
just soft and beginning to brown, 2 minutes. Add the cream, stir to
blend, and turn off the heat.

Drain the peas and transfer them and the shallot-cream mixture to a
food processor or blender. Add the mint and kosher salt and process
until smooth. Use the saucepan you cooked in to reheat the purée
over low heat, stirring often. Finish with a pinch of flaky salt
before serving.

CHANTERELLE CHICKEN
OVER EGG NOODLES WITH SAUTÉED ASPARAGUS

SERVES 4

One rainy August, not long ago, I picked a wild bounty—
13 pounds of chanterelles not far from my house in the
Hudson Valley. For weeks, my family ate chanterelle omelets,
chanterelle skirt steak, chanterelles on toast, and plenty
of this Chanterelle Chicken. What a year! It was an embar-
rassment of riches. If you can't find any of these delicate,
fragrant mushrooms at your farmers' market or grocery store,
use another, preferably wild, mushroom instead. Morels, which
I adore, would do beautifully. This meal is delicious paired
with Tossed Greens (page 37).

— CHANTERELLE CHICKEN —

ONE 2- TO 4$^1/_2$-LB/1- TO 2-KG CHICKEN

1 TBSP PEANUT OIL, PLUS MORE FOR THE CHICKEN

KOSHER SALT

5 TBSP/70 G BUTTER

2 LEEKS, WHITE AND LIGHT GREEN PARTS ONLY,
CUT INTO THIN ROUNDS

8 OZ/225 G CREMINI MUSHROOMS, BRUSHED
CLEAN, TRIMMED, AND SLICED
(FEEL FREE TO SUBSTITUTE CHANTERELLES)

2 CUPS/480 ML DRY RIESLING WINE

2 CUPS/480 ML CHICKEN STOCK

5 FRESH THYME SPRIGS

3 CARROTS, PEELED AND CUT INTO $^1/_2$-IN/12-MM
BATONS

8 OZ/225 G FRESH CHANTERELLE MUSHROOMS,
BRUSHED CLEAN, TRIMMED, SLICED

1 CUP/240 ML HEAVY (WHIPPING) CREAM

BLACK PEPPER

EGG NOODLES (PAGE 89)

Preheat the oven to 450°F/230°C/gas 8. Rub the chicken with peanut oil, sprinkle with kosher salt, and set on the countertop for 30 minutes or so to take the chill off before cooking.

Heat the 1 tsp peanut oil in a 12-in/30-cm or larger cast-iron frying pan or a 5-qt/5-l or larger Dutch oven. Set the chicken in the pan and cook over medium heat until nicely browned on the sides and bottom, about 10 minutes. No need to brown the top. Transfer the chicken to a plate, pour off any excess fat, and wipe away any burned bits in the pan.

Add 3 tbsp of the butter to the pan and place it over medium heat. Add the leeks and cremini mushrooms and cook for 5 minutes, or until the leeks have softened and the mushrooms are fragrant. Add the wine and stock, then return the chicken to the pan, nestling it breast-side up in the liquid and vegetables. Add the thyme and carrots. Put the chicken in the oven and roast for 30 minutes before either inserting an instant-read thermometer into the thickest part of a thigh or cutting into a thigh with a paring knife. The thermometer should register 175°F/80°C. If using a knife, look for clear, not red or pink, juices running from the spot where you pierced the meat and opaque, barely pink flesh at the bone. If the chicken isn't done, roast for 5 to 10 minutes longer and check it again.

When the chicken is nearly done, melt the remaining 2 tbsp butter in a heavy sauté pan over high heat. Add the chanterelle mushrooms and a pinch of salt and sauté until the mushrooms release some of their liquid without burning or losing their texture, 6 to 8 minutes. Set aside.

When the chicken is done, remove it from the oven and let rest for 5 minutes before you carve it (see page 18). To make a sauce, pour the liquid from the pot into a fat separator. Discard the solids. (You can also use a heatproof jar and use a spoon to skim off as much fat as you can.) Return the defatted liquid to the pan, cook over high heat, and whisk in the cream. Cook until the liquid thickens slightly. Taste the sauce and season with salt and pepper.

Arrange the noodles on each plate, top with the chicken, and ladle on plenty of sauce. Scatter the chanterelles on top and serve.

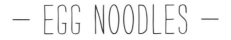
— EGG NOODLES —

Plain. Noncompetitive. Making the main attraction shine. (Like
the sibling you never had.)

8 OZ/225 G FRESH OR DRIED EGG NOODLES

2 TO 3 TBSP BUTTER, AT ROOM TEMPERATURE

KOSHER SALT

Bring a large saucepan three-fourths full of lightly salted water
to a boil over high heat. Add the noodles, stir once or twice to keep
them from sticking, and cook until just tender, about 2 minutes for
fresh noodles or 10 minutes for dried, or according to the package
directions.

Drain well in a colander, then return to the hot pan and toss with
the butter and a pinch of salt. Be sure the noodles are hot when you
serve them.

— SAUTÉED ASPARAGUS —

I hate to see asparagus boiled. Even steaming them doesn't
feel right. By sautéing these tender spears in hot butter, you
add flavor instead of leaching it out.

1 TBSP BUTTER

1 LB/455 G ASPARAGUS, WOODY ENDS SNAPPED OFF

¹/4 TSP KOSHER SALT

FLAKY SALT FOR FINISHING

Melt the butter in a heavy sauté pan over medium heat. Add the
asparagus and the kosher salt and cook for 1 to 2 minutes, shaking
the pan frequently; very thin asparagus will be nearly cooked.
Try to get some color on the stalks over high heat without over-
cooking them, a few seconds more.

If you have thick stalks, add 2 tbsp water to the pan and cook,
covered, for 1 to 2 minutes longer. You want to lose the raw flavor
but keep the snap.

Transfer the asparagus to a plate, finish with a pinch of flaky
salt, and serve.

TARRAGON CHICKEN
WITH SHELL BEANS
AND ACINI DI PEPE

SERVES 4

Poulet à l'Estragon embodies the flavors of Old World France, yet remains fresh and alert. The combination is otherworldly and elegant. Make this recipe early in the spring when perennial tarragon has just returned to your garden but the other herbs have yet to make a showing. There's nothing creamy or heavy about this recipe. It's just clean, hearty ingredients coming together.

— TARRAGON CHICKEN —

ONE 2- TO 4$^{1}/_{2}$-LB/1- TO 2-KG CHICKEN

1 SHALLOT, MINCED

LEAVES OF 6 TO 8 LARGE FRESH TARRAGON SPRIGS, CHOPPED

2 TBSP BUTTER, AT ROOM TEMPERATURE

$^{1}/_{2}$ TSP KOSHER SALT

FLAKY SALT AND BLACK PEPPER FOR FINISHING

Preheat the oven to 450°F/230°C/gas 8.

Set the chicken in a 12-in/30-cm or larger cast-iron frying pan or a 5-qt/5-l or larger Dutch oven.

Put half of the shallot and half of the tarragon in a small bowl and set aside. In another small bowl, mash the remaining shallot and tarragon with the butter and kosher salt.

Using your fingers, gently work 1 tbsp of the tarragon butter under the breast skin, pushing the butter in as far as you can reach to the front of the breast and down into the thighs. Try not to tear the skin. Rub the remaining 1 tbsp tarragon butter all over the outside of the breast and leg skin.

Put the chicken in the oven and roast for 30 minutes before either inserting an instant-read thermometer into the thickest part of a thigh or cutting into a thigh with a paring knife. The thermometer should register 175°F/80°C. If using a knife, look for clear, not red or pink, juices running from the spot where you pierced the meat and opaque, barely pink flesh at the bone. If the chicken isn't done, roast for 5 to 10 minutes longer and check it again.

When the chicken is done, take it out of the oven and let rest for 5 minutes before you carve it (see page 18). Place the meat on a warmed platter and sprinkle with the reserved tarragon and shallot, a pinch of flaky salt, and a grind of pepper to serve.

— SHELL BEANS AND ACINI DI PEPE —

Mixing these flavorful gems with some buttery pasta dots is
a delightful rhapsody in small.

1/2 CUP *ACINI DI PEPE* (*PASTINA*, TO SOME)

1 TBSP BUTTER

2 CUPS/280 G SHELLED FRESH BEANS SUCH AS FAVA, LIMA, CHICKPEA, OR CRANBERRY, PEELED IF NECESSARY (SEE PAGE 21)

KOSHER SALT AND BLACK PEPPER FOR FINISHING

Bring a saucepan three-fourths full of water to a boil over high heat. Add the pasta, stir once or twice to prevent sticking, and cook until al dente, about 1 minute or according to the package directions. Drain into a fine-mesh sieve and set aside.

Melt the butter in a heavy sauté pan over medium heat. Add the beans and sauté until tender, about 3 minutes. Add the pasta to the pan and cook, stirring frequently, for 2 minutes, or until the pasta is thoroughly heated. Season with salt and pepper before serving.

TRIPLE-MUSTARD-CRUSTED CHICKEN
WITH FINGERLING POTATOES AND SATSUMA-FENNEL SALAD

SERVES 4

Here's a hearty meal for those days when the snow just keeps
getting deeper on the path, no matter how often you shovel it
aside. The Satsuma-Fennel Salad is a shot of brightness. It's
difficult to overstate the virtues of this particular variety
of citrus. Buy a big bag, eat them out of hand, and do what
you can to save enough to make this memorable salad.

— TRIPLE-MUSTARD-CRUSTED — CHICKEN

ONE 2- TO 4^1/$_2$-LB/1- TO 2-KG CHICKEN

1 TBSP PEANUT OIL, PLUS MORE FOR THE CHICKEN

KOSHER SALT

3 CUPS/720 ML CHICKEN STOCK

2 TBSP DIJON MUSTARD

2 TBSP DRY MUSTARD

2 TBSP MUSTARD SEEDS

Preheat the oven to 450°F/230°/gas 8. Rub the chicken with peanut oil,
sprinkle with salt, and set on the countertop for 30 minutes or so
to take the chill off before cooking.

Heat the 1 tbsp peanut oil in a 12-in/30-cm or larger cast-iron frying pan or a 5-qt/5-l or larger Dutch oven. Set the chicken in the pan and cook over medium heat until nicely browned on the sides and bottom, about 10 minutes. No need to brown the top. Transfer the chicken to a plate, pour off any excess fat, and wipe away any burned bits in the pan.

Add the stock, Dijon, and dry mustard to the pan over medium heat and whisk to combine. Return the chicken to the pan, breast-side up. Sprinkle the mustard seeds on top.

Put the chicken in the oven and cook, uncovered, for 30 minutes before either inserting an instant-read thermometer into the thickest part of a thigh or cutting into a thigh with a paring knife. The thermometer should register 175°F/80°C. If using a knife, look for clear, not red or pink, juices running from the spot where you pierced the meat and opaque, barely pink flesh at the bone. If the chicken isn't done, cook for 5 to 10 minutes longer and check it again.

When the chicken is done, remove it from the oven and let rest for 5 minutes before you carve it (see page 18). To make a sauce, pour the liquid from the pan into a fat separator. (You can also use a heatproof jar and use a spoon to skim off as much of the fat as you can.) Return the defatted liquid to the pan and cook over medium heat. Reduce the sauce to 1 cup/240 ml. Taste for seasoning before pooling the sauce on each plate and then portioning out the chicken to serve.

— FINGERLING POTATOES —

This is how potatoes should taste. Simple, soft,
and unassuming.

1 LB/455 G FINGERLING POTATOES SUCH YELLOW
FINN OR RUSSIAN BANANA, SCRUBBED

1 TBSP OLIVE OIL OR BUTTER

1/4 CUP/10 G CHOPPED FRESH PARSLEY

FLAKY SALT AND PEPPER

Put the potatoes in a large pot of cold water and bring to a boil over medium-high heat. Cook until tender, 10 to 20 minutes. Stick a paring knife into the center of a potato to test; if it slides right in with no resistance, your potatoes are done. Drain and return the potatoes to the pot you cooked them in. Toss with the olive oil and parsley. Season with salt and pepper before serving.

— SATSUMA-FENNEL SALAD —

I'm obsessed with satsumas, a citrus mutant from Japan that is neither mandarin nor tangerine. From the second they arrive in my grocery store in mid-January through late March, I buy, buy, buy, like some delirious monopolist trying to corner the market. I'm the crazy lady who scoops every last one up from the display, leaving nothing but the sign for the other shoppers to gawk at. Take my advice and buy them if you see them. If you don't eat them all in the parking lot, you can make this delicious salad.

1 LARGE FENNEL BULB, TOP REMOVED, FEATHERY FRONDS RESERVED

2 SATSUMAS, PEELED AND SECTIONED

1 TBSP VERY GOOD OLIVE OIL

1 TSP FRESH LEMON JUICE

$1/2$ TSP KOSHER SALT

BLACK PEPPER

Remove the very tough outer leaves from the fennel bulb. Cut the bulb in half, core, and cut into 2-in/5-cm dice. Put the diced fennel in a large salad bowl.

Cut the satsuma sections in half and put them in the bowl with the fennel. Add the olive oil, lemon juice, and salt and season with pepper. Toss gently to mix. Scatter some of the fennel fronds on top and serve.

TRUFFLED ROAST CHICKEN
WITH GLAZED CHERVIL CARROTS
AND RICED POTATOES
SERVES 4

One of my favorite New York stories takes place in the days leading up to Christmas, not long after my husband and I had moved to Brooklyn's Park Slope from Vermont. Dwight had gotten it into his head that he *had* to taste a black truffle. Then reality set in. A grad student (me) and a freelance writer (him) couldn't afford a truffle. We settled on some truffled rice instead. It would have to do.

We'd long since discovered Balducci's on lower Sixth Avenue, so that's where Dwight headed. At the counter, he asked for a pint of the rice the truffles were stored in. He couldn't help, of course, asking how much the smallest truffle would cost. Told it was more than two hundred dollars, he settled for the rice and was about to walk away when he caught the aproned man behind the counter giving him a sly wink. "Have a look inside when you get home," he said. Mystified, my husband finished his shopping and left. When we went to make our risotto the next evening, there it was: an ink-black truffle the size of a walnut nestled deep in the pearly rice. We feasted on it for days—treating each shred like it was some impossibly precious commodity—which it was. The truffle butter I buy at Murray's Cheese is from Aux Délices des Bois and comes in a 3 oz/85 g tub. D'Artagnan also makes both white and black truffle butter.

— TRUFFLED ROAST CHICKEN —

ONE 2- TO 4^1/$_2$-LB/1- TO 2-KG CHICKEN

4 TBSP TRUFFLE BUTTER (NOT TRUFFLE OIL!),
AT ROOM TEMPERATURE

1 SMALL BLACK TRUFFLE OR A PIECE OF A LARGER
TRUFFLE (WHATEVER YOU HAVE OR CAN AFFORD IS
BETTER THAN NOTHING, IT'S OPTIONAL)

1/$_2$ TSP KOSHER SALT

1 CUP/240 ML CHICKEN STOCK

1 TBSP BUTTER

6 OZ/170 G CREMINI MUSHROOMS, BRUSHED
CLEAN AND CHOPPED (ABOUT 2 CUPS)

FLAKY SALT FOR FINISHING

Preheat the oven 450°F/230°C/gas 8. Set the chicken on the counter-top for 30 minutes or so to take the chill off before cooking.

Work your fingers under the skin of the chicken, loosening it from the meat, all the way from the thighs across the top of the breast, without tearing it. Working under the skin, use a small paring knife to gently cut the cartilage attaching the skin to the top of the breastbone. Once the skin is loose, gently cut a slit in the breast meat parallel to the beastbone, forming a pocket along each side. Stuff 1 tbsp of the truffle butter into the breast pockets. Stuff another 1 tbsp around the thighs and on top of the breast. Press the skin on the outside to smooth out the bird and to help distribute the truffle butter. Rub another 1 tbsp truffle butter on the skin of the breast and legs.

If you have a truffle, place four thin slices under the skin of the breast, two on each side.

Sprinkle the chicken with the kosher salt and put it in a 12-in/30-cm cast-iron frying pan or a 5-qt/5-l Dutch oven.

Pour the stock in the pan, put the chicken in the oven, and roast for 30 minutes before either inserting an instant-read thermometer into the thickest part of a thigh or cutting into a thigh with a paring knife. The thermometer should register 175°F/80°C. If using a paring knife, look for clear, not red or pink, juices running from the spot where you pierced the meat and opaque, barely pink flesh at the bone. If the chicken isn't done, roast for 5 to 10 minutes longer and check it again.

While the chicken is cooking, melt the 1 tbsp butter in a frying pan over high heat. Add the mushrooms and cook, stirring frequently, until the mushrooms release some of their liquid and begin to dry out in the pan, 8 to 12 minutes. When the mushrooms are tender and fragrant but dry, take them off the heat and stir the remaining 1 tbsp truffle butter into the hot mushrooms. Set aside.

When the chicken is done, remove it from the oven and let rest for 5 minutes. Carve it (see page 18) in the pan you roasted it in to catch the juices. Arrange the meat on a platter and keep warm in a low oven.

To make a sauce, pour the liquid from the pan into a fat separator. (You can also use a heatproof jar and use a spoon to skim off as much fat as you can.) Return the defatted liquid to the pan and cook over high heat, scraping the pan as it begins to simmer. When the liquid is hot, turn off the heat and pour it over the chicken. If you have a truffle, use a fine grater to shave some fresh, raw truffle over each plate. (Be sure to save some for the potatoes!) Finish with a pinch of flaky salt and serve.

— GLAZED CHERVIL CARROTS —

This is a classic French method of preparing carrots, producing invariably delicious results. Perhaps it's that little bit of caramelization that does it. Try to buy carrots with the tops on—they're fresher.

8 MEDIUM CARROTS, PREFERABLY WITH GREENS INTACT, OR 1 LB/455 G NEW CARROTS (20 TO 30)

1 TBSP BUTTER

1/2 TSP RAW SUGAR

1/2 TSP KOSHER SALT

1/4 CUP/10 G CHOPPED FRESH CHERVIL LEAVES

FLAKY SALT FOR FINISHING

As soon as you get them home, cut the tops off the carrots, leaving about 1 in/2.5 cm of the green tops intact—these are a delicious addition to the taste, and the carrots are very pretty on the plate with that bit of green.

If using regular carrots, peel them and cut them in half length-wise, and then into finger-length batons. If using very young carrots, leave them whole. Put the carrots, along with the butter, sugar, and kosher salt into a pot with a tight-fitting lid. Place over medium heat, cover, and cook for 6 to 8 minutes, or until the pot has just gone dry and the carrots begin to caramelize. Transfer the carrots to a platter, scatter the chervil on top, and finish with a pinch of flaky salt before serving.

— RICED POTATOES —

Fluffy, delicate, buttery, rich. I do love the French.

2 LB/910 G YUKON GOLD OR OTHER YELLOW-FLESHED POTATOES

1 CUP/240 ML HEAVY (WHIPPING) CREAM

3 TBSP BUTTER

1 TSP KOSHER SALT

DOLLOP OF TRUFFLE BUTTER OR SHAVED BLACK TRUFFLE (FROM TRUFFLED ROAST CHICKEN, PAGE 96; OPTIONAL)

Fill a large saucepan three-quarters full with cold water and drop the potatoes in it as you peel them. Cut them in half if they are very large or varied in size. Bring to a boil over high heat and cook for 20 to 25 minutes, or until tender. Insert a knife into the center of the largest one to test. You should feel no resistance.

While the potatoes are cooking, combine the cream, butter, and salt in a small saucepan over very low heat. Do not let the mixture boil, but do get it quite hot.

Drain the potatoes and then work them through a ricer back into the pan you cooked them in. Pour the cream mixture over the riced potatoes. Add a dollop of truffle butter or shaved truffle (if using). Treat the potatoes as you would treat cake batter—mix them just enough to get the cream distributed, but no more. Test the consistency and taste for salt. Be sure they're piping hot when you bring them to the table.

COLD ROAST CHICKEN
WITH ARTICHOKES, ROASTED POTATOES, AND ROMAINE HEARTS WITH HERB AIOLI

SERVES 4

This effortless meal will rescue any steamy Sunday after-
noon. As you work, place a discreet ice cube in your glass of
white wine (who'll know?). Once you sit down to the table, you
and your guests will remain cool and content alternating
between the pleasures of dipping your potatoes, chicken, and
artichoke into this potent, velvety sauce. Watch the kids
zip through the sprinkler as you finish your meal with a
taste of well-ripened cheese chased by a cool rib of
aioli-dipped romaine.

— COLD ROAST CHICKEN —

CRISPY ROAST CHICKEN (PAGE 27) OR GRILLED THIGHS (PAGE 213)

Prepare the chicken. Let it cool for 1 hour at room temperature or,
if you want it really cold, refrigerate until you're ready to eat.

Carve the meat (see page 18) and pile on a platter. Serve buffet
style or pass at the table.

— ARTICHOKES —

I might add a little wine or a bay leaf to the water, but more
often than not, plain water does the trick just fine—
especially if you're dipping the artichoke in Herb Aioli.

4 ARTICHOKES

Put enough water in a stockpot fitted with a steamer basket so that
the water just shows through the holes in the basket. Trim the stems
and the prickly tips off the top of the artichokes and set them upside
down in the steamer basket. Cook until tender, about 30 minutes; the
leaves should pull off without too much effort. Taste one to see if
the flesh is tender. (Artichokes very greatly in size, so cooking them
can take as long as 1 hour.)

Remove the steamer from the pot and let the artichokes cool briefly
on the countertop, then refrigerate until chilled, about 1 hour.

— ROASTED POTATOES —

Crispy and soft, these potatoes go well with almost anything.
For the best flavor, use Yukon gold potatoes or a fingerling
variety such as Russian Banana or Yellow Finn. Look for firm,
freshly dug potatoes, free of the wrinkles and blemishes that
mar potatoes that have been stored too long.

1 LB/455 G YUKON GOLD OR FINGERLING POTATOES,
SCRUBBED

1/4 CUP/60 ML OLIVE OIL

1 TSP KOSHER SALT

1/3 CUP/15 G CHOPPED FRESH FLAT-LEAF PARSLEY

Preheat the oven to 450°F/230°C/gas 8.

Put the potatoes in a large pot of cold water and bring to a boil over high heat. Cook until tender when pierced with a knife, 20 to 25 minutes. Drain and let cool.

Cut fingerling potatoes in half lengthwise or larger potatoes into 1/2-in/12-mm wedges. Toss with the olive oil and lay the potatoes out on a baking sheet. Roast for 15 minutes, then turn and roast until the potatoes are crispy, 10 to 15 minutes longer. Transfer to a serving platter and sprinkle with the salt and parsley before serving. They need not be hot but to keep them crisp, return them to the oven, heat off and door ajar.

— ROMAINE HEARTS —

Be sure your lettuce is fresh. Ignore those prepackaged
"hearts of romaine" and reach for the biggest, brightest,
heaviest whole head of lettuce you can find. That heft
is your clue to the crispy, tightly packed core of leaves
at the center.

2 SMALL OR 1 LARGE HEAD ROMAINE LETTUCE

HERB AIOLI (FACING PAGE)

Ruthlessly pull off and discard the tough outer leaves until there are tender, light green leaves with no tough top. Now, pull off each individual leaf right down to the core, rinsing each in cold water before placing it on a clean kitchen towel. Gently wrap the leaves in the towel and put in the refrigerator until your meal is winding down. To serve, stack the leaves on a platter and pass them with the aioli.

— HERB AIOLI —

Making mayonnaise requires some whisking muscle, but most of all it requires the right ingredients at the correct temperature. Spare yourself the frustration: unrefined olive oil will make your life miserable as your mayonnaise splits time and again despite your most attentive, steady whisking. I hate to cheat and use vegetable oil so I use the olive oil labeled "pure" not "extra virgin."

2 EGG YOLKS, AT ROOM TEMPERATURE

2 TBSP FRESH LEMON JUICE

1 CUP/240 ML OLIVE OIL (NOT EXTRA-VIRGIN)

1/2 HEAD GARLIC, CLOVES PEELED AND MINCED

1/2 TSP KOSHER SALT

BLACK PEPPER

1/4 CUP/10 G CHOPPED FRESH HERBS SUCH AS PARSLEY, TARRAGON, BASIL, CHIVES, OR ANY COMBINATION

In a large metal bowl, beat the egg yolks vigorously using a balloon whisk. After the yolks turn light yellow, whisk in the lemon juice. Drizzle a tiny bit of olive oil into the mixture, whisking all the while. Continue to add the olive oil in a thin stream, whisking constantly, until it's all incorporated. The mixture will stiffen as the oil forms an emulsion with the egg yolk.

Add the garlic, salt, some pepper, and the herbs and mix well. Transfer to a pretty bowl, cover, and refrigerate for 30 minutes before serving; this helps to stiffen the aioli.

LATIN CHICKEN

LATIN CHICKEN

The recipes in this chapter encompass a giant geographical area that includes South America, Central America, the Caribbean, and Cuba. Much of the food from these diverse regions, over the course of centuries and sometimes in a much shorter span of time, has been absorbed into what we loosely call Southwestern, Tex-Mex, or Mexican food in the United States. It has been a major force in shaping American cuisine.

Between the love of cooking over an open fire (who does it better than the Argentines?) and the obsession with chiles, this is food I always look forward to cooking and eating. Aside from those flavorful, fiery chiles, the most critical elements are cumin, corn, garlic, fresh cilantro, and lime. From corn tortillas to cumin-scented black beans, an array of salsas to a punchy cilantro cream, you'll see these ingredients again and again in the coming chapter. Keep them on hand, and be sure to buy a big bag of chiles and mix together a jar of Raw Hot Sauce (page 112). I promise it'll change—for the better—your relationship with hot sauce, no matter which brand you're addicted to.

DRINKS

Don't miss the opportunity to whip up a margarita made with good tequila and fresh lime juice. If that's too strong for you, try the drink we've dubbed the Raul Julia after the late, great actor: beer poured over a glassful of ice with the juice of one lime. It'll stand up to any heat.

ON THE TABLE

Serving warm tortillas with these dishes makes good sense. The tortillas I buy are made by La Tortilla Factory in Santa Rosa, California. Find a brand or, better yet, a source you like and keep them on hand. There's nothing so good as a chicken taco as a vehicle for leftovers (see Roadside Chicken Tacos, page 118).

SWEETS

My favorite dessert when I'm eating this cuisine is fried tortillas and ice cream, topped with hot honey and cinnamon. Frozen lime pops made from fresh lime juice and sweetened with agave nectar are light and refreshing in hot weather. Mexican wedding cookies with plenty of walnuts, made so short they crumble when you bite into them, are irresistible with a cup of strong coffee after a big meal.

STUFFED ANAHEIM CHILES
WITH RED RICE AND
RAINBOW SALSA

SERVES 4

This is a classic Tex-Mex meal, one that tastes especially good with some Flaco Jiménez music on the iPod. Stuffed chiles used to be one of my favorite things to order when I went out, but then I made them at home and realized how much better they could be. Serve these covered with cheese and salsa made from super-flavorful tomatoes, along with cumin-scented black beans (see page 125), and you'll find it as hard as I do to go back to a restaurant version. Prepare a cook's margarita to sip while you work—with fresh lime juice, top-shelf tequila, and just a drop of triple sec—and you'll approach nirvana, Southwestern style.

— STUFFED ANAHEIM CHILES —

8 LARGE ANAHEIM CHILES

1 TBSP PEANUT OIL

1 SWEET ONION SUCH AS VIDALIA, FINELY CHOPPED

1 HEAD GARLIC, CLOVES PEELED AND MINCED

2 SMALL HOT CHILES SUCH AS CHERRY BOMB OR ARBOL, SEEDED (BUT RESERVE THE SEEDS) AND CHOPPED

2 TSP CUMIN SEEDS

1 TSP ANCHO CHILE POWDER

$1^1/_2$ LB/680 G BONELESS, SKINLESS CHICKEN THIGHS, CUT INTO $^1/_2$-IN/12-MM PIECES

$1^1/_2$ TSP KOSHER SALT

1 CUP/140 G RED RICE (RECIPE FOLLOWS)

6 OZ/170 G FRESH GOAT CHEESE, AT ROOM TEMPERATURE

$^1/_2$ CUP/55 G SHREDDED CHEDDAR CHEESE

$^1/_2$ CUP/120 ML MEXICAN *CREMA* OR SOUR CREAM

4 GREEN ONIONS, WHITE AND TENDER GREEN PARTS ONLY, CHOPPED

$^1/_4$ CUP/10 G CHOPPED CILANTRO LEAVES

Preheat the oven to 350°F/175°C/gas 4.

Cut straight across the tops of the Anaheim chiles to remove the stems like a cap and reveal the interior, as you would when carving a pumpkin for a jack-o'-lantern. Reserve the tops. Gently remove any membranes within reach and knock out the seeds.

Heat the peanut oil in a heavy frying pan over medium heat. Add the onion, garlic, and hot chile seeds (but not the flesh yet) and sauté for 5 minutes. Add the cumin seeds, ancho chile powder, and chopped chiles and sauté for another 5 minutes, stirring frequently. Add the chicken and cook at a low simmer for 10 minutes. The pan should still have some liquid in it. Remove from the heat and mix in the salt and rice.

Using a wooden spoon, get as much of the filling into the Anaheim chiles as you can. Use the spoon's handle to gently force the filling down into the narrow end of the fruit. When the Anaheim chiles are nearly full, top off each with a generous 1 tbsp of the goat cheese and then replace the tops to hold in the filling. Line the stuffed chiles up in a glass baking dish or other flat ovenproof dish just big enough so that they are touching. Sprinkle the Cheddar on top and bake for 35 minutes, or until the cheese has spots of brown and the chiles are beginning to wrinkle and brown. To serve, top with *crema*, green onions, and cilantro.

— RED RICE —

This is a starch that thinks it's a salad, with fresh tomato and the kick of chile to brighten the flavors.

1 1/2 CUPS/310 G LONG-GRAIN OR BASMATI RICE

3 CUPS/720 ML WATER

1 TSP KOSHER SALT

1 TBSP PEANUT OIL

1 CHERRY BOMB, ARBOL, OR SERRANO CHILE, SEEDED AND CHOPPED

3 MEDIUM TOMATOES, ABOUT 1 1/2 LB/680 G TOTAL WEIGHT, CHOPPED

1 TSP SWEET PAPRIKA

FLAKY SALT FOR FINISHING

Rinse the rice in a colander under cold running water until the water runs clear. Drain off any remaining water and transfer the rice to a saucepan with a tight-fitting lid.

Add the 3 cups/720 ml water and kosher salt, place over low heat and cook until the rice is tender and the water has evaporated, 12 to 15 minutes. Remove from the heat and leave covered to keep warm.

Heat the peanut oil in a frying pan over medium-high heat, add the chile, and sauté over high heat until fragrant. Just when you think it's starting to burn, add the tomatoes and all their juices and sauté until the pan is dry. Before servi ng, combine with the rice and paprika, mixing gently just to combine but not so as to create mush. Taste and adjust the seasoning. Add a pinch of flaky salt before serving.

— RAINBOW SALSA —

I'm a sucker for the look of the Rainbow tomato, with its swirls of green, orange, and red, but what I love more is the flavor of the Sungold, the orange cherry tomato that has achieved well-deserved popularity. If you can't find any, use the best heirloom tomato you can find.

2 CUPS/340 G SUNGOLD CHERRY TOMATOES, HALVED

3 BREAKFAST OR CHERRY BELLE RADISHES, DICED

1 SMALL RED ONION, MINCED

3 GREEN ONIONS, WHITE AND TENDER GREEN PARTS ONLY, THINLY SLICED

1/2 RED BELL PEPPER, DICED

1/2 CUP/20 G CHOPPED CILANTRO LEAVES

JUICE OF 1 LIME

1 TBSP OLIVE OIL

1 HABANERO CHILE, SEEDED AND MINCED, OR 1 TSP RAW HOT SAUCE (PAGE 112)

1/2 TSP KOSHER SALT

In a bowl, combine the tomatoes, radishes, red onion, green onions, bell pepper, cilantro, lime juice, olive oil, and chile and stir to mix. Stir in the salt just before serving.

ARROZ CON POLLO
WITH RAW HOT SAUCE, ORANGE-CARROT SLAW, AND SALTY-SWEET FRIED BANANAS

SERVES 4

Arroz con Pollo is a beloved global staple that is tradition-
ally made with a rangy barnyard bird, stewed and cut into
small pieces. There are tons of versions of this beloved dish
out there. Here's mine, with lots of chicken and not too many
beans—the opposite of what you'll find in most places.

— ARROZ CON POLLO —

8 TO 10 BONE-IN, SKIN-ON CHICKEN THIGHS

1 TBSP PEANUT OIL, PLUS MORE FOR THE CHICKEN

KOSHER SALT

1 YELLOW ONION, COARSELY CHOPPED

1 TSP ANCHO CHILE POWDER OR
1 DRIED ANCHO CHILE

1 TSP CUMIN SEEDS

$1/4$ TSP GROUND CINNAMON OR 1 CINNAMON STICK

3 GARLIC CLOVES, THINLY SLICED

1 CUP/200 G LONG-GRAIN WHITE RICE

1 CUP/200 G BLACK BEANS, HOMEMADE (SEE
PAGE 125) OR RINSED AND DRAINED CANNED BEANS

4 CUPS/960 ML CHICKEN STOCK

$1/4$ CUP/10 G CHOPPED CILANTRO LEAVES

FLAKY SALT FOR FINISHING

$1/2$ CUP/120 ML MEXICAN *CREMA* OR SOUR CREAM

CHICKEN POSOLE
WITH FRIED TORTILLAS,
TOMATILLO SALSA,
AND CILANTRO CREMA

SERVES 4

Here's a meal to throw together at the last minute and eat
in front of your latest Netflix delivery. Not that it's not
good enough for the table—far from it. But there's something
appealing about reclining while eating this big bowl of
hearty stew thick with floating shards of handmade chips.
Make the salsa and the stew as spicy as you like.

— CHICKEN POSOLE —

8 TO 10 BONE-IN CHICKEN THIGHS, SKIN REMOVED

2 TBSP PEANUT OIL

3 GARLIC CLOVES, THINLY SLICED

5 CUPS/1.2 L CHICKEN STOCK

1 TO 2 FRESH HOT CHILES SUCH AS JALAPEÑO,
ARBOL, OR SERRANO, CUT INTO THIN ROUNDS
(THE MORE SEEDS YOU KEEP, THE SPICIER IT WILL BE)

1 TSP KOSHER SALT

$^1/_2$ ORANGE OR RED BELL PEPPER, DICED

KERNELS FROM 6 EARS FRESH CORN
(ABOUT 3 CUPS/510 G)

2 CUPS/300 G YELLOW OR WHITE HOMINY, RINSED

JUICE OF 2 LIMES

$^1/_2$ CUP/20 G COARSELY CHOPPED CILANTRO LEAVES

FRIED TORTILLAS (RECIPE FOLLOWS)

TOMATILLO SALSA (PAGE 117)

CILANTRO CREMA (PAGE 117)

Set the chicken on the countertop for 30 minutes or so to take the
chill off before cooking.

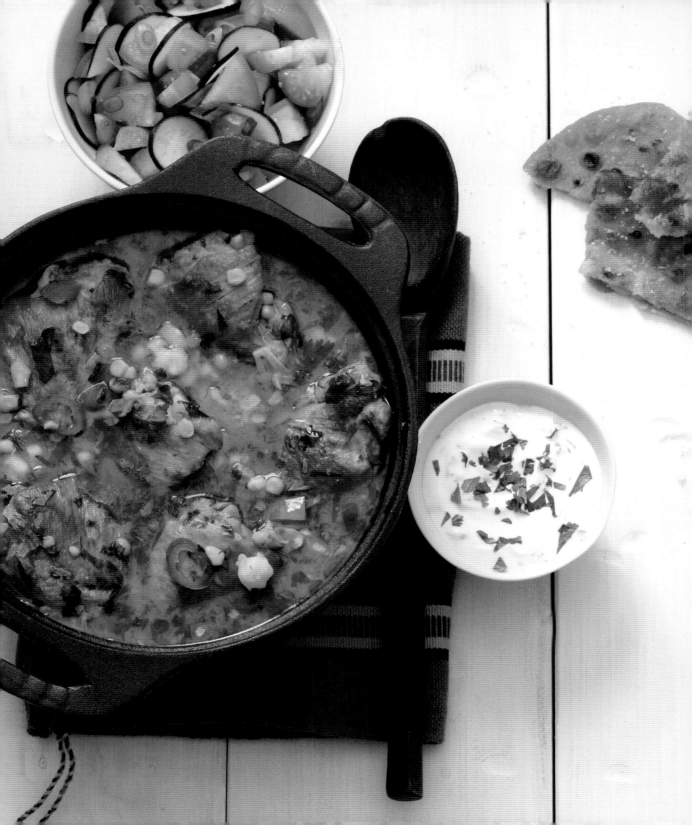

In a 5-qt/5-l Dutch oven, heat the peanut oil over medium-high heat. Working in batches, lay the chicken pieces in the pan, skin-side down, and cook, turning frequently, for 10 minutes, or until nicely browned on both sides, adding more oil if needed. Transfer the chicken to a plate.

When all of the chicken is browned, add the garlic to the hot pan and cook, stirring, until fragrant, just 30 seconds or so, then add the stock, chile(s), and salt. Return the chicken to the pan and poke it down into the liquid. Reduce the heat to medium-low. Cover tightly and cook for 35 minutes, then stir in the bell pepper, corn, hominy, and lime juice.

Return the stew to a simmer and cook until the chicken is very tender, the bell pepper is softened, and the hominy is heated through, 8 to 10 minutes longer. Stir in the cilantro. Taste and adjust the seasoning. Serve in big wide bowls with a handful of broken fried tortillas, a dollop of salsa, and a spoonful of crema.

— FRIED TORTILLAS —

So messy. So good.

1 CUP/240 ML PEANUT OIL

12 (OR MORE!) SMALL CORN TORTILLAS

KOSHER SALT

In a large, deep frying pan, heat the peanut oil to 350°F/180°C on a deep-frying or instant-read thermometer. Adjust the heat as needed so that the oil does not smoke. Put as many tortillas as you can fit in the pan without stacking them—a little overlap is fine. Cook for 3 to 5 minutes, then use tongs to flip them and fry until golden brown and crispy, 1 to 2 minutes longer. Transfer to paper towels to drain. Sprinkle with salt immediately. Repeat to fry the rest of the tortillas. Break up into big chips and serve.

— TOMATILLO SALSA —

Tomatillos have a bright, curious flavor—equal parts
citrus, melon, and tomato. Make this salsa as spicy as you
like; the flavor of the tomatillos won't disappear.

5 TOMATILLOS, PAPERY HUSKS REMOVED

7 CHERRY BELLE RADISHES OR OTHER CRISP,
SLIGHTLY SPICY RADISH, THINLY SLICED

4 GREEN ONIONS, WHITE AND TENDER GREEN PARTS
ONLY, THINLY SLICED

1/2 TO 1 HABANERO OR JALAPEÑO CHILE, CHOPPED,
OR RAW HOT SAUCE (PAGE 112) TO TASTE

JUICE OF 1 LIME

1 TSP OLIVE OIL

1/2 TSP KOSHER SALT

Bring a large saucepan three-fourths full of water to a boil over
high heat. Add the tomatillos. As soon as the water returns to a
simmer, drain the tomatillos and rinse with cold water, as you would
for hard-boiled eggs. When the tomatillos are cool enough to handle,
cut them in half or, if they are bigger, into quarters. Put them in a
colorful bowl along with the radishes, green onions, chile, lime
juice, olive oil, and salt. Toss until well combined and serve.

— CILANTRO CREMA —

If you can find it, Mexican *crema* is a great thing to have on
hand. It lasts for weeks in the refrigerator and has a flavor
that is somewhere between sour cream and crème fraîche, with
the consistency of loosely whipped cream.

1 1/2 CUPS/360 ML MEXICAN *CREMA* OR
SOUR CREAM

1/2 CUP/20 G COARSELY CHOPPED CILANTRO LEAVES

Put the *crema* and cilantro in a blender and process until smooth.
Transfer to a bowl or cream pitcher and serve.

ROADSIDE CHICKEN TACOS
WITH BLACK BEAN-QUINOA SALAD AND FRESH CORN RELISH

SERVES 4

Tacos made with great leftovers like chicken, fish, or steak (my husband loves to try to use the meat picked from day-old barbecued pork ribs) are a standard meal at my house. Everybody gets involved and makes their own just the way they like them. Keep a package of tortillas on hand, a jar of *crema* or sour cream, and a tomato or two. Fresh cilantro, corn relish, diced onion, chiles, and cheese are all great but not essential. Warning: Once you've made your own tacos, using only fresh ingredients, you'll realize that the world is filled with bland, limp excuses for tacos. Welcome home.

— ROADSIDE CHICKEN TACOS —

1/2 CUP/20 G CHOPPED CILANTRO LEAVES

1 LARGE RIPE HEIRLOOM TOMATO, COARSELY CHOPPED, OR 1 PT/340 G CHERRY TOMATOES, HALVED

6 GREEN ONIONS, WHITE AND TENDER GREEN PARTS ONLY, THINLY SLICED

1 FRESH HOT CHILE SUCH AS JALAPEÑO, CUT INTO THIN ROUNDS WITH SEEDS INTACT, OR 1 RECIPE RAW HOT SAUCE (PAGE 112)

1/2 CUP/120 ML MEXICAN *CREMA*, SOUR CREAM, OR CRÈME FRAÎCHE

FLAKY SALT

1 TBSP OLIVE OIL OR BUTTER

3 CUPS/600 G COARSELY CHOPPED SPICY ROAST CHICKEN (PAGE 135)

1 GARLIC CLOVE, THINLY SLICED

12 SMALL CORN OR FLOUR TORTILLAS

1 TO 1 1/2 CUPS/115 TO 170 G CRUMBLED *QUESO BLANCO* OR *QUESO FRESCO*, CRUMBLED FRESH GOAT CHEESE, OR SHREDDED EXTRA-SHARP CHEDDAR CHEESE

Preheat the broiler.

Put the cilantro, tomato, green onions, chile, and *crema* in individual serving bowls or ramekins on the table. Set out a small bowl of flaky salt.

Heat the olive oil in a large sauté pan over low heat. Add the chicken and garlic and cook for 1 to 2 minutes, or just until the chicken is warmed through. Put the chicken in a serving bowl and cover to keep warm.

Next, arrange the tortillas in a single layer on a baking sheet. *Queso fresco* and *queso blanco* don't melt, so if using either of those for your cheese, just crumble into a bowl and set on the table with the other toppings. If you're using goat or Cheddar cheese, sprinkle a portion on each tortilla. Slip under the broiler until the cheese is melted and the tortillas brown on the edges, 30 seconds to 5 minutes, depending on the intensity of your broiler.

Place two tortillas on each plate and put the rest on a platter on the table to fight over later. Everyone should have at it—building the perfect taco to their liking. Don't overstuff your taco! It should fold in half without too much trouble and be easy to eat without making a big mess.

— BLACK BEAN-QUINOA SALAD —

This is a healthful side dish, but that's not why I like it. If anything, I find the name "quinoa" so annoying that I have felt like going out of my way *not* to eat it. But that, I confess, would be nuts.

1$^1/_2$ CUPS/300 G DRIED BLACK BEANS OR
2$^1/_2$ CUPS/500 G CANNED BEANS, RINSED AND DRAINED

1 HABANERO CHILE, HALVED

1 CUP/225 G QUINOA

$^1/_4$ CUP/10 G COARSELY CHOPPED CILANTRO LEAVES

1 CUP/170 G CHERRY TOMATOES, QUARTERED

6 GREEN ONIONS, WHITE AND TENDER GREEN PARTS
ONLY, THINLY SLICED

1 TBSP OLIVE OIL

JUICE OF 1 LIME

$^1/_2$ TSP KOSHER SALT

RAW HOT SAUCE (PAGE 112; OPTIONAL)

FLAKY SALT FOR FINISHING

If using dried beans, rinse them in a colander, keeping an eye out for stray rocks. Put the beans in a large saucepan with a tight-fitting lid and cover with water. Place the pot over medium-low heat, add the habanero, and cook, stirring occasionally, until the beans are tender, about 1 hour. Add additional water if necessary. When the beans are tender but not mushy or falling apart, drain and set aside to cool. Discard the habanero.

Bring a medium saucepan three-fourths full of water to a boil over high heat. Add the quinoa and cook until the grains have plumped and are tender, 12 to 15 minutes. Drain well in a fine-mesh sieve and set aside to cool.

Once the beans and quinoa are cool, combine them in a large serving bowl. Add the cilantro, tomatoes, green onions, olive oil, lime juice, and kosher salt. Toss gently, taking care not to break up the beans. Taste and adjust the seasoning. Add a little hot sauce to taste, if you prefer it spicy, and finish with a pinch of flaky salt before serving.

— FRESH CORN RELISH —

Don't use old, starchy corn. Your corn should be so fresh it feels like a crime to cook it.

KERNELS FROM 4 EARS FRESH CORN (ABOUT 2 CUPS/340 G)

JUICE OF 1 LIME

1 TBSP CORIANDER SEEDS, TOASTED AND LIGHTLY CRUSHED (SEE PAGE 21)

1/2 TSP KOSHER SALT

In a small, pretty serving bowl, mix together the corn, lime juice, coriander seeds, and salt.

CHICKEN-GOAT CHEESE ENCHILADAS

WITH LIME-CILANTRO SUCCOTASH AND BLACK BEANS

SERVES 4

I first made these enchiladas when my husband and I spent a month at my mom's place in central Idaho. Perched on a cliff over a swimming hole on the Salmon River, the feel of the place is hard to capture. Between the cold-water swimming and the desert air, being there lends itself to a lazy rhythm that, over time, convinces me that I was born to be a tequila-drinking, hot pepper—obsessed cowgirl.

— CHICKEN-GOAT CHEESE ENCHILADAS —

6 BONE-IN, SKIN-ON CHICKEN THIGHS

1 CUP/240 ML PEANUT OIL, PLUS MORE FOR THE CHICKEN

5 MEDIUM TOMATOES, ABOUT 2$^{1}/_{2}$ LB/1.2 KG TOTAL WEIGHT, QUARTERED

1 BELL PEPPER, HALVED AND SEEDED

2 JALAPEÑO CHILES, HALVED, WITH SEEDS INTACT

1 CANNED CHIPOTLE CHILE IN *ADOBO* SAUCE OR 1 DRIED CHIPOTLE, RECONSTITUTED IN HOT WATER FOR 30 MINUTES AND DRAINED

KOSHER SALT

PINCH OF CAYENNE PEPPER (OPTIONAL)

12 CORN TORTILLAS

$^{1}/_{2}$ CUP/55 G PEANUTS, COARSELY CHOPPED

4 OZ/115 G GOAT CHEESE

1 CUP/115 G SHREDDED SHARP WHITE CHEDDAR CHEESE

$^{1}/_{2}$ CUP/20 G COARSELY CHOPPED CILANTRO LEAVES

SOUR CREAM OR CREMA FOR SERVING

Preheat the oven to 450°F/230°C/gas 8.

Rub the thighs with peanut oil. Lay them skin-side up on a baking sheet along with the tomatoes, bell pepper, and jalapeños. Roast the vegetables until tender; the tomatoes will begin to color and the peppers will blacken on the edges. The jalapeños will be done first. Check them after about 10 minutes. The tomatoes and bell pepper will take about 15 minutes. As the vegetables are finished, transfer to a plate.

Roast the chicken for a total of 30 minutes before either inserting an instant-read thermometer into the thickest part of a thigh or cutting into a thigh with a paring knife. The thermometer should register 175°F/80°C. If using a knife, look for clear, not red or pink, juices running from the spot where you pierced the meat and opaque, barely pink flesh at the bone. If the chicken isn't done, roast for 5 to 10 minutes longer and check it again. When the chicken is done, set it aside to cool. Reduce the oven temperature to 350°F/180°C/gas 4.

Put the roasted tomatoes and jalapeños and the chipotle chile in a blender. Add 1 tsp salt and blend until smooth. Taste the sauce. I like my food spicy, but you may not. Adjust accordingly by using more chipotles or by adding a pinch of cayenne. Pour the sauce into a large, shallow bowl and set aside. Cut the roasted bell pepper lengthwise into 12 strips. Sprinkle with salt and set aside.

When the chicken is cool enough to handle, remove from the bone and chop it, skin and all. Season with a pinch of salt and set aside.

Heat the 1 cup/240 ml peanut oil in a heavy frying pan over medium-high heat. Line a plate with paper towels. When the oil is hot but not smoking, fry the tortillas in batches, adding as many as you can fit without crowding the pan. I usually work with three at a time. Watch carefully, as the tortillas color quickly. When browned and slightly crisped, about 1 minute on each side, transfer the tortillas to the paper towels to drain.

To assemble the casserole, dunk each tortilla quickly in the sauce and lay it in a 9-by-13-in/23-by-32-cm glass or ceramic baking dish. Place one strip of the bell pepper in the center of each tortilla. Top with a heaping spoonful of chicken, a sprinkle of peanuts, and a bit of goat cheese. (Keep an eye on your quantities; the idea is to have enough for all 12 tortillas.) Roll up the tortillas and

lay them seam-side down in a row (or rows) across the baking dish. Pour the remaining tomato sauce over the tortillas as evenly as possible. Finish by sprinkling on the Cheddar cheese.

Bake for 10 to 15 minutes, or just long enough to reheat everything and melt the cheese. Garnish with the cilantro and sour cream and serve.

— LIME-CILANTRO SUCCOTASH —

Let's say you got totally carried away at the farmers' market, returning home with corn on the cob, fresh beans, squash, and a big bunch of herbs—well, this is what you're going to make. Summer food at its best and amazing the next day, eaten cold straight out of the bowl.

1 TBSP OLIVE OIL

2 GARLIC CLOVES, THINLY SLICED

1 JALAPEÑO CHILE, MINCED

KERNELS FROM 4 EARS FRESH CORN
(ABOUT 2 CUPS/340 G)

1 CUP/140 G SHELLED FRESH BEANS SUCH AS LIMA,
FAVA, OR CRANBERRY, PEELED IF NECESSARY
(SEE PAGE 21)

1 SUMMER SQUASH, CUT IN HALF LENGTHWISE AND
THEN CROSSWISE INTO 1/4-IN/6-MM HALF-MOONS

1 TBSP VERY GOOD OLIVE OIL

JUICE OF 1 LIME

1/2 TSP KOSHER SALT

BLACK PEPPER

1/4 CUP/10 G COARSELY CHOPPED CILANTRO

FLAKY SALT FOR FINISHING

In a large sauté pan, heat the olive oil over low heat. Add the garlic and jalapeño and cook until fragrant, 1 to 2 minutes. Add the corn, beans, and squash and cook for 3 minutes over high heat, stirring frequently. When the vegetables are tender but still crisp, transfer them to a serving bowl and stir in the olive oil, lime juice, and kosher salt. Season with pepper. Finish by sprinkling the cilantro and a pinch of flaky salt over the top before serving.

— BLACK BEANS —

These freshly made garlic-and-cumin-scented beans are so
much better than canned. No need to soak the beans, I promise.

2 CUPS/400 G DRIED BLACK BEANS

1 TBSP PEANUT OIL

1 LARGE YELLOW ONION, THINLY SLICED

1/2 HEAD GARLIC,
CLOVES PEELED BUT LEFT WHOLE

1 TBSP CUMIN SEEDS

6 CUPS/1.4 L WATER

2 TSP KOSHER SALT

Rinse the beans in a colander, keeping an eye out for stray rocks.

In a large saucepan with a tight-fitting lid, heat the peanut oil
over medium heat. Add the onion, garlic, and cumin seeds and sauté
until the onion begins to color and the cumin is fragrant. Add the
water and the beans. Reduce the heat to low, cover, and cook for
2 hours, stirring occasionally. Watch for scorching as the beans
finish cooking, adding more water as needed.

When the time is up, uncover the pot, stir in the salt, and cook,
uncovered, until the beans are tender and any remaining water
has evaporated. Taste for salt before serving. Remove whole garlic
cloves before serving.

JERK THIGHS
WITH JAMAICAN PEAS
AND WATERMELON SALAD

SERVES 4

Jamaican in origin, jerk is seasoning with an attitude and
a name to match . . . bold, and inescapably linked to the
Jamaican hot pepper that is hotter than most can handle—
the Scotch bonnet.

— JERK THIGHS —

2 TBSP PEANUT OIL	1/2 TSP FRESHLY GRATED NUTMEG
1/2 HEAD GARLIC, CLOVES PEELED AND MINCED	1/2 TSP GROUND CLOVES
1 OR 2 SCOTCH BONNET CHILES, MINCED	1/2 TSP GROUND CINNAMON
1 TSP CELERY SEEDS	1 TBSP KOSHER SALT
1 TSP GROUND CUMIN	1 TBSP RAW SUGAR
1 TSP GROUND ALLSPICE	8 TO 10 BONE-IN, SKIN-ON CHICKEN THIGHS

In a small bowl, combine the peanut oil, garlic, chile(s), celery
seeds, cumin, allspice, nutmeg, cloves, cinnamon, salt, and sugar
and stir to make a smooth paste. Spread 2 to 3 tsp of the paste on
the skin of the chicken thighs. Let stand at room temperature for
30 minutes before cooking.

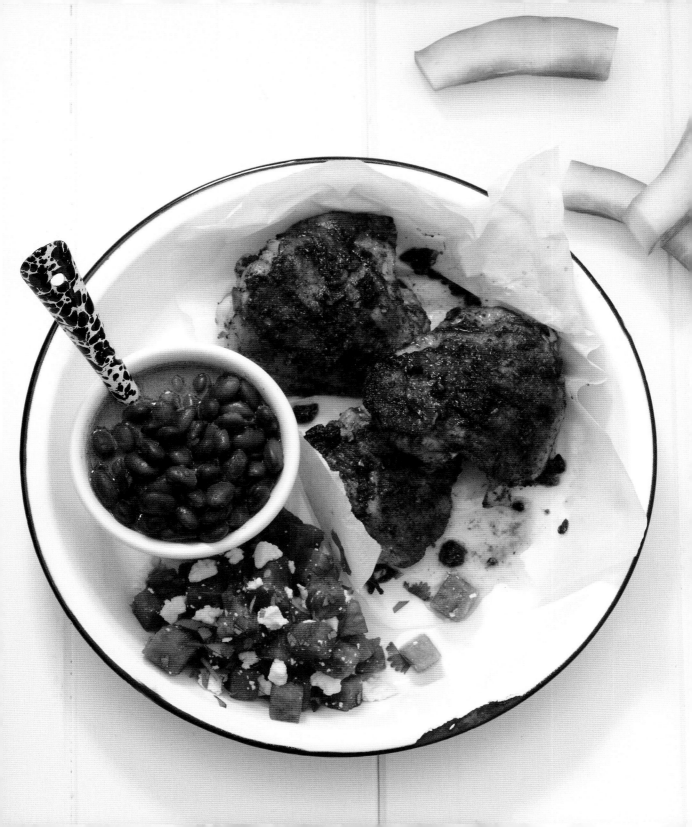

Build a medium fire in a charcoal or wood grill or heat a gas grill to medium. Use a clean, well-cured grate. If you are using charcoal or wood, you want hot embers, not flames.

Arrange the thighs, skin-side down, on the grill and let them cook for 5 minutes or so before you move them. After that, I like to flip them every 5 minutes or so to keep them from sticking and to keep from burning the skin. Plan on standing, turning, flipping, and generally worrying the chicken for 30 to 40 minutes.

If your chicken is burning or the fat is igniting flames, turn the heat down or move the chicken to a cooler spot on the grill. (You can also douse the flames with a squirt bottle if there's no room to move the chicken out of the way.) Work slowly and the result will be a deep-mahogany-colored exterior concealing a well-cooked but juicy interior. That smoky flavor and crispy skin are worth the wait.

When the chicken is done, you will see that it has shrunk considerably. The meat should be firm but with a little give when you poke it with your finger. Look for a reading of 175°F/80°C on an instant-read thermometer. If you're unsure, cut into a piece and take a peek. Look for clear, not red or pink, juices running from the spot where you pierced the meat and opaque, barely pink flesh at the bone.

Platter the chicken and serve.

— JAMAICAN PEAS —

Jamaican "peas" aren't really peas at all—they're red beans, usually cooked with coconut milk and chiles and, more often than not, rice. I've left the rice out in favor of a lighter, cleaner flavor. These easy beans come out tender and spicy.

2 CUPS/400 G DRIED RED BEANS

1 SCOTCH BONNET CHILE, HALVED

1²/₃ CUPS/400 ML UNSWEETENED COCONUT MILK

2 GARLIC CLOVES

3 CUPS/720 ML WATER

¹/₂ TSP KOSHER SALT

Rinse the beans in a colander, keeping an eye out for stray rocks.

In a large saucepan with a tight-fitting lid, combine the beans, coconut milk, water, chile, and garlic. Cover the pot and cook over medium-low heat for 2 hours, stirring occasionally. Watch for scorching as the beans finish cooking, adding more water if needed. When the time is up, uncover the pot, stir in the salt, and cook, uncovered, until the beans are tender and any remaining water has evaporated. Taste for salt before serving.

— WATERMELON SALAD —

Watermelon in hot weather tastes as good as anything else I can think of. Hopped up on salt, cilantro, and lime, it's ridiculous. Freshly made cheeses in the Spanish tradition of *queso fresco* include *panela*, *queso de prensa*, or simply *queso blanco*. Substitute French feta if you can't find any of them.

6 OZ/170 G *QUESO FRESCO*	1/4 TSP KOSHER SALT
6 CUPS/850 G SEEDED AND CUBED WATERMELON	1/2 CUP/20 G CHOPPED CILANTRO LEAVES
JUICE OF 1 LIME	PINCH OF FLAKY SALT

Combine the *queso fresco*, watermelon, and lime juice in a bowl. Toss. Just before serving, sprinkle on the kosher salt and cilantro. Toss gently and finish with a pinch of flaky salt.

ROAST CHICKEN WITH KUMQUATS,

SPICY BUTTERNUT SQUASH, AND CILANTRO RICE

SERVES 4

This variation on the orange and poultry marriage is perfect for those Sunday nights in February. I'm thinking of one when the winter vegetables have begun to all taste the same and you're craving flavors that will warm you up, electrifying your sense of taste and smell. The acidity of the orange juice in this sumptuous braise, paired with the depth of flavor that ancho chiles deliver, are a potent combination. The Spicy Butternut Squash and Cilantro Rice are not to be missed.

— ROAST CHICKEN WITH KUMQUATS —

ONE 2- TO 4^{1}/$_{2}$-LB/1- TO 2-KG CHICKEN

1 TBSP PEANUT OIL, PLUS MORE FOR THE CHICKEN

KOSHER SALT

2 BAY LEAVES

12 KUMQUATS

1 VIDALIA ONION, THINLY SLICED

1/$_{2}$ TSP ANCHO CHILE POWDER

1/$_{2}$ TSP CUMIN SEEDS

1/$_{2}$ CUP/120 ML FRESH ORANGE JUICE

2 CUPS/480 ML CHICKEN STOCK

1 ORANGE, CUT CROSSWISE INTO ROUNDS 1/$_{2}$ IN/12 MM THICK

EAST ASIAN CHICKEN

EAST ASIAN CHICKEN

I'm devoted to Asian food. Maybe that's because so much of it is so
elegantly spicy. The predominant flavors you'll find here—fresh
ginger, fish sauce, cilantro, lime, mint—lure me back for more over
and over again. Simple, unassuming, light, and tropical, this food
reminds me of Thailand—the luxurious silks, the saffron robes, the
fine beach sand that gets into everything. Be sure to have on hand
Thai fish sauce (*nam pla*); some dark soy sauce like the mushroom
soy I often call for; and *sambal oelek*, or Asian chili paste with
garlic. A supply of jasmine rice will see you through the chapter
and a package of cellophane noodles (made from mung beans) will
come in handy.

DRINKS

Offer me a light, lemony hefeweizen. Hitachino makes my favorite. The company also makes a white ale that's just about as good a beer as I've ever had. I'll also happily drink a crisp, grapefruit-scented Sauvignon Blanc with spicy food. Rieslings are good, too, because they can stand up to the big flavors in this chapter.

ON THE TABLE

I love the way my table looks when it is covered with small bowls—for sweet sauces, hot sauces, soy sauces, and chiles. Pretty chopsticks can add to the cacophony of color and, as one of the many people in the world who tends to eat too fast, I use chopsticks whenever I can, if only to slow myself down. Some of the Chinese or Japanese dishes here would traditionally be eaten with chopsticks. The Thai food would not—but there's no rule against it.

SWEETS

The fruit of Asia is so gorgeous, it's hard for me to move beyond it when it comes to dessert. Papaya with lime and salt? There's always coconut milk to be transformed into puddings or poured over sliced mango, or watermelon to be frozen and blended into an icy slush and sprinkled with salt and hot chiles.

CRISPY CHICKEN SALAD

SERVES 4

I'm sorry to admit that the first time I made this salad I
ate almost the whole thing right out of the mixing bowl. I
guess I was hungry. Or maybe it had to do with the fact that
this combination is ridiculously refreshing, salty, sweet, and
savory—all at once.

1/4 CUP/60 ML FRESH LIME JUICE

2 TBSP PEANUT OIL

1 BIRD'S-EYE OR OTHER FRESH HOT CHILE, MINCED

1 TSP THAI FISH SAUCE

1/2 TSP KOSHER SALT

1 ENGLISH CUCUMBER

3 CUPS/250 G SHREDDED NAPA CABBAGE

4 GREEN ONIONS, WHITE AND TENDER GREEN PARTS, THINLY SLICED

1/2 CUP/20 G CHOPPED CILANTRO LEAVES

1/2 CUP/20 G CHOPPED FRESH THAI BASIL LEAVES

1/2 CUP/20 G CHOPPED FRESH MINT LEAVES

1 MEDIUM PAPAYA, ABOUT 2 LB/910 G, PEELED, SEEDED, AND CUBED

2 CUPS/400 G CHOPPED COOKED CRISPY ROAST CHICKEN (PAGE 27)

1/4 CUP/3.5 G PUFFED RICE

FLAKY SALT FOR FINISHING

In the bottom of a big salad bowl, mix the lime juice, peanut oil,
chile, fish sauce, and kosher salt.

Cut the cucumber in half lengthwise and then crosswise into slices
1/2-in/12-mm thick. Add the cucumber, cabbage, green onions, cilantro,
basil, mint, and papaya to the bowl with the dressing. When you're
ready to serve the salad, toss gently to distribute the ingredients
evenly and then top with the chopped chicken. Finish with a sprin-
kling of puffed rice and a pinch of flaky salt.

CHIANG MAI GREEN CURRY

SERVES 4

This recipe is inspired by the green curry my father, Bruce, has cooked for me many times. Not for the shy or delicate, this is a profoundly spicy concoction that will give a spark to every cell in your body. You'll want a supply of icy lager, lime wedges, and a big centerpiece bouquet of napa cabbage and Thai basil to cool things off. Bites of the greenery will interrupt the effect of the chiles, confusing your brain just long enough to reach for another bite of the delicious curry.

8 BONE-IN, SKIN-ON CHICKEN THIGHS

KOSHER SALT

2 TBSP PEANUT OIL, PLUS MORE FOR THE CHICKEN

ONE 6-IN/15-CM PIECE FRESH GINGER, PEELED AND THINLY SLICED

4 GARLIC CLOVES, CRUSHED

2 STALKS LEMONGRASS, TENDER WHITE MIDSECTION ONLY , PEELED AND SLICED

3 TO 5 BIRD'S-EYE OR OTHER FRESH HOT CHILES, CUT INTO THIN ROUNDS WITH SEEDS INTACT

1/2 CUP/30 G CILANTRO ROOTS AND STEMS, CAREFULLY CLEANED, PLUS 1/4 CUP/10 G CHOPPED CILANTRO LEAVES

3 TBSP THAI FISH SAUCE, PLUS MORE IF NEEDED

ONE 13.5-OZ/400-ML CAN UNSWEETENED COCONUT MILK

2 CUPS/480 ML CHICKEN STOCK

1 MEDIUM GLOBE EGGPLANT, CUT INTO BITE-SIZE CUBES

2 KAFFIR LIME LEAVES

1 RED BELL PEPPER, SEEDED AND CUT LENGTHWISE INTO PINKIE-WIDE STRIPS

1/4 CUP/10 G CHOPPED FRESH MINT LEAVES

JASMINE RICE (PAGE 156)

Rub the chicken with peanut oil, sprinkle with kosher salt, and set on the countertop for 30 minutes or so to take the chill off before cooking.

Heat the 2 tbsp peanut oil in a 12-in/30-cm or larger cast-iron frying pan or a 5-qt/5-l or larger Dutch oven over medium heat. Working in batches, lay the thighs in the pan, skin-side down, and cook, turning frequently, for 10 minutes, or until nicely browned on both sides. Transfer the chicken to a plate.

Use either a food processor or a mortar and pestle to transform the ginger, garlic, lemongrass, chiles, cilantro roots and stems, and 3 tbsp fish sauce into a textured, slightly chunky paste. Skim the fat from the top of the can of coconut milk and add the fat to a large, heavy pan. Place the pan over medium-low heat and sauté the paste in it for 5 minutes, scraping the bottom frequently with a rubber spatula to avoid scalding. Add the chicken, coconut milk, stock, eggplant, and lime leaves and simmer, covered, over low heat for 25 minutes. Scrape and stir frequently.

Add the bell pepper and cook for 5 minutes longer before either inserting an instant-read thermometer into the thickest part of a thigh or by cutting into a thigh with a paring knife. The thermometer should register 175°F/80°C. If you're using a knife, look for clear, not red or pink, juices running from where you pierced the meat and opaque, barely pink flesh at the bone. If the chicken isn't done, roast for 5 to 10 minutes longer and check it again.

Taste the curry for seasoning and spice. It should be potent and delicious! Add a little fish sauce if it needs more salty flavor.

To serve, bring the whole pot to the table, sprinkle with the mint and cilantro leaves and pass the rice on the side.

LEMONGRASS CHICKEN STIR-FRY

SERVES 4

Forgo your local, so-so Chinese take-out—cook this tonight
instead. You'll be amazed at how delicious your own stir-fry can
be when you combine fresh vegetables, a few simple aromatics, a
dash of soy sauce, and top-quality chicken. If you
don't own a wok, use your biggest, heaviest frying pan
and turn the heat up all the way.

MARINADE

2 TSP CORNSTARCH

1 TSP WATER

2 TBSP DARK MUSHROOM SOY SAUCE

1 TSP FERMENTED BEAN PASTE (OPTIONAL)

1 TSP TOASTED SESAME OIL

6 TO 8 SKIN-ON CHICKEN THIGHS, BONED AND
CUT INTO BITE-SIZE CHUNKS

2 CARROTS, PEELED AND SHREDDED

1 TBSP RICE VINEGAR

1 TBSP RAW SESAME SEEDS

1 TBSP PEANUT OIL

2 CUPS/115 G BROCCOLI FLORETS

1 CUP/140 G SNAP PEAS, TRIMMED

$1/2$ RED BELL PEPPER,
CUT INTO PINKIE-WIDE STRIPS

$1/2$ GREEN BELL PEPPER,
CUT INTO PINKIE-WIDE STRIPS

$1/4$ CUP/40 G FRESH GINGER, PEELED AND
CUT INTO MATCHSTICKS

2 STALKS LEMONGRASS, TENDER WHITE
MIDSECTION ONLY, PEELED AND CHOPPED

2 GARLIC CLOVES, THINLY SLICED

1 OR 2 BIRD'S-EYE OR OTHER HOT CHILES, MINCED

$1/4$ CUP/30 G PEANUTS, CHOPPED

JASMINE RICE (PAGE 156)

$1/4$ CUP/10 G CHOPPED CILANTRO LEAVES

SOY SAUCE FOR SERVING

RAW HOT SAUCE (PAGE 112) OR
SRIRACHA SAUCE FOR SERVING

To make the marinade: In a large bowl, combine the cornstarch and
water and stir with a fork to make a paste. Add the mushroom soy
sauce, bean paste (if using), and sesame oil and stir.

Add the chicken to the marinade and turn to coat on all sides. Marinate at room temperature for at least 30 minutes and up to 1 hour, or cover and refrigerate up to 24 hours. (If refrigerating, return the chicken to room temperature for 30 minutes or so to take the chill off before cooking.)

Combine the carrots, vinegar, and sesame seeds in a small bowl, stir, and set aside. Heat a wok or large, heavy frying pan over high heat until very hot, 1 to 2 minutes, then add the peanut oil. Heat the oil until very hot but not smoking. Add the chicken to the wok, reserving the marinade. Toss and stir the chicken until it is nicely browned all over, 3 to 5 minutes. Remove the chicken to a plate and set aside.

Add the broccoli to the wok, along with the reserved marinade. Toss and stir until just tender, about 5 minutes, then add the snap peas, bell peppers, and carrot mixture. Toss and stir for 1 minute, then return the chicken to the wok, along with any juices accumulated on the plate, and add the ginger, lemongrass, garlic, chile(s), and peanuts. Toss and stir until the garlic softens and the liquid thickens. If the wok seems dry, add just enough water to make a sauce, stirring to scrape up any browned bits from the bottom of the pan.

Divide the rice among individual plates, scoop the stir-fry on top, and sprinkle with the cilantro to serve. Pass the soy sauce and Hot Sauce for those who like it salty *and* spicy.

SUMO WRESTLER STEW (*CHANKONABE*)

SERVES 4

This is a very soothing, and very Japanese, way to load
up on the carbohydrates: buckwheat udon next to potatoes
over rice—but with plenty of chicken and vegetables thrown
in for essential touches of protein and earthy flavor. If it's
one of those nights when you really want comfort food—
or you're planning on running a marathon the next
day—here it is, in a single bowl. The ingredient list is
long and a little weird. Look for burdock, kombu, udon,
and miso paste in any well-stocked Asian grocery or
health-food store. Your reward will be a stunning,
complex soup and an outstanding night's rest.

Heat the peanut oil in a 12-in/30-cm or larger cast-iron frying pan or a 5-qt/5-l or larger Dutch oven. Set the chicken in the pan and cook over medium heat until nicely browned on the sides and bottom, about 10 minutes. No need to to brown the top. Transfer the chicken to a plate and pour off any excess fat in the pan.

Skim the fat from the top of the can of coconut milk and add the fat to the pan along with the garlic, ginger, bok choy, bell pepper, mushrooms, and turmeric. Cook over medium heat, stirring often, for 5 to 8 minutes, or until the bell pepper and mushrooms are soft and the garlic is fragrant. Stir in the fish sauce, coconut milk, and water. Return the chicken to the pan, breast-side up.

Put the chicken in the oven and braise, uncovered, for 30 minutes before either inserting an instant-read thermometer into the thickest part of a thigh or cutting into a thigh with a paring knife. The thermometer should register 175°F/80°C. If using a knife, look for clear, not red or pink, juices running from the spot where you pierced the meat and opaque, barely pink flesh at the bone. If the chicken isn't done, cook for 5 to 10 minutes longer and check it again.

When the chicken is done, remove the pan from the oven and let the chicken rest for 5 minutes before you carve it (see page 18). (Do this right in the pan, if you can manage.) Pour the liquid from the pan into a fat separator. (You can also use a heatproof jar and use a spoon to skim off as much of the fat as possible.) Serve with plenty of the sauce, the mint and cilantro, and a pinch of flaky salt.

— JASMINE RICE —

The best jasmine rice comes from Thailand and has a date on the bag. Jasmine rice served with spicy Asian dishes should not be salted.

1 1/2 CUPS/285 G JASMINE RICE 3 CUPS/720 ML WATER

Rinse the rice in a colander under cold running water until the water runs clear. Drain off any remaining water and transfer the rice to a saucepan with a tight-fitting lid. Add the 3 cups/720 ml water, place over medium heat, cover, and cook until the rice is tender and the water has evaporated, 12 to 15 minutes. Fluff with a fork before serving.

BLACK SOY THIGHS
WITH SHELL BEANS AND COCONUT RICE

SERVES 4

Chicken marinated in mushroom soy sauce is dark, smoky, and delicious. Cook it outdoors over hardwood charcoal or plain hardwood. Add the zing of hot chile peppers and this will be something you'll want to eat once a week. The chicken pairs beautifully with the fresh herbs, beans, and coconut-scented rice.

— BLACK SOY THIGHS —

3 TBSP *SAMBAL OELEK* OR CHILE-GARLIC SAUCE

3 TBSP MUSHROOM SOY SAUCE (SUBSTITUTE REGULAR SOY SAUCE IF NECESSARY)

3 TBSP THAI FISH SAUCE

1 TBSP PEANUT OIL

8 TO 10 BONE-IN, SKIN-ON CHICKEN THIGHS

1/4 CUP/10 G COARSELY CHOPPED CILANTRO LEAVES

1/4 CUP/10 G COARSELY CHOPPED MINT LEAVES

FLAKY SALT FOR FINISHING

Stir together the *sambal oelek*, soy sauce, fish sauce, and peanut oil in a glass baking dish. Add the chicken and turn to coat on both sides. Marinate at room temperature for at least 30 minutes and up to 1 hour, or cover and refrigerate up to 24 hours. (If refrigerating, return the chicken to room temperature for 30 minutes or so to take the chill off before cooking.)

\Rightarrow

Build a medium fire in a charcoal or wood grill or heat a gas grill to medium. Use a clean, well-cured grate. If you are using charcoal or wood, you want hot embers, not flames.

Remove the thighs from the marinade and put them, skin-side down, on the grill and let them cook for 5 minutes or so before you move them. After that, I like to flip them every 5 minutes or so to keep them from sticking and to keep from burning the skin. Plan on standing, turning, flipping, and generally worrying the chicken for 30 to 40 minutes.

If your chicken is burning or the fat is igniting flames, turn the heat down or move the chicken to a cooler spot on the grill. (You can also douse the flames with a squirt bottle if there's no room to move the chicken out of the way.) Work slowly and the result will be a deep-mahogany-colored exterior concealing a well-cooked but juicy interior. That smoky flavor and crispy skin are worth the wait.

When the chicken is done, you will see that it has shrunk considerably. The meat should be firm but with a little give when you poke it with your finger. An instant-read thermometer inserted into the thickest part of a thigh should register 175°F/80°C. If you're unsure, cut into a piece to take a peek. Look for clear, not red or pink, juices running from the spot where you pierced the meat and opaque, barely pink, flesh at the bone.

Let the chicken rest for 5 minutes, then sprinkle on the cilantro, mint, and a pinch of flaky salt. Platter it and bring it to the table.

— SHELL BEANS —

I love fava beans, but fresh lima beans, cranberry beans, or chickpeas are also delicious. Use frozen limas or, better yet, edamame if you can't sniff out any fresh beans.

2 TBSP OLIVE OIL

1 LARGE SHALLOT, MINCED

2 CUPS/280 G SHELLED FRESH OR FROZEN BEANS SUCH AS FAVA, LIMA, CRANBERRY, OR CHICKPEA, PEELED IF NECESSARY (SEE PAGE 21)

1 TBSP DARK SOY SAUCE

1/4 CUP/10 G COARSELY CHOPPED CILANTRO LEAVES

In a heavy sauté pan, heat the olive oil. Combine the shallot and the beans, cooking over low heat for 5 to 7 minutes or until tender but not mushy (for frozen beans, rinse first in hot water to remove any ice crystals). Add the soy sauce. Taste for seasoning, adding more soy sauce as needed. Transfer to a bowl and toss with the cilantro before serving.

— COCONUT RICE —

A welcome change from plain rice, with a subtle sweetness and mellow, rich quality.

1 CUP/190 G JASMINE RICE

ONE 13.5-OZ/400-ML CAN UNSWEETENED COCONUT MILK

1/2 TSP KOSHER SALT

1/4 CUP/30 G SHREDDED UNSWEETENED COCONUT, TOASTED (SEE PAGE 21)

FLAKY SALT FOR FINISHING

Rinse the rice in a colander under cold running water until the water runs clear. Drain off any remaining water and transfer the rice to a saucepan with a tight-fitting lid. Add the coconut milk and salt, place over medium heat, cover, and cook until the rice is tender and the liquid has evaporated, 15 to 20 minutes. Fluff with a fork and transfer to a bowl. Sprinkle with the coconut and a pinch of flaky salt before serving.

KOREAN FRIED CHICKEN
WITH SWEET-AND-SPICY SAUCE,
ROASTED SHISHITO PEPPERS,
AND BLACK SESAME RICE BALLS

SERVES 4

Korean fried chicken has a cult following these days.
It's anyone's guess what gives it the kind of audience it
has. Maybe it's as simple as this: you transform something as
primally delicious as fried chicken into super-spicy fried
chicken. I've made this version as fiery, crispy, and
obsession-worthy as possible.

— KOREAN FRIED CHICKEN —

1/4 CUP/60 ML *SAMBAL OELEK*

2 TSP KOSHER SALT

8 TO 10 BONE-IN, SKIN-ON CHICKEN THIGHS

1 1/2 CUPS/190 G ALL-PURPOSE FLOUR

1/4 CUP/30 G CORNSTARCH

1 TSP CAYENNE PEPPER

PEANUT OIL FOR DEEP-FRYING

3 GREEN ONIONS SLICED

SWEET-AND-SPICY SAUCE (PAGE 162)

Combine the *sambal oelek* and 1 tsp of the salt in a large bowl. Add
the chicken and toss to coat. Marinate at room temperature for at
least 30 minutes and up to 1 hour, or cover and refrigerate up to
24 hours. (If refrigerating, return the chicken to room temperature
for 30 minutes or so to take the chill off before cooking.)

When you're ready to cook, combine the flour, cornstarch, remaining 1 tsp salt, and cayenne in a large bowl and set aside.

Set the temperature on a deep-fryer for 365°F/185°C. Fill it one-third full of peanut oil, or enough so that the chicken thighs will be fully covered but not so deep that there's any danger of the oil overflowing. (If you prefer, use a heavy stockpot or large Dutch oven. Put the pot over medium-high heat and clip a deep-frying thermometer to the side of the pot, or use your instant-read thermometer. You want the oil at a steady 365°F/185°C.)

When the oil is hot, remove a thigh from the marinade and dredge it in the flour mixture to coat on both sides. Repeat with a few more thighs; work in manageable batches of three or four thighs at a time. Lower them into the hot oil. Adjust the heat as needed to return the oil to 365°F/185°C, but keep it low enough so that the chicken doesn't burn. The oil should not smoke. Cook for 6 minutes, turning the thighs halfway through. Using a wire mesh strainer or a slotted spoon, transfer to a plate. Shake off any excess oil or bits that may be clinging to the chicken. Repeat to fry the rest of the thighs.

Let all the thighs cool for at least 10 minutes before the second round of frying. Return the oil to 365°F/185°C. Dredge the partially cooked chicken pieces in the flour mixture again before lowering them into the oil. Turn the chicken frequently, as often as every 3 minutes. This will prevent one side from burning. To cook through, the chicken may take as long as 15 to 20 minutes total. It should not blacken, but will get very dark. The cooking time will depend on how big the thighs are and on how many you cook at one time.

Either insert an instant-read thermometer into the thickest part of a thigh or cut into a thigh with a paring knife. The thermometer should register 175°F/80°C. If using a knife, look for clear, not red or pink, juices running from the spot where you pierced the meat and opaque, barely pink meat at the bone.

When the chicken is done, transfer it to a wire rack and sprinkle with the green onions. Serve hot, drizzled with the Sweet-and-Spicy Sauce.

— SWEET-AND-SPICY SAUCE —

If you are unable to find Tien Tsins, you can substitute
habanero or serrano chiles.

5 TIEN TSIN CHILES, FRESH OR DRIED

1 RIPE TOMATO, CUT INTO CHUNKS

1 TBSP RAW SUGAR

1 TBSP DARK SOY SAUCE

1 TBSP SESAME SEEDS

Combine all the ingredients in a small saucepan and simmer over
medium heat for 15 minutes. Transfer the contents of the pan to a
blender and process until smooth.

— ROASTED SHISHITO PEPPERS —

These peppers really are trendy, but I don't care. I'm in love.
They can be difficult to find—ask around your farmers'
market. Trust me, a pound is not too much for four people—if
you've got a hungry crowd that loves a little spice roulette,
have at it. Every tenth one of these mostly sweet, slightly
spicy peppers will set your mouth ablaze.

1 LB/455 G SHISHITO PEPPERS

3 TBSP PEANUT OIL

KOSHER SALT

FLAKY SALT FOR FINISHING

Preheat the oven to 500°F/260°C/gas 10.

Toss the peppers in the peanut oil and sprinkle with a pinch of
kosher salt. Roast the peppers with plenty of room between them
on a baking sheet. Shake the pan after about 5 minutes to help the
peppers brown more evenly. Ideally, you want them blistered, with
little flecks of black. If your oven isn't up to the job, don't worry.
Browned and soft is just fine. Pile the peppers on a platter, give
them a final pinch of flaky salt, and eat them hot.

— BLACK SESAME RICE BALLS —

Here's a recipe for rice that looks like snowballs—or, with
flecks of green onion, like something you'd find on the pages
of a Dr. Seuss book. This is a fun way to eat rice; besides,
the rice balls make a great little sponge to soak up any
errant sauce or chicken juices you might have left behind
on your plate.

2 CUPS/380 G SWEET OR STICKY RICE

4 CUPS/960 ML WATER

6 GREEN ONIONS, WHITE AND TENDER GREEN PARTS
ONLY, CHOPPED

1 TBSP THAI FISH SAUCE

1 TBSP BLACK SESAME SEEDS

FLAKY SALT FOR FINISHING

Add the rice to a saucepan with a tight-fitting lid. Add the water,
place over medium-low heat, cover, and cook until the rice is tender
and the water has evaporated, 15 to 20 minutes. Watch for sticking
toward the end of the process.

Let the rice cool for 10 minutes, add the green onions and fish
sauce, and then use an ice-cream scoop to form as many mounds as
you have rice—you should end up with around ten mounds. Wet your
hands and gently shape each portion into a ball—don't pack it
together too tightly. Scatter the sesame seeds on top along with a
pinch of salt and serve.

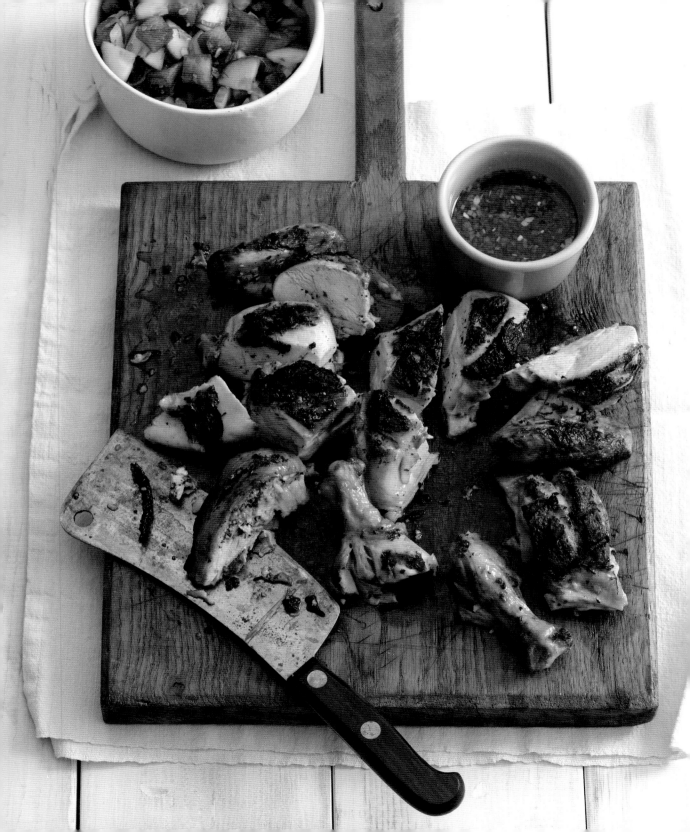

GAI YANG
WITH BIRD'S-EYE CHILE DIPPING SAUCE AND WATERMELON-CUCUMBER SALAD

SERVES 4

In 1988 my father, Bruce, sold his restaurant Rose et LeFavour in St. Helena, CA, and took off to spend his first of several winters in Bangkok. He rented a small house on a dirt street, Soy Pra Atit, just blocks away from the Bang Lamphu shopping district. On the hottest days, tired from studying Thai at the language school, he would walk down to a take-out restaurant in that neighborhood where they cooked and sold only one item—*gai yang*. (The literal translation of *gai yang* is "cooped chicken" as opposed to *gai ban*, which means "yard chicken.") He'd stand in a long line to order and then hang around for fifteen to twenty minutes while the chickens were grilled over a big charcoal fire. The wait was worth it. Half a large chicken, blistered and juicy, was 18 *baht* (50 cents), a whole one was 30 *baht* (80 cents), and each order came with a cup of sauce and a large scoop of jasmine rice. (Don't forget to make a big pot.) He ordered his cleavered into wonderfully irregular bony bits, and that's how I recommend you do it here.

— GAI YANG —

1 HEAD GARLIC, CLOVES PEELED AND MINCED

20 BLACK PEPPERCORNS

5 CILANTRO ROOTS OR
1 LARGE BUNCH CILANTRO WITH STEMS, CHOPPED

1 TBSP THAI FISH SAUCE

2 TSP RAW SUGAR

ONE 3- TO 4-LB/1.4- TO 1.8-KG CHICKEN

JASMINE RICE (PAGE 156)

Combine the garlic, peppercorns, cilantro, fish sauce, and sugar together in a mortar. Using a pestle, pound into a paste. (If you don't have a mortar and pestle, crush the garlic and peppercorns with the side of a knife, chop the cilantro and garlic as finely as you can, and stir well in a bowl. You won't have a paste, but it'll be just fine.)

Place the chicken on a baking sheet or in a roasting pan and slash across the breast, thighs, and legs with a knife. Rub the paste all over the chicken and into the cuts you've made. Marinate at room temperature for at least 1 hour and for up to 2 hours, or refrigerate for up to 24 hours. (If refrigerating, return the chicken to room temperature for 30 minutes or so to take the chill off before you cook it.)

Build a medium fire in a charcoal or wood grill or heat a gas grill to medium. Use a clean, well-cured grate. If you are using charcoal or wood, you want hot embers, not flames.

Butterfly the chicken (see page 14). Put the chicken skin-side down on the grill, laying it flat. Let cook for 5 minutes or so before you move it. After that, I like to flip the chicken every 5 minutes or so to keep it from sticking and to keep from burning the skin. Because you have a whole butterflied chicken, most of the time on the grill will be spent skin-side down. Nonetheless, plan on standing, turning, flipping and generally worrying the chicken for 30 to 40 minutes. A few black spots in this case are in the spirit of the meal.

If the fat or chicken is burning or is igniting flames, turn the heat down or move the chicken to a cooler spot on the grill. (You can also douse the flames with a squirt bottle if there's no room to move the chicken out of the way.) The meat should be firm but with a little give when you poke it with your finger. An instant-read thermometer inserted into the thigh should read 175°F/80°C. If you're unsure, cut into a thigh and take a peek. Look for clear, not red or pink, juices running from the spot where you pierced the meat and opaque, barely pink flesh at the bone.

Transfer the cooked chicken to a cutting board. Using a cleaver—or your biggest, sharpest knife—chop the whole chicken into a dozen pieces or so. You will be chopping right through the bones. This is a fun but messy job—don an apron and go at it without hesitation. Serve the chopped chicken on a platter with plenty of rice.

— BIRD'S-EYE CHILE DIPPING SAUCE —

If you don't have bird's-eye chiles, substitute the hottest
chiles you can find—habaneros would be my choice. If you
don't have very hot chiles, the sauce will be too sweet.

3 TO 5 BIRD'S-EYE CHILES, MINCED

2 GARLIC CLOVES, MINCED

1/3 CUP/65 G RAW OR PALM SUGAR

1/4 CUP/60 ML WATER

1/4 CUP/60 ML RICE VINEGAR

Make sure your ingredients are properly minced. Give them a few
pounds in a mortar and pestle if you have one, or lay a large knife
across the chiles and garlic and press down hard to crush them.
Heat the sugar and water in a small saucepan over low heat until
the sugar dissolves. Add the vinegar, chiles, and garlic and bring the
mixture to a simmer. Cook until fragrant, 1 or 2 minutes, then trans-
fer the sauce to dipping bowls to cool before serving.

— WATERMELON-CUCUMBER SALAD —

I first made this salad on a scorching day in July. It's a
little sweet, a little salty, and—if you run it around on
your plate—just a little spicy. At risk of sounding immodest,
it's also crazy good.

6 CUPS/850 G SEEDED AND CUBED WATERMELON

1/2 ENGLISH CUCUMBER, QUARTERED
LENGTHWISE AND THEN CUT CROSSWISE INTO
SLICES 1/4-IN/6-MM THICK

1/4 CUP/10 G CHOPPED FRESH THAI BASIL LEAVES

1/4 CUP/10 G CHOPPED FRESH MINT LEAVES

PINCH OF KOSHER SALT

Toss everything together in one big bowl and serve. If you need to
work ahead, set aside the herbs and salt to toss in just before you
take it to the table.

PHUKET BEACH CART SANDWICHES
WITH SAMBAL MAYONNAISE
AND CARROT-MUNG BEAN SALAD

SERVES 4

Breadwise, there are two ways to go with this brilliant sand-
wich. One route: Use a pillowy soft hamburger bun as a vehicle
for the chicken patty so that nothing gets in the way of
your enjoyment of the spicy, rich meat. The second choice is
to go for more texture and flavor, opting for something like
toasted sourdough levain. The choice isn't an easy one . . .
perhaps it's best to have one of each.

— PHUKET BEACH CART SANDWICHES —

2 LB/910 G BONELESS CHICKEN THIGHS

2 OR 3 BIRD'S-EYE OR HABANERO CHILES,
COARSELY CHOPPED

1 TSP CORIANDER SEEDS

1/3 CUP/75 ML THAI FISH SAUCE

1 TBSP RAW SUGAR

2 TSP BAKING POWDER

1/2 TSP GROUND CINNAMON

8 SLICES SOURDOUGH BREAD OR
4 HAMBURGER BUNS, SPLIT

SAMBAL MAYONNAISE (RECIPE FOLLOWS)

1 CUP/40 G CILANTRO LEAVES

Preheat the oven to 300°F/150°C/gas 2.

Cut the chicken into chunks and combine with the chiles (the more
seeds you add, the hotter the mix will be), coriander seeds, fish
sauce, sugar, baking powder, and cinnamon in a bowl. Working in
batches, process the mixture to a paste in a food processor. Stop

the machine to scrape down the sides of the bowl as needed. There should be no chunks of chicken or visible strands of sinew.

Using an ice-cream scoop or a large spoon, divide the paste into four balls, scooping them onto a parchment paper-lined baking sheet. Gently flatten each ball into a bun-size patty and bake until the meat is opaque through the center (cut one open to peek), about 30 minutes. An instant-read thermometer inserted into the center should register 160°F/71°C.

Toast the bread. Let cool, then smear each slice with a generous coating of the mayonnaise. Layer some cilantro on each slice of bread. Lay a patty on the cilantro and close up the sandwiches with another herb-and-mayo-layer. This beats a burger any day.

— SAMBAL MAYONNAISE —

1/2 CUP/120 ML HOMEMADE OR BEST-QUALITY STORE-BOUGHT MAYONNAISE

1 TBSP *SAMBAL OELEK*

SWEET CHILE SAUCE

Mix together the mayonnaise, *sambal oelek*, and chile sauce to taste in a small mixing bowl. You're done!

— CARROT-MUNG BEAN SALAD —

1 1/2 CUPS/300 G MUNG BEANS

1 BIRD'S-EYE CHILE OR OTHER FRESH HOT CHILE, MINCED

2 TBSP FRESH LIME JUICE

2 TBSP THAI FISH SAUCE

2 TBSP PEANUT OIL

5 LARGE CARROTS, ABOUT 1 LB/450 G TOTAL WEIGHT, PEELED AND DICED

2 TBSP BLACK SESAME SEEDS

1/2 TSP KOSHER SALT

Bring a large pot of water to a boil and add the mung beans and chile. Cook for 25 minutes. Drain. Add the lime juice, fish sauce, peanut oil, carrots, sesame seeds, and salt. Toss and serve.

CHAPTER 5 SOUTH ASIAN CHICKEN

SOUTH ASIAN CHICKEN

Working on the recipes for this chapter was a challenge of the best kind. I used to cheat when I made curry, using the pastes that you can buy at Asian groceries as the bases of my sauces. There's nothing wrong with these convenient little tubs, but the flavor doesn't come close to the colossal flavor you get when you mix together the litany of spices, herbs, and aromatics yourself. Getting all these items together just requires a little shopping—it's not hard. This food is unmistakable—made for subcontinental heat but surprisingly gratifying to eat over a heap of buttery rice in the deep chill of winter.

In a perfect world, your pantry would have black, green, *and* brown cardamom pods; turmeric, peppercorns, cumin, coriander, fenugreek seeds, garam masala, and mustard seeds; garlic; fresh ginger; chickpea flour; and plenty of onions. To get the flavor and heat that distinguishes this region's cuisine, your pantry would also boast plenty of chiles. Sanaam chiles are traditional, but I've only found them dried. For fresh chiles, I use other varieties, including serrano, jalapeño, arbol, and Cherry Bomb. To add to your arsenal of dried chiles, try the exciting cascabel and Dundicut varieties.

DRINKS

A tall glass of toasty, milky chai over ice is delicious with fiery dishes. Of course, there's nothing so refreshingly Indian as a *lassi*. Whip up one of these sweet-tart smoothies in the blender with yogurt, fresh mango, and ice. It will definitely cut the heat of the spiciest curry. If you're in the mood for beer, find one with the body and complexity to hold its own next to this food. I like a pale ale such as Sierra Nevada.

ON THE TABLE

I love to make spicy peanuts by frying them up with a little butter, some fresh or dried chiles, and a mix of ground cinnamon, cardamom, allspice, and salt. The peanuts are irresistible when eaten while still warm from the pan. The Onion Flatbread on page 186 makes a delicious substitute for naan, the traditional bread of India. (If you don't have time for homemade bread, there are some very good commercial naan available. Refresh it by sticking it briefly in a 400°F/200°C/gas 6 oven and coating it with a gloss of salted butter.)

SWEETS

Make a rich, not-too-sweet rice pudding with plenty of raisins, coconut milk, cinnamon, and a pinch of salt. Pour some dark rum over it if you're feeling really decadent.

CHANA DAL WITH CHICKEN

SERVES 4

Every hot meal my sister, Nicole, and I ate during 30 days hiking from Jiri to Everest Base Camp in Nepal included dal in one form or another. I adore this warm, mildly spicy dish made with chickpeas rather than lentils (that's why it's called "chana"). Just smelling it cooking evokes that grueling trip with my extraordinary sister in one of the most rugged, beautiful places on Earth.

8 TO 10 BONE-IN, SKIN-ON CHICKEN THIGHS

2 TBSP PEANUT OIL, PLUS MORE FOR THE CHICKEN

KOSHER SALT

4 TO 6 FRESH CHILES SUCH AS SERRANO, ARBOL, OR JALAPEÑO, MINCED

1/4 CUP/30 G MUSTARD SEEDS

1 TBSP CUMIN SEEDS, TOASTED AND GROUND (SEE PAGE 21)

1 TSP GROUND TURMERIC

TWO 15-OZ/430-G CANS CHICKPEAS, THOROUGHLY RINSED AND DRAINED

2 CUPS/480 ML CHICKEN STOCK

FLAKY SALT FOR FINISHING

1/2 CUP/20 G CHOPPED CILANTRO LEAVES

TOSSED GREENS (PAGE 37)

BASMATI RICE (PAGE 193)

Preheat the oven to 450°F/230°C/gas 8. Rub the chicken with peanut oil, sprinkle with kosher salt, and set on the countertop for 30 minutes or so to take the chill off before cooking.

Heat 1 tbsp of the peanut oil in a 12-in/30-cm or larger cast-iron frying pan over medium heat. Working in batches, lay the thighs in the pan, skin-side down, and cook, turning frequently, for 10 minutes, or until nicely browned on both sides. Transfer the chicken to a plate and pour off any excess fat but don't wash the pan.

Reduce the heat to medium-low, add the remaining 1 tbsp peanut oil to the pan, and add the chiles, mustard seeds, cumin, turmeric, and 1 tsp kosher salt. Cook, stirring frequently, until the spices are fragrant and the mustard seeds begin to pop, 3 to 5 minutes. Add the chickpeas and stock and stir. Using a potato masher or the back of a spatula, crush the chickpeas gently until you have a blend of coarsely mashed and whole beans.

Tuck the chicken thighs into the beans, skin-side up. The thighs should be nestled in the hot liquid, but not submerged. Add any juices from the plate and put the pan in the oven. Roast for 25 minutes before either inserting an instant-read thermometer into the thickest part of a thigh or cutting into a thigh with a paring knife. The thermometer should register 175°F/80°C. If using a knife, look for clear, not red or pink, juices running from the spot where you pierced the meat and opaque, barely pink flesh at the bone. If the chicken isn't done, cook for another 5 to 10 minutes longer and check it again. When the chicken is done, remove it from the oven and let rest for 5 minutes.

Portion out the dal onto plates or shallow bowls and put two or three chicken thighs on top. Sprinkle with a pinch of flaky salt and scatter the cilantro on top before serving. Pass the Tossed Greens and Basmati Rice at the table.

CHICKEN-VEGETABLE KADHI

WITH CHICKPEA CAKES AND YOGURT-MINT SAUCE

SERVES 4

Kadhi just means yogurt-based curry. If you want a smooth, lovely sauce, follow the instructions for mixing the chickpea flour into the yogurt. The starch stabilizes the yogurt so that it won't curdle when you add it to the hot pan or heat it as you cook the chicken. The results should be a rich, spicy, smooth sauce and succulent chicken thighs.

There's a lot of cardamom in this recipe—green, brown, and black. The black cardamom (or so-called Nepali variety) is the strongest; the brown a close second; and the green much milder. If you don't have cardamom of many colors, don't worry—use what you have. Add some of the Mixed Condiments on page 191 to brighten your plates, if you like.

— CHICKEN-VEGETABLE KADHI —

<u>MARINADE</u>

1/2 HEAD GARLIC, CLOVES PEELED AND
CRUSHED BUT LEFT WHOLE

TWO 6-IN/15-CM PIECES FRESH GINGER, PEELED,
HALVED, AND THINLY SLICED

JUICE OF 1 LEMON

1 TBSP KOSHER SALT

1 TBSP RAW SUGAR

3 FRESH HOT CHILES SUCH AS ARBOL, SERRANO, OR
SANAAM, CUT INTO THIN ROUNDS,
WITH SEEDS INTACT

1 TBSP PEANUT OIL

8 TO 10 BONE-IN, SKIN-ON CHICKEN THIGHS

2 CUPS/480 ML WHOLE PLAIN YOGURT

2 TBSP CHICKPEA FLOUR OR
1 TBSP ALL-PURPOSE FLOUR

3 TBSP PEANUT OIL

6 GREEN CARDAMOM PODS

4 BROWN OR BLACK CARDAMOM PODS

1 TBSP CORIANDER SEEDS

1 TBSP FENUGREEK SEEDS

1 TSP CUMIN SEEDS

1 TSP GROUND TURMERIC

1 TSP GARAM MASALA

2 YELLOW ONIONS, COARSELY CHOPPED

2 TOMATOES, CHOPPED

1 HEAD CAULIFLOWER, TRIMMED AND CUT INTO
BITE-SIZE FLORETS

1 RED OR ORANGE BELL PEPPER,
SEEDED AND COARSELY CHOPPED

FLAKY SALT FOR FINISHING

To make the marinade: Stir together the garlic, ginger, lemon juice, salt, sugar, chiles, and peanut oil in a mixing bowl.

Add the chicken to the marinade and turn to coat on both sides. Marinate at room temperature for at least 1 hour and up to 2 hours, or cover and refrigerate up to 24 hours, turning occasionally. (If refrigerating, return the chicken to room temperature for 30 minutes or so to take the chill off before cooking.)

When you're ready to cook, remove the chicken from the marinade, reserving the marinade.

In a small bowl, work a little yogurt into the chickpea flour to form a loose paste, slowly adding more yogurt until the yogurt is integrated. Use a whisk to smooth out any lumps. Set aside.

In a 12-in/30-cm or larger cast-iron frying pan or a 5-qt/5-l or larger Dutch oven, heat 1 tbsp of the peanut oil over medium heat. Working in batches, lay the chicken thighs in the pan, skin-side

down, and cook, turning frequently, for 8 to 10 minutes, or until nicely browned on both sides. Transfer the chicken to a plate and pour off any excess fat but don't wash the pan.

Add the remaining 2 tbsp peanut oil to the pan and heat over low heat. Add the green and brown cardamom, the coriander, fenugreek, cumin, turmeric, and garam masala. Cook the spices until fragrant, 2 to 3 minutes. Use a rubber spatula to keep the spices from sticking and burning. Add the marinade from the chicken and cook for 30 seconds, then add the onions and sauté for about 10 minutes, or until they begin to brown and stick. Stir in the tomatoes and then immediately add the yogurt mixture, beginning with just a spoonful and then slowly but steadily whisking in the rest. Finally, add the chicken along with the cauliflower and bell pepper.

Cover and cook over medium-low heat until the vegetables are tender and the chicken is cooked through, 25 to 30 minutes. An instant-read thermometer inserted into the thickest part of a thigh should register 175°F/80°C. If you're unsure, cut into the thigh to take a peek. Look for clear, not red or pink, juices running from the spot where you pierced the meat and opaque, barely pink flesh at the bone.

Taste the sauce and adjust its flavor with a pinch of salt or extra chiles before serving.

— CHICKPEA CAKES —

I gobble up these little cakes the same way I do Jujyfruits at the movies. Don't miss out.

1 TBSP BUTTER OR OLIVE OIL

1 TSP CUMIN SEEDS

1 TSP CORIANDER SEEDS, LIGHTLY CRUSHED

1 TBSP MUSTARD SEEDS

1 TSP MINCED DRIED DUNDICUT OR SANAAM CHILE OR 1 FRESH HABANERO OR SERRANO CHILE, MINCED

2 CUPS/220 G CHICKPEA FLOUR

1¼ CUPS/300 ML BOILING WATER

1 EGG, BEATEN

1 TSP KOSHER SALT

2 TBSP PEANUT/GROUNDNUT OIL

FLAKY SALT FOR FINISHING

YOGURT-MINT SAUCE (RECIPE FOLLOWS)

Melt the butter in a small saucepan over medium heat. Add the cumin, coriander, mustard seeds, and chile and cook, stirring frequently with a rubber spatula, until the mustard seeds pop and you are hit by the wonderful smell of toasting cumin, about 2 minutes. Transfer to a small dish and set aside.

In a heat-proof bowl, combine the chickpea flour and boiling water. Whisk until the mixture is thoroughly combined and smooth. Add the toasted spice mixture, the egg, and kosher salt and stir to mix well. The batter should be a little thicker than pancake batter—soft, but not at all runny.

In a large frying pan or on a griddle, heat the peanut oil over medium heat until shimmering but not smoking. Do a quick test cake, dolloping a heaping spoonful of batter into the hot pan for a small pancake about the diameter of a lime. It should sizzle and brown on one side in 3 to 5 minutes; flip it and cook until nicely browned and the center is not at all gooey, 2 to 3 minutes longer.

When you feel your pan is just hot enough, repeat to fry the remaining chickpea cakes, working in batches to avoid crowding the pan. Transfer the cooked cakes as they are finished to a wire rack or a plate lined with paper towels. Sprinkle with a pinch of flaky salt while they're still hot and serve with Yogurt-Mint Sauce.

— YOGURT-MINT SAUCE —

Sneaky spicy and cooling all at once—this sauce is supposed to trick your senses.

1 CUP/240 ML WHOLE PLAIN YOGURT

2 TBSP CHOPPED FRESH MINT

1 BIRD'S-EYE OR SERRANO CHILE, MINCED

1 TBSP FRESH LEMON JUICE

½ TSP KOSHER SALT

Mix everything together in a small, colorful bowl. Leave the chile's seeds out if you prefer a less spicy sauce.

CHICKEN ADOBO
WITH GRILLED PATTYPAN SQUASH

SERVES 4

Adobo, like a lot of words in the food world, means many different things to many people. To some, it's a rub. To others, it's a sauce. To the rest, it's a cooking method. Sorting through the differences reveals some common elements, which I've distilled here into a concoction representative of nothing so much as the massive human diaspora that has produced the rich mix of foods and flavors that belong precisely to nobody and to anybody. This meal is delicious with Red Rice (page 109) on the side.

— CHICKEN ADOBO —

ADOBO SAUCE

1/2 RIPE TOMATO, COARSELY CHOPPED

4 GARLIC CLOVES

1 TO 2 SCOTCH BONNET OR OTHER VERY HOT FRESH CHILE(S)

JUICE OF 1 LIME

1 TBSP PEANUT OIL

1/2 CUP/20 G FRESH OREGANO LEAVES, TORN INTO SMALL PIECES IF LARGE

1 TSP RAW SUGAR

1 TSP KOSHER SALT

2 TBSP CIDER VINEGAR

2 TBSP SOY SAUCE

1 TBSP PEANUT OIL

8 TO 10 BONE-IN, SKIN-ON CHICKEN THIGHS OR ONE 3- TO 4-LB/1.4- TO 1.8-KG, CHICKEN, BUTTERFLIED (SEE PAGE 14)

To make the adobo sauce: Combine the tomato, garlic, chile(s), lime juice, peanut oil, oregano, sugar, and salt in a blender or food processor. Pulse once or twice—blend just enough to mince the herbs. Transfer the sauce to a saucepan and cook over low heat until thickened, 5 to 8 minutes. Set aside.

Stir together the vinegar, soy sauce, and peanut oil in a glass baking dish. Add the chicken and turn to coat on both sides. Marinate at room temperature for at least 30 minutes and up to 1 hour, or cover and refrigerate up to 24 hours. (If refrigerating, return the chicken to room temperature for 30 minutes or so to take the chill off before cooking.)

Build a medium fire in a charcoal or wood grill or heat a gas grill to low. Use a clean, well-cured grate. If you are using charcoal or wood, you want hot embers, not flames.

Put the chicken, skin-side down, on the grill and let it cook for 5 minutes or so before you move it. After that, I like to turn it every 5 minutes or so to keep it from sticking and to keep from burning the skin. Plan on standing, turning, flipping, and generally worrying the chicken for 30 to 40 minutes.

If your chicken is burning or the fat is igniting flames, turn the heat down or move the chicken to a cooler spot on the grill. (You can also douse the flames with a squirt bottle if there's no room to move the chicken out of the way.) Work slowly and the result will be a deep-mahogany-colored exterior concealing a well-cooked but juicy interior. That smoky flavor and crispy skin are worth the wait.

When the chicken is done, you will see that it has shrunk considerably. The meat should be firm but with a little give when you poke it with your finger. An instant-read thermometer should register 175°F/80°C. If you're unsure, cut into the thickest part of a thigh to take a peek. Look for clear, not red or pink, juices running from the spot where you pierced the meat and opaque, barely pink flesh at the bone. When the chicken is cooked, paint a little of the adobo sauce on, flip, and coat the other side. Cook the chicken with the sauce briefly, but don't let it blacken.

Platter and serve with the adobo sauce on the side.

— GRILLED PATTYPAN SQUASH —

A treat of summer and, if you garden at all, from your own backyard. I love the shape and flavor of these beauties and they make a terrific side with the spicy chicken.

4 TO 6 PATTYPAN SQUASH, ABOUT 8 OZ/225 G TOTAL WEIGHT

1 TBSP PEANUT OR OLIVE OIL

$1/2$ TSP KOSHER SALT

Build a medium fire in a charcoal or wood grill or heat a gas grill to low. Use a clean, well-cured grate. If you are using charcoal or wood, you want hot embers, not flames.

Slice each squash in half by turning it on its side and cutting through from side to side to make $1/2$ in/12 mm slices. This preserves the pretty shape. Toss the pieces with the peanut oil and salt and grill until tender and slightly charred. Serve immediately.

MULLIGATAWNY WITH APPLE

AND ONION FLATBREAD

SERVES 4

This is as close to fast food as you'll find in this book.
The Mulligatawny with Apple recipe is designed to transform
leftover chicken into the best thing you've had all day. You
shouldn't have to shop—most of us have a tin of curry powder,
an apple, and a can of coconut milk sitting around. Don't miss
out on the Onion Flatbread because you're feeling lazy or
rushed. Let me prove to you that it requires no bread-making
skills and will take less than an hour from start
to finish. Most of all, you will love having this crispy
bread to dip into your fine soup.

A side of Tossed Greens (page 37) will complete this simple meal.

— MULLIGATAWNY WITH APPLE —

1 TBSP PEANUT OIL

1 YELLOW ONION, THINLY SLICED

3 GARLIC CLOVES, SLICED

1 TBSP MADRAS CURRY POWDER

4 CUPS/960 ML CHICKEN STOCK

3 CUPS/600 G CHOPPED CRISPY ROAST CHICKEN
(PAGE 27)

1 TART APPLE SUCH AS GRANNY SMITH,
PEELED AND DICED

JUICE OF $^1/_2$ LEMON

JUICE OF 1 LIME

1 CUP/240 ML UNSWEETENED COCONUT MILK

BLACK PEPPER

KOSHER SALT

$^1/_2$ CUP/20 G CHOPPED CILANTRO LEAVES

Heat the peanut oil over medium heat in a large saucepan or Dutch oven. Add the onion and cook, stirring frequently, until the onion is soft but not brown, 3 to 5 minutes. Add the garlic and curry powder. Cook for 1 to 2 minutes longer, or until you begin to smell the garlic and spices. Add the stock and chicken, cover, and simmer over low heat for 10 minutes. While the soup cooks, toss the apple with the lemon juice and set aside.

Whisk in the lime juice and coconut milk and season with a little pepper. Taste for salt—it will almost certainly need a good pinch. Ladle the soup into big bowls and garnish with the apples and cilantro before serving.

— ONION FLATBREAD —

Once of the best things to come out of the past decade in food is the no-knead bread revolution. Out with the intimidating myths, in with the simplicity of yeast, salt, and flour. You can do this and you'll be the hero of the house when you pull it off. (If you want in on a great cheat, just buy a round of pizza dough from your local pizza joint and go straight to the instructions for making the topping and rolling out the dough.)

2½ CUPS/315 G ALL-PURPOSE FLOUR

1 1/4 CUPS/300 ML WARM WATER (ABOUT 105°F/40°C BUT NO MORE THAN 110°F/43°C)

1½ TSP INSTANT DRY YEAST

1 TSP KOSHER SALT

1/4 CUP/60 ML OLIVE OIL, PLUS MORE FOR ROLLING THE DOUGH AND GREASING THE PAN

1 TBSP BUTTER

1 RED ONION, THINLY SLICED

½ TSP MADRAS CURRY POWDER

FLAKY SALT FOR FINISHING

Preheat the oven to 500°F/260°C/gas 10.

Mix the flour, water, yeast, kosher salt, and the ¼ cup olive oil together in a large bowl. It's not necessary to knead the dough, just mix it together. Set it somewhere warm, near the stove or oven is ideal, and let it do its work for 30 minutes or so. No need to cover it or in any way baby it. Heat the butter in a sauté pan over medium-low heat, add the onion and curry powder, and cook, stirring frequently, for 20 to 30 minutes, or until the onion is soft and beginning to caramelize. Set aside to cool.

Once the dough has shown some signs of life—risen slightly or begun to bubble—cut off a piece the size of a tennis ball. Add a little flour if it's crazy sticky. Once you can hold it without having it stick to your hands, drizzle some olive oil on your work surface and either roll the dough out with a rolling pin or flatten it with oily hands. Get it as thin as you can in any shape—without fussing. Transfer the dough to an oiled baking sheet and repeat. (Don't worry too much if the dough rips, just squish it back together and move on.) Once you have six to eight flatbreads, distribute the onion on the tops along with a pinch of flaky salt.

When you're close to eating, put the baking sheet with the flatbread in the oven and cook for 10 to 12 minutes or until the edges begin to brown. You do want them to crisp and even slightly blackened. Cut into irregular triangles and eat them hot or cold.

CURRIED CHICKEN
WITH FRIED OKRA
AND MIXED CONDIMENTS
SERVES 4

It was 1972 and my mom, Pat, had discovered "curry." Wherever
she got the recipe, it was different and it was all hers. I
loved it. The mellow curry powder-driven sauce, the pale yellow
of turmeric, the sweet coconut milk. Besides, when you're seven,
what's not to love when you get to pile your dinner with
raisins and that gummy super-sweet coconut sold in the tight
little bag? Here's my 2011 version of that memorable dish,
made with the kinds of spices and chiles you would have been
hard-pressed to find in New York, never mind in rural Colorado,
circa 1972. To serve, I like to fill the table with all of the
elements piled into serving dishes small and large—the curry,
Fried Okra, Basmati Rice (page 193), Mixed Condiments—all
making for a gorgeous table and a wonderfully chaotic meal
as everyone passes, grabs, eats, and talks.

— CURRIED CHICKEN —

8 TO 10 BONE-IN, SKIN-ON CHICKEN THIGHS

2 TBSP PEANUT OIL, PLUS MORE FOR THE CHICKEN

KOSHER SALT

2 CUPS/480 ML WHOLE PLAIN YOGURT

2 TBSP CHICKPEA FLOUR OR
1 TBSP ALL-PURPOSE FLOUR

1 YELLOW ONION, THINLY SLICED

5 GARLIC CLOVES, CRUSHED WITH THE SIDE
OF A CHOPPING KNIFE

ONE 6-IN/15-CM PIECE FRESH GINGER, PEELED AND
CHOPPED

8 GREEN CARDAMOM PODS

2 BROWN CARDAMOM PODS

1 TBSP GROUND TURMERIC

2 FRESH HOT CHILES SUCH AS BIRD'S-EYE,
SERRANO, OR HABANERO

8 BLACK PEPPERCORNS

8 GREEN PEPPERCORNS

8 PINK PEPPERCORNS

1 TBSP MUSTARD SEEDS

2 TBSP FRESH LEMON JUICE

2 CUPS/480 ML CHICKEN STOCK

Rub the chicken with peanut oil, sprinkle with kosher salt, and set on the countertop for 30 minutes or so before cooking.

In a small bowl, work a little yogurt into the chickpea flour to form a loose paste, slowly adding more yogurt until all the yogurt is integrated. Use a whisk to smooth out any lumps. Set aside.

Heat the 2 tbsp peanut oil in a 12-in/30-cm or larger cast-iron or a 5-qt/5-l or larger Dutch oven over medium heat. Working in batches, lay the chicken in the pan, skin-side down, and cook, turning frequently, for 10 minutes, or until nicely browned on both sides. Transfer the chicken to a plate and pour off any excess fat but don't wash the pan.

Add the onion, garlic, ginger, green and brown cardamom, turmeric, chiles, peppercorns, and mustard seeds and sauté, stirring frequently, for 5 minutes, or until fragrant. The pan should not go dry.

Add the stock, lemon juice, and then the yogurt mixture, stirring constantly. Finally, return the chicken to the pan, skin-side up, cover, and simmer gently for 25 to 30 minutes over low heat. An instant-read thermometer inserted into the thickest part of a thigh should register 175°F/80°C. If you're unsure, cut into a thigh to take a peek. Look for clear, not red or pink, juices running from the spot where you pierced the meat and opaque, barely pink, flesh at the bone. Serve with mixed condiments.

— FRIED OKRA —

Look for snappy, happy, crispy okra. Like beans, carrots, and asparagus, okra should not be flaccid or bendable. Salty and fresh, this okra is worth making.

1 CUP/240 ML PEANUT OIL

2 EGGS

1 CUP/110 G CHICKPEA FLOUR

1/2 TSP KOSHER SALT

1/2 TSP CAYENNE PEPPER

12 OZ/350 G OKRA, TRIMMED AND HALVED LENGTHWISE (ABOUT 2 1/2 CUPS)

FLAKY SALT FOR FINISHING

Heat the peanut oil in a large, heavy frying pan until shimmering but not smoking, or until it reaches around 350°F/180°C on a deep-frying thermometer.

Crack the eggs into a wide, shallow bowl and beat well. In a second wide, shallow bowl, whisk together the flour, kosher salt, and cayenne. Dip the okra pieces in the egg, turning to coat both sides, then dredge thoroughly in the seasoned flour. Shake off the excess flour. Working in batches, add the okra to the hot oil. Fry for 3 to 5 minutes, turning once. You want each piece crispy, brown, and tender all the way through. Sprinkle with the flaky salt and serve hot.

— MIXED CONDIMENTS —

BLACKENED STONE-FRUIT RELISH (PAGE 215)

UNSWEETENED COCONUT, TOASTED (SEE PAGE 21)

DRIED CURRANTS OR RAISINS

RED ONION MACERATED IN CIDER VINEGAR

SHREDDED CARROTS MIXED WITH TOASTED CUMIN SEEDS (SEE PAGE 21)

JULIENNED OR CUCUMBER THREADS (CUT WITH A VEGETABLE PEELER) IN YOGURT

MINCED TOMATO WITH CHOPPED FRESH MINT

Each of these condiments should be placed in a bowl on the table. Each person will compose their dish as they please—some making theirs sweet, others spicy.

CHICKEN-CASHEW CURRY
OVER BASMATI RICE
WITH MUSTARD CARROT RIBBONS
SERVES 4

This "curry" (my apologies to Madhur Jaffrey, who once sniffed, "The word *curry* is as degrading to India's great cuisine as the term *chop suey* was to China's") is assertively flavored and a deep ochre yellow. With cauliflower and zucchini cooked right in, what you'll have in your bowl is an exotic meal worthy of a day spent wandering shoeless on the cool marble floors of the Taj Mahal.

— CHICKEN-CASHEW CURRY —

8 BONE-IN, SKIN-ON CHICKEN THIGHS

1 TBSP PEANUT OIL, PLUS MORE FOR THE CHICKEN

KOSHER SALT

$1/2$ CUP/55 G CASHEWS, FINELY GROUND
(SEE PAGE 21)

1 TBSP MUSTARD SEEDS

1 TSP GARAM MASALA

2 TSP GROUND TURMERIC

3 GREEN CARDAMOM PODS

1 TBSP CORIANDER SEEDS

$1/2$ TSP FENUGREEK SEEDS (OPTIONAL)

2 CUPS/480 ML CHICKEN STOCK

1 CUP/240 ML UNSWEETENED COCONUT MILK

1 LARGE, SLENDER ZUCCHINI, CUT INTO ROUNDS
ABOUT $1/2$ IN/12 MM THICK

$1/2$ HEAD CAULIFLOWER, CUT INTO BITE-SIZE FLORETS

$1/4$ CUP/10 G CHOPPED CILANTRO LEAVES

FLAKY SALT FOR FINISHING

Rub the chicken with peanut oil, sprinkle with kosher salt, and set on the countertop for 30 minutes or so to take the chill off before cooking.

Heat the 1 tbsp peanut oil in a 12-in/30-cm or larger cast-iron frying pan or a 5-qt/5-l or larger Dutch oven over medium-high heat. Working in batches, lay the chicken thighs in the pan, skin-side down, and cook, turning frequently, for 10 minutes, or until nicely browned on both sides. Transfer the chicken to a plate and pour off any excess fat but don't wash the pan.

Add the cashews, mustard seeds, garam masala, turmeric, cardamom, coriander, and fenugreek (if using) to the hot pan and stir well. Cook for 2 to 3 minutes, or until fragrant and the mustard seeds pop. Add the stock and coconut milk, stir, and then nestle the chicken thighs into the sauce, skin-side up. Simmer, uncovered, for 20 minutes before adding the zucchini and cauliflower. Cook, covered, for 8 to 10 minutes longer, or until the vegetables are just tender. Sprinkle on the cilantro and a little flaky salt before serving.

— BASMATI RICE —

I am a huge fan of brown rice, but many people—including my husband, Dwight—are not. If you choose to make brown basmati rice, just plan accordingly, since it will take as long as 45 minutes.

2 CUPS/380 G WHITE BASMATI RICE

4 CUPS/960 ML WATER

3 TBSP BROWN MUSTARD SEEDS

2 TBSP BUTTER

FLAKY SALT FOR FINISHING

Rinse the rice in a colander under cold running water until the water runs clear. Drain off any remaining water and transfer the rice to a saucepan with a tight-fitting lid. Add the 4 cups/960 ml water, place over medium heat, cover, and cook until rice is tender and the water has evaporated, 12 to 15 minutes.

Heat a pan over medium heat, add the mustard seeds and toast for 1 minute before adding the butter. Once the butter melts, toss with the rice. Finish with a generous pinch of flaky salt before serving.

— MUSTARD CARROT RIBBONS —

Delicious, fast, and pretty, I love carrots done this way
served cold or hot.

1 TBSP OLIVE OIL OR BUTTER

6 MEDIUM CARROTS, ABOUT 1 1/2 LB/680 G, PEELED
AND THEN MADE INTO RIBBONS WITH A VEGETABLE
PEELER (ABOUT 4 CUPS)

2 TBSP MUSTARD SEEDS

2 TBSP PEELED AND GRATED FRESH GINGER

PINCH OF CAYENNE PEPPER

1/4 TSP KOSHER SALT

2 TBSP CHOPPED CILANTRO LEAVES

Heat the olive oil in a heavy sauté pan over medium heat. Add the
carrots, mustard seeds, and ginger and cook, stirring frequently,
for 5 to 7 minutes. The carrots should begin to blacken ever so
slightly on the edges (delicious!) and the seeds should pop and
color without blackening. Transfer to a bowl and top with the
cayenne, salt, and cilantro before serving.

NEPALESE GUESTHOUSE CHICKEN
WITH TEA-SCENTED LENTILS AND MINTED YOGURT

SERVES 4

The first bite of this dish, with the taste of lentils, tea leaves, spices, and yogurt, makes me feel a little dizzy—like I'm perched on rocky ground at 12,611 ft/3,860 m, thinking about the next day's hike out of Tengboche, Nepal. If I were there again, facing the prospect of gaining even more altitude the next day, I'd be hoping for a good night's sleep despite the thin, cold air. Smoky, fragrant chicken paired with spicy lentils and cool, sweet yogurt is as honest a meal as you're going to come by. Ladle out a portion of lentils into the bottom of a big wide bowl. Top with a chicken thigh or two and before you begin eating, add a big dollop of yogurt. A steamy, milky mug of Darjeeling tea on the side makes me feel the straps of my backpack like nothing else can.

— NEPALESE GUESTHOUSE CHICKEN —

8 TO 10 BONE-IN, SKIN-ON CHICKEN THIGHS

1 TSP CUMIN SEEDS OR ½ TSP GROUND CUMIN

1 GREEN OR BROWN CARDAMOM POD OR ½ TSP GROUND CARDAMOM

1 TBSP PEANUT OIL

1 TBSP DARJEELING TEA (ABOUT 1 TEA BAG)

1 TSP KOSHER SALT

5 PEPPERCORNS, CRUSHED, OR 1 TSP GROUND PEPPER

½ TSP SMOKED PAPRIKA

TEA-SCENTED LENTILS (PAGE 197)

MINTED YOGURT (PAGE 197)

Grind the cumin seeds and cardamom in a spice grinder or a clean coffee grinder (actually, coffee makes a tasty rub, too, so don't fuss too much! Skip this if you're using ground spices.) In a small bowl, combine the cumin, cardamom, peanut oil, tea, salt, pepper, and paprika and stir to make a paste. (Reserve 1 tsp of the paste to add to the lentils.) Spread the paste on the skin of the chicken. Let stand at room temperature for 30 minutes or so before cooking.

Build a medium-low fire in a charcoal or wood grill or heat a gas grill to medium-low. Use a clean, well-cured grate. If you are using charcoal or wood, you want hot embers, not flames. Put the thighs, skin-side down, on the grill and let them cook for 5 minutes or so before you move them. After that, I like to flip them every 5 minutes or so to keep them from sticking and to keep from burning the skin. Plan on standing, turning, flipping, and generally worrying the chicken for 30 to 40 minutes.

If your chicken is burning or the fat is igniting flames, turn the heat down or move the chicken to a cooler spot on the grill. (You can also douse the flames with a squirt bottle if there's no room to move the chicken out of the way.) Work slowly and the result will be a deep-mahogany-colored exterior concealing a well-cooked but juicy interior. That smoky flavor and crispy skin are worth the wait.

When the chicken is done, you will see that it has shrunk considerably. The meat should be firm but with a little give when you poke it with your finger. An instant-read thermometer should register 175°F/80°C. If you're unsure, cut into a piece to take a peek. Look for clear, not red or pink, juices running from the spot where you pierced the meat and opaque, barely pink flesh at the bone.

Pile the plates with lentils. Divide the chicken thighs on top and add a dollop of the Minted Yogurt on the side to serve.

— TEA-SCENTED LENTILS —

Plain but earthy, these tea-scented legumes will get you up
the mountain.

1 TBSP PEANUT OIL

1 SMALL YELLOW ONION, CHOPPED

5 CUPS/1.2 L CHICKEN STOCK

1 TBSP DARJEELING TEA (ABOUT 1 TEA BAG)

1 1/2 CUPS/300 G RED OR YELLOW LENTILS

1/2 TSP KOSHER SALT

1/2 TSP MADRAS CURRY POWDER

1 TSP SPICE PASTE FROM NEPALESE GUESTHOUSE
CHICKEN (PAGE 195)

Heat the peanut oil in a large sauté pan over medium heat, add the
onion, and cook for 5 to 8 minutes. Add the stock, tea, and lentils.
Cover and simmer for 12 to 15 minutes or until the lentils are tender
but not mushy. Mix in the salt, curry powder, and spice paste. Serve
hot or at room temperature.

— MINTED YOGURT —

Use full-fat yogurt without sugar, gelatin, or any other
additives. I love my Seven Stars Farm yogurt from
Phoenixville, PA. It's the best!

1 CUP/240 ML WHOLE PLAIN YOGURT

1/4 CUP/10 G CHOPPED FRESH MINT

Mix the yogurt and mint together in a blender until smooth.

GINGER-CORIANDER CHICKEN
WITH ROASTED CAULIFLOWER

SERVES 4

Come on, how many times have you bored yourself, your family—even your dog—by cooking the same chicken and rice dish? Don't do it again. Just brown your chicken, toast some spices, chop a little garlic and some herbs, and put everything in one pot with some stock to work its magic in the oven. Toss the cauliflower with oil and salt and stick it in that same oven. The rice is just rice until it meets that fragrant sauce. Because it doesn't depend on chiles for spice and flavor, this simple chicken will work for kids, too. Any heat-obsessed grown-ups can always spoon on some Raw Hot Sauce (page 112).

— GINGER-CORIANDER — CHICKEN

8 TO 10 BONE-IN, SKIN-ON CHICKEN THIGHS OR ONE 3- TO 4-LB/1.4- TO 1.8-KG CHICKEN

1 TBSP PEANUT OIL, PLUS MORE FOR THE CHICKEN

KOSHER SALT

1 RED OR ORANGE BELL PEPPER, SEEDED AND DICED

ONE 6-IN/15-CM PIECE FRESH GINGER, PEELED AND THINLY SLICED

1 TBSP CORIANDER SEEDS

1 TBSP YELLOW MUSTARD SEEDS

4 GARLIC CLOVES, CRUSHED

3 CUPS/720 ML CHICKEN STOCK

BLACK PEPPER

BASMATI RICE (PAGE 193)

1/2 CUP/40 G CHOPPED GREEN ONIONS, WHITE AND TENDER GREEN PARTS ONLY

1/2 CUP/20 G CHOPPED CILANTRO LEAVES

FLAKY SALT FOR FINISHING

Preheat the oven to 450°F/230°C/gas 8.

Rub the chicken with peanut oil, sprinkle with kosher salt, and set on the countertop for 30 minutes or so to take the chill off before cooking.

Heat the 1 tbsp peanut oil in a 12-in/30-cm or larger cast-iron frying pan or a 5-qt/5-l or larger Dutch oven over medium-high heat. Working in batches, lay the chicken thighs in the pan, skin-side down, and cook, turning frequently, for 10 minutes or until nicely browned on both sides. (For a whole chicken, brown only the bottom and sides. No need to turn it upside down, as the top will brown in the oven.) Transfer the chicken to a plate and pour off any excess fat but don't wash the pan.

Reduce the heat to low, and add the bell pepper, ginger, coriander seeds, mustard seeds, and garlic to the pan. Swirl the spices and aromatics around for 2 to 3 minutes, or just until the mustard seeds begin to pop. Add the stock and return the chicken to the pan, skin-side up. Put the pot in the oven, uncovered, for 30 minutes. Insert an instant-read thermometer into the thickest part of a thigh. It should register 175°F/80°C. If you're unsure, cut into a thigh at the joint and take a peek. Clear juices running from the spot where you pierce the meat and just beyond pink but opaque flesh through to the joint is what you want.

Remove the pan from the oven and let the chicken rest for 5 minutes before carving (see page 18). Taste the sauce and adjust the seasoning with kosher salt and pepper. Divide the rice among individual plates and arrange the chicken meat on top. Ladle the liquid and vegetables from the pan around the chicken and over the rice, being sure to portion out the delicious whole spices and sliced ginger. To serve, sprinkle on a handful of green onions and cilantro. A pinch of flaky salt on top and you're ready to eat.

— ROASTED CAULIFLOWER —

Trust me on this: roasting cauliflower is the best way to
cook it and roasting it with coriander only makes what is
very good better.

1 HEAD CAULIFLOWER, TRIMMED AND
CUT INTO BITE-SIZE FLORETS

1/2 TSP KOSHER SALT

2 TBSP CORIANDER SEEDS, CRUSHED

2 TBSP PEANUT OIL

FLAKY SALT FOR FINISHING

Preheat the oven to 450°F/230°C/gas 8.

Put the cauliflower in a large mixing bowl, add the kosher
salt, coriander seeds and peanut oil. Toss to coat. Cover a large
baking sheet with parchment paper (if you have it) and spread
out the cauliflower in one layer. Drizzle any oil left in the
bowl over the cauliflower. Roast for 10 to 15 minutes or until
the cauliflower shows a few flecks of black on the edges and
plenty of brown. A pinch of flaky salt, and you're ready to eat.

CHAPTER
6

MIDDLE EASTERN AND AFRICAN CHICKEN

MIDDLE EASTERN
AND
AFRICAN CHICKEN

What drives this disparate chapter are the classic ingredients of great Mediterranean food (olives, couscous, lemons, almonds, figs) set alongside African staples like collard greens, peanuts, and yams. There are plenty of chiles here to go around—you certainly won't lack for heat.

For your pantry, buy the best saffron threads you can afford, and truly fresh pistachios, almonds, coriander seeds, dry-cured olives, green olives, and lemons. You could make a batch of Preserved Lemons (page 226) so that you'll have them when you want them.

DRINKS

Drink mint tea or mix together some ginger beer (really ginger water) by combining two good-size pieces of ginger, peeled and sliced, with some hot water. Let it soak as long as you can, add simple syrup and lemon juice. Orange-flower water or rum will make it sing. Pour over ice and garnish with a slice of fruit. You could also cheat and make ginger- or ginseng-based iced teas. My favorite, made in Colorado, has a funny name: SPORTea. Put a big pitcher of it in the refrigerator and sip it with all your spicy food.

ON THE TABLE

Packaged pita bread has become so common in the United States and many other countries that most people have never eaten a really fresh one. Look for pita made the same day at your bakery or try making a batch of Onion Flatbread (page 186). To capture the mood of the region, decorate the table with brightly colored Moroccan tea glasses, white napkins, and plenty of fresh flowers. Loads of low, twinkling tea lights will make you feel like you've stepped into the pages of a Paul Bowles short story.

SWEETS

Dates stuffed with marzipan will give you a hit of sweet without filling you up. Almond cake, made with slivered almond, marzipan, and kirsch, is one of my favorite desserts. It would go beautifully with the food here.

BEDOUIN STEW
WITH FRESH GARLIC CHICKPEAS AND TOMATO RELISH

SERVES 4

The Bedouin tribes of the Sahara are famous for their hospitality despite their historically nomadic culture and the desert's rugged environmental conditions. I imagine this stew might be what Peter O'Toole would have eaten—if he ate at all—as he crossed the desert in the 1962 film *Lawrence of Arabia*. If you'd like to eat in the Bedouin manner, rather than serving the pieces whole, shred the chicken into the sauce and make a pot of rice. Get rid of all forks, knives, and spoons and use your (right!) hand to make balls of rice, chicken, and sauce. Pop one into your mouth and return for another.

— BEDOUIN STEW —

8 TO 10 BONE-IN, SKIN-ON CHICKEN THIGHS OR ONE 3- TO 4-LB/1.4- TO 1.8-KG CHICKEN

1 TBSP PEANUT OIL, PLUS MORE FOR THE CHICKEN

KOSHER SALT

3 GARLIC CLOVES, THINLY SLICED

1 TSP GROUND TURMERIC

1 SERRANO OR HABANERO CHILE, MINCED

1 TBSP GROUND CORIANDER

2 TOMATOES, CHOPPED

3 CUPS/720 ML CHICKEN STOCK

¼ CUP/10 G CHOPPED FRESH MINT LEAVES

JUICE OF 1 LEMON

BLACK PEPPER

FLAKY SALT FOR FINISHING

Rub the chicken with peanut oil, sprinkle with kosher salt, and set on the countertop for 30 minutes or so to take the chill off before cooking.

Heat the 1 tbsp peanut oil in a 12-in/30-cm or larger cast-iron frying pan or a 5-qt/5-l or larger Dutch oven over medium-high heat. Working in batches, lay the chicken in the pan, skin-side down, and cook, turning frequently, for 10 minutes, or until nicely browned on both sides. (For a whole chicken, brown only the bottom and sides as the top will brown in the oven.) Transfer the chicken to a plate and pour off any excess fat but don't wash the pan.

Add the garlic, turmeric, chile, coriander, tomatoes, and 1/2 tsp kosher salt to the pan. Reduce the heat to medium-low and cook, until you begin to smell the garlic and some of the moisture from the tomatoes has evaporated, 3 to 5 minutes. Add the stock and stir before returning the chicken to the pan, skin-side up (or breast-side up for a whole chicken). Cook for 30 minutes before either inserting an instant-read thermometer into the thickest part of a thigh or cutting into a thigh with a paring knife. A thermometer should register 175°F/80°C. If using a knife, look for clear, not red or pink, juices running from the spot where you pierced the meat and opaque, barely pink flesh at the bone. If the chicken isn't done, roast for 5 to 10 minutes longer and check it again.

Remove the chicken from the pan and pour the liquid into a fat separator. (You can also use a heatproof jar and use a spoon to skim off as much fat as you can.) Return the defatted liquid to the pan, add the mint and lemon juice and season with pepper. Taste and adjust the seasoning. (Carve the chicken [see page 18] if using a whole bird.) Finish the chicken with a pinch of flaky salt and serve.

— FRESH GARLIC CHICKPEAS —

Appearing more and more often in markets, fresh chickpeas
are an oddity most people don't know what to do with. Buy a
big bag! After living for years with only the wan canned or
dried varieties, it's such a pleasure to experience the subtle
milky green of the fresh pea. The peeling takes time, but if
you have children around, let them pitch in. If you can't find
fresh chickpeas, use well-rinsed canned chickpeas.

2 TBSP OLIVE OIL

3 CUPS/430 G FRESH CHICKPEAS, PEELED

3 GARLIC CLOVES, THINLY SLICED

FLAKY SALT FOR FINISHING

In a heavy sauté pan, heat the olive oil over medium heat. Add the
chickpeas and cook gently for 10 minutes before adding the garlic.
Cook until the chickpeas are tender and the garlic is soft and
fragrant, 3 to 5 minutes longer. Transfer to a bowl and sprinkle
with a generous pinch of flaky salt before serving.

— TOMATO RELISH —

A condiment that adds color and acidity to everything
on the plate.

2 LARGE RIPE TOMATOES, CHOPPED

2 TBSP CIDER VINEGAR

1/4 CUP/10 G CHOPPED FRESH PARSLEY

1/2 TSP KOSHER SALT

In a small bowl, mix together the tomatoes, vinegar, parsley, and salt.
Enjoy at room temperature.

PIRI PIRI KUKU
WITH CHOPPED GREENS
AND TOASTED MILLET

SERVES 4

I love the word *kuku*—it means "chicken" in many parts of
Africa. I can't resist combining it with the playful name
of the ubiquitous African chile and its eponymous sauce.
Millet and greens—collard, mustard, and other kinds—are
very African.

Use $^1/_4$ cup/60 ml of the sauce to marinate the chicken. You'll
have plenty left over for dipping and a good bit for the next
morning's eggs. It's good! Use a mix of chiles such as serrano,
Anaheim, bird's-eye, and Scotch bonnet.

— PIRI PIRI KUKU —

PIRI PIRI SAUCE

$^1/_4$ CUP/60 ML PEANUT OIL

$^1/_2$ CUP/55 G COARSELY CHOPPED FRESH HOT
CHILES SUCH AS ANAHEIM, ARBOL, HABANERO, OR
SERRANO, WITH SEEDS AND MEMBRANES

$^1/_4$ CUP/60 ML APPLE CIDER VINEGAR

1 TSP GROUND TURMERIC

$^1/_4$ TSP GROUND GREEN CARDAMOM

1 TSP SMOKED PAPRIKA

1 TBSP DRY MUSTARD

1 TSP KOSHER SALT

1 TBSP RAW SUGAR

8 TO 10 BONE-IN, SKIN-ON CHICKEN THIGHS

FLAKY SALT FOR FINISHING

To make the sauce: Combine the peanut oil, chiles, vinegar, turmeric, cardamom, paprika, mustard, kosher salt, and sugar in a blender or food processor and process until smooth. Transfer to a saucepan over medium heat and cook, stirring frequently, until thick and reduced by half, about 20 minutes or so. Remove from the heat and set aside to cool. (The sauce will keep, tightly covered in the refrigerator, for up to 10 days.)

Put the thighs in a mixing bowl, add 1/4 cup/60 ml of the sauce, and turn to coat. Marinate at room temperature for at least 30 minutes and up to 1 hour, or cover and refrigerate up to 24 hours. (If refrigerating, return the chicken to room temperature for 30 minutes or so to take the chill off before grilling.)

Build a medium fire in a charcoal or wood grill or heat a gas grill to medium-low. Use a clean, well-cured grate. If you are using charcoal or wood, you want hot embers, not flames.

Put the thighs, skin-side down, on the grill and let them cook for 5 minutes or so before you move them. After that, I like to flip them every 5 minutes or so to keep them from sticking and to keep from burning the skin. Plan on standing, turning, flipping, and generally worrying the chicken for 30 to 40 minutes.

If your chicken is burning or the fat is igniting flames, turn the heat down or move the chicken to a cooler spot on the grill. (You can also douse the flames with a squirt bottle if there's no room to move the chicken out of the way.) Work slowly and the result will be a deep-mahogany-colored exterior concealing a well-cooked but juicy interior. That smoky flavor and crispy skin are worth the wait.

When the chicken is done, you will see that it has shrunk considerably. The meat should be firm but with a little give when you poke it with your finger. An instant-read thermometer inserted into the thickest part of a thigh should register 175°F/80°C. If you're unsure, cut into a piece to take a peek. Look for clear, not red or pink, juices running from where you pierced the meat and opaque, barely pink flesh at the bone.

When the chicken is done, let it rest for 5 minutes. Give it a pinch of flaky salt and serve. Pass the remaining Piri Piri Sauce at the table.

— CHOPPED GREENS —

I adore bok choy, kale, and all kinds of Asian greens like tatsoi, choy sum, mustard, and mizuna. If you're shy about greens, start with baby bok choy and work your way up. If you're working with mature kale or something with a hefty stem and center spine, cut the leaf off the stem and then either chop or discard the stems and spines.

8 OZ/225 G COOKING GREENS (SEE RECIPE INTRODUCTION), TOUGH STEMS REMOVED

1 TBSP OLIVE OIL

1 SHALLOT, MINCED

3 GARLIC CLOVES, THINLY SLICED

1 TSP KOSHER SALT

Rinse the greens under cold water, leaving them wet. Heat the olive oil in your largest sauté pan over medium-low heat. Add the shallot and sauté for 2 minutes, then add the garlic. Cook for 1 minute before adding the greens and salt.

Stir the greens to coat with the oil, garlic, and shallot and then cover the pan. Cook until the greens are tender but still with some resistance, 5 to 8 minutes. Older greens will need a little longer (as much as 12 to 15 minutes) and possibly an additional splash of water before they are cooked; baby greens can flash in and out of the pan so they go to the table just wilted.

— TOASTED MILLET —

I love millet, a traditional African grain, because it's neither too earthy—like kasha—nor bitter. Cooked like pasta, it's easy to make and oh so good for you.

1 CUP/225 G MILLET

1 TBSP OLIVE OIL

3/4 TSP KOSHER SALT

1/4 CUP/10 G CHOPPED FRESH HERBS SUCH AS OREGANO, MINT, BASIL, AND PARSLEY

Bring a large saucepan three-fourths full of water to a boil over high heat. Add the millet and cook for 25 to 30 minutes, or until the grains are tender but not mushy. Drain well in a fine-mesh sieve and transfer to a bowl. Toss with the olive oil, salt, and herbs and serve.

GRILLED THIGHS
WITH BLACKENED STONE-FRUIT RELISH, SAFFRON RICE, AND FROZEN PICKLED CUCUMBERS

SERVES 4

Who doesn't love stone fruit? Because it has a limited season, I make the most of it, scattering cherries on yogurt, peaches on ice cream, and nectarines and plums into pies, clafouti, galettes, and crisps. When I still haven't had enough, I go for the salt and spice. Stone fruit makes a perfect relish. Use fruit that is delicious and flavorful eaten out of hand so you will have a worthy relish.

— GRILLED THIGHS —

8 TO 10 BONE-IN, SKIN-ON CHICKEN THIGHS

1 TBSP PEANUT OIL

1/2 TSP KOSHER SALT

FLAKY SALT FOR FINISHING

Rub the chicken with the peanut oil, sprinkle with the kosher salt, and set on the countertop to take the chill off for 30 minutes or so before cooking.

Build a medium fire in a charcoal or wood grill or heat a gas grill to medium-low. Use a clean, well-cured grate. If you are using charcoal or wood, you want hot embers, not flames.

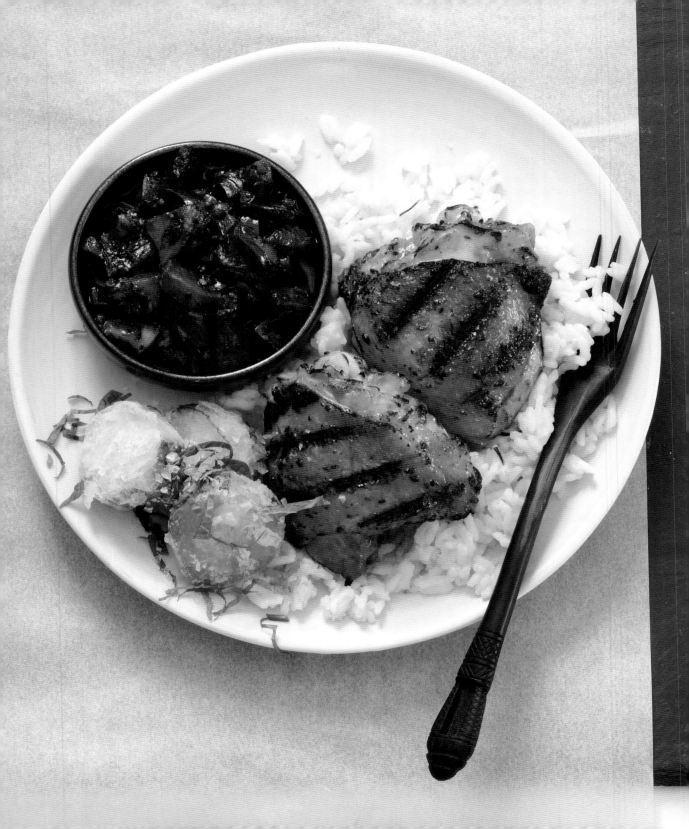